Canon® EOS 50D
Digital Field Guide

Canon® EOS 50D Digital Field Guide

Charlotte K. Lowrie

WILEY

Wiley Publishing, Inc.

Canon® EOS 50D Digital Field Guide

Published by
Wiley Publishing, Inc.
10475 Crosspoint Boulevard
Indianapolis, IN 46256
www.wiley.com

ISBN: 978-0-470-45559-3

Manufactured in the United States of America

10 9 8 7 6 5 4 3 2 1

For general information on our other products and services or to obtain technical support, please contact our Customer Care Department within the U.S. at (800) 762-2974, outside the U.S. at (317) 572-3993 or fax (317) 572-4002.

Wiley also publishes its books in a variety of electronic formats. Some content that appears in print may not be available in electronic books.

Library of Congress Control Number: 2009920910

WILEY

About the Author

Charlotte K. Lowrie is a professional editorial, portrait, and stock photographer and an award-winning writer based in the Seattle, Washington area. Her writing and photography have appeared in newsstand magazines and on Web sites. Her images have appeared on the Canon Digital Learning Center, and she is a featured photographer on www.takegreat pictures.com. She is the author of 11 books including the best-selling *Canon EOS Rebel XSi/450D Digital Field Guide* and the *Canon EOS Rebel XTi/400D Digital Field Guide.* She is the co-author of *Exposure and Lighting for Digital Photographers Only.* In addition to shooting ongoing photography assignments, Charlotte teaches two photography classes at BetterPhoto.com every month.

You can see more of Charlotte's images on her Web site at wordsandphotos.org.

Credits

Associate Acquisitions Editor
Aaron Black

Senior Project Editor
Cricket Krengel

Technical Editor
Ben Holland

Copy Editor
Kim Heusel

Editorial Manager
Robyn Siesky

Business Manager
Amy Knies

Senior Marketing Manager
Sandy Smith

Vice President and Executive Group Publisher
Richard Swadley

Vice President and Executive Publisher
Barry Pruett

Senior Project Coordinator
Kristie Rees

Graphics and Production Specialists
Ana Carrillo
Andrea Hornberger
Jennifer Mayberry
Christin Swinford

Quality Control Technicians
Melissa Cossell
Amanda Graham

Proofreading and Indexing
Penny Stuart
Broccoli Information Management

This book I dedicated in loving memory to Vera Sauer, a woman whose love, strength, integrity, and faith were, and continue to be, an inspiration to all who knew her.

Contents at a Glance

Contents

Chapter 3: Controlling Exposure and Focus 47

Chapter 4: Getting Great Color 91

Part II: Doing More with the EOS 50D 133

Chapter 6: Shooting in Live View or Tethered 135

Chapter 5: Customizing the EOS 50D 115

Chapter 7: Working with Flash and Studio Lights 147

Chapter 8: Lenses and Accessories 165

Chapter 9: Using the EOS 50D in the Field 189

Part III: Appendixes 221

Appendix A: The Fundamentals of Exposure 223

Appendix B: Exploring RAW Capture 235

Appendix C: Maintaining the 50D 243

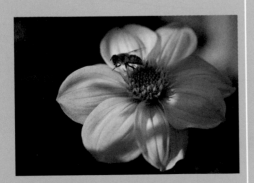

Glossary 249

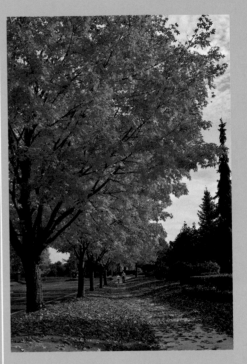

Index 257

Introduction

Welcome to the Canon EOS 50D Digital Field Guide. With the EOS 50D, Canon combined speed and responsiveness with high resolution and a full complement of features — all in a lightweight and fun-to-use camera. Whether this is your first digital SLR or you're an experienced photographer, this book is written to help you get the most from the camera. From personal experience, I know that the 50D is a fine tool that will help you realize and express your creative vision.

Achieving your creative vision with the 50D involves not only mastering the buttons, dials, and menus, but also learning what to expect from the camera as you work with it in the field, and, of course, your own skilled eye and creativity. It is in the field where you come to appreciate the camera's broad range of features, timesaving custom options, full creative control, and, of course, the data-rich images that the 50D delivers.

This book is designed to help you learn the basics and to go deeper into the camera so that you can take advantage of its full potential. If you're new to digital SLR's, then I suggest that you read at a high level, using the techniques that are described while saving the in-depth explanations for later. As you gain experience, then you can come back to the more detailed sections to understand more about the camera and photography itself. And if you're a more experienced photographer, I hope that the book will answer questions you may have, reveal new and creative ways to use the 50D, and inspire you to use the 50D to its full potential.

As a long-time photographer, I firmly believe that this book should not be only a reference book. Rather, I believe that photographers want to know how the camera responds and how it delivers in real shooting situations. I've used the EOS 50D long enough to be able to offer insights into the camera's performance and to share recommendations based on my experience. As readers often tell me, their preferences are different from my preferences. But you can use my recommendations as a springboard to setting up and shooting with the 50D in a way that suits your style and subject.

I hope that this book shows you things you didn't know before, that it clarifies concepts that were previously confusing, and, most important, I hope that it inspires you to make wonderful images. Writing this book was a rewarding journey for me. I hope that reading the book will be a rewarding journey into the creative world of photography for you.

Making the Most of This Book

As much as is practicable, this book follows a sequence from learning the camera controls to setting up the camera, shooting and focus controls, controlling all aspects of image color, setting Custom Functions, and using a flash. By the time that you finish reading Chapter 5, you will have a good understanding of what the camera offers from the top level through to the finer details. But more important, with Chapter 5, you have the opportunity to setup the camera for your most common scenes and subjects. The time saving of using the custom options on the 50D including the C shooting modes translates directly into time savings for you in the field.

The 50D offers Live View shooting with some enhancements over previous versions of Live View. Chapter 6 gives you a step-by-step guide on how to set up for and use Live View shooting, and what scenes and subjects are best suited for shooting with Live View. This chapter also discusses shooting with the 50D attached to the computer, or *tethered* shooting. You learn how you can control the camera entirely from your computer including setting an instant sort of Custom White Balance, changing exposure settings, and more.

Chapter 7 concentrates on using the built-in and an accessory flash unit, using multiple Speedlites with stands and light modifiers such as softboxes and umbrellas, and there is also a brief look at using the 50D with a studio lighting system.

I've seldom met a photographer who isn't looking to buy another lens. And in Chapter 8, you look at lenses and their characteristics. You can use these lens characteristics for both classic renderings as well as creative applications.

One of the distinguishing characteristics of the Digital Field Guide series of books is a concentration on shooting with cameras in real-world shooting scenarios. Chapter 9 is devoted to shooting in the field. Three common and broadly applicable areas are discussed: Landscape and Nature, Portraits, and Action and Events. From the information on these three subject areas, you can extrapolate to many other subjects including travel, architecture and interiors, documentary, and stock subject, environmental portraits, headshots, publicity, editorial assignments, and more. The focus of Chapter 9 is to provide suggestions and examples from my experience with the 50D that you can use or modify for your photography. Again, my experiences can serve as a starting place for you to setup your shooting.

Finally, Appendix A is a must read if you're new to photography. Here you learn the basics of photographic exposure. And if you're contemplating RAW shooting, be sure to read Appendix B that outlines the advantages, and takes a look at a sample RAW image conversion.

I hope that this book helps you not only make the most of your EOS 50D, but that it also inspires and challenges you in your daily shooting.

The editor, the staff at Wiley, and I hope that you enjoy reading this book as much as we enjoyed creating it for you.

Navigating and Setting Up the EOS 50D

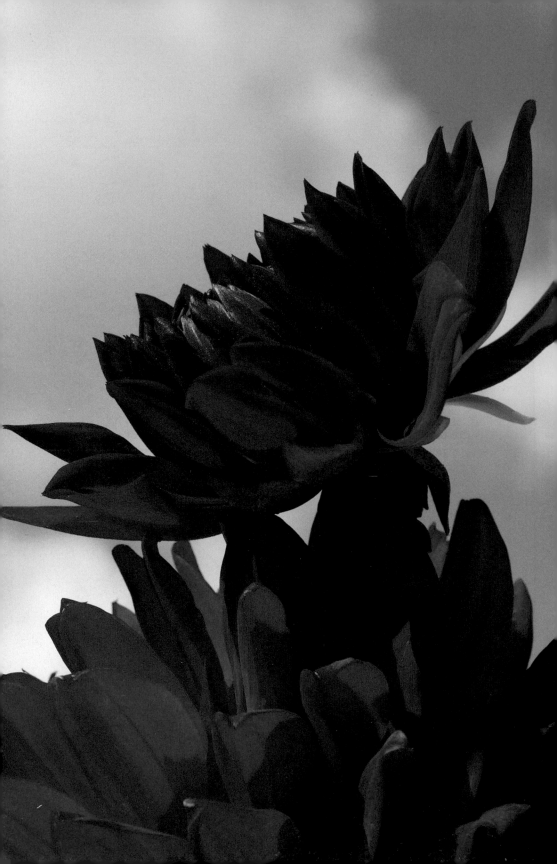

Roadmap to the EOS 50D

Three words can describe Canon's 50D dSLR — fast, sleek, and fun. It fits easily and comfortably in the hand with a compact yet substantial heft. It responds with the speed of a gazelle delivering images at a rate of 6.3 frames per second (fps) and at a stunning 15.1-megapixels. The EOS 50D is packed with Canon's latest features and technologies that collectively deliver speedy and reliable performance and superior image quality. Whether you're new to digital photography or a veteran, the EOS 50D hits a sweet spot of high image resolution, speed, and creative control.

This chapter puts some of the new features and technologies of the EOS 50D into everyday perspective and offers a roadmap to navigating the camera controls and menus. Where possible, I offer paradigms for using the camera that help you spend less time remembering what control to use and more time shooting.

Key Technology

Before we begin, it's worthwhile to look at key technology that the 50D offers. The first, the 15.1-megapixel image sensor at 4752 × 3168 pixels produces full-resolution prints at 15.5 × 10.7 inches at 300 ppi, or 19.4 × 13.4 inches at 240 ppi for inkjet prints. The new CMOS (complementary metal-oxide semiconductor) features Canon's newest technology including:

◆ **"Gapless" microlens technology and increased ISO range.** While the EOS 50D packs more and smaller pixels on a sensor that's the same size as the EOS 40D (4.7 versus 5.7 micron pixels sizes,

respectively), the new sensor is engineered to increase each pixel's light sensitive area and to use a larger microlens over each pixel. The spaces between microlens on the sensor array are now gapless so that each microlens covers more of the pixel surface than in previous Canon digital SLR sensors. Thus the EOS 50D provides approximately 1 to 1.5 f-stops better digital noise performance at high ISO sensitivities than previous sensors. In everyday shooting, this translates into new opportunities for lowlight shooting particularly when you're using an Image-Stabilized (IS) lens.

✦ **DIGIC 4 processor.** Every new iteration of Canon's DIGIC processor improves the speed of image processing, and that's no less true with the fourth generation of Canon's on-board processor. The 14-bit DIGIC 4 processor offers 30 percent faster image processing than previous processors. It also offers increased functionality including full and variable resolutions; High ISO Noise Reduction options; Auto Lighting Optimizer with three selectable levels; and Peripheral Illumination Correction, or vignette control, for JPEG capture (and vignette control for RAW files using Canon's Digital Photo Professional program). And the faster processor results in a faster and more responsive autofocus system. Taken together, DIGIC 4 performs more processing with more selectable options for image correction — all with no appreciable loss of speed and performance.

Camera Features Overview

If you've had your EOS 50D for any amount of time, then you are likely familiar with most of the controls on the camera. However, the following sections are designed to provide a paradigm for using the controls in logical and efficient ways because once you learn the overall design, you can make camera adjustments more efficiently. And chances are that there are some buttons and controls that you haven't figured out yet, so these sections help you make full use of all the 50D has to offer.

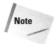 *Note* *It's important to become familiar with the names of camera controls now because I refer to these names throughout this book.*

There are three main controls that can be used together or separately to control most functions on the EOS 50D. Here is a quick synopsis of the controls and when to use them.

✦ **Main dial and Quick Control dial.** You use the Main and Quick Control dials to make changes for the for dual-function buttons located along the top LCD panel such as the AF-Drive button (Autofocus mode and Drive mode). Use the Main dial to change the first named function. So for the AF-Drive button, you turn the Main dial to change the Autofocus mode. For the second named function, you make changes using the Quick Control dial. So, you turn the Quick Control dial to change the Drive mode. This holds true for the

Metering mode-White Balance and ISO-Flash Compensation buttons on the camera as well. Some camera menu screens such as the Quality screen also use the Main and Quick Control dials for selecting different values on the screen.

✦ **Multi-controller.** This eight-way control functions as a button when it's pressed, and as a joystick when it's tilted in any direction. With the new Quick Control screen, the Multi-controller is the primary control. Ironically, the Quick Control dial would seem to be the logical choice to activate the Quick Control screen, but, such is not the case. To activate the Quick Control menu, press the center of the Multi-controller, and then tilt the Multi-controller to move around the screen. Once an option is selected on the Quick Control screen, you can turn the Quick Control dial or Main dial to make changes.

1.2 The Multi-controller

✦ **Set button.** The Set button is located in the center of the Quick Control dial, and you use it to confirm changes you make to many menu items and to open submenus. When you're using the Quick Control screen, you can select a setting, such as White Balance, and then press the Set button to display all the options for the setting, in this case, the White Balance screen showing all White Balance options.

Main dial Quick Control dial

1.1 The Main and Quick Control dials

Front of the camera

While you, as the photographer, don't often see the front of the camera, it includes the nicely sculpted grip that increases control and balance when handling the camera, and it includes controls that you use often.

The front-of-the-camera features include, from left to right side, the following:

✦ **Shutter button.** The Shutter button is a two-step control. When you press the Shutter button halfway, the 50D meters the light in the scene and focuses on the subject using either the autofocus (AF) point that you've selected or at the AF point(s) that the camera's selected automatically. Completely pressing the Shutter button fires the shutter to make the picture. In High-Speed or Low-Speed Continuous drive mode, pressing and holding the Shutter button starts burst shooting at either 3 frames per second (fps) or 6.3 fps, respectively. In Self-timer modes, pressing the Shutter button completely initiates the 2- or 10-second timer, and after the timer delay, the shutter fires to make the picture.

✦ **Red-eye Reduction/Self-timer lamp.** When using the built-in flash with the Red-eye reduction option turned on, this lamp lights to help reduce pupil size to reduce the appearance of red in the subject's eyes if the subject looks at the lamp. In the two Self-timer modes, this lamp flashes to count down the seconds, either 2 or 10 seconds, to shutter release.

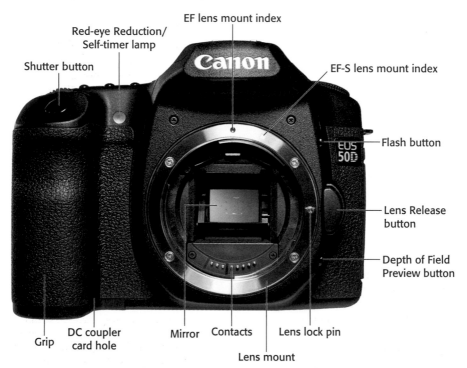

1.3 EOS 50D camera front

✦ **Mirror.** As you compose an image, the reflex mirror reflects light from the lens to the pentaprism so that you can see in the eyepiece of the viewfinder what will be captured by the imaging sensor. The viewfinder offers 95 percent frame coverage. In Live View shooting the mirror is flipped up to allow a live view of the scene. If you are using Live mode focusing, the mirror flips down to focus, thereby suspending Live View momentarily.

✦ **Lens mount and contacts.** The lens mount is compatible with Canon's EF and EF-S lenses. EF-S lenses are compatible with only the cropped image sensor size of the 50D and other Canon EOS digital SLR cameras. EF lenses are compatible with all EOS digital SLRs. The lens mount includes a red index marker that's used to line up EF-mount lenses and a white index mount marker that's used to line up EF-S lenses.

✦ **Depth of field preview button.** Pressing this button stops down the lens diaphragm to the currently selected aperture so that you can preview the depth of field in the viewfinder. The larger the area of darkness, the more extensive the depth of field will be. The button can be used in regular and Live View shooting. If the lens is set to the maximum aperture, the Depth-of-field preview button can't be depressed because the diaphragm is already fully open.

✦ **Lens Release button.** This button releases the lens from the lens mount. To disengage the lens, depress and hold down the Lens Release button as you turn the lens so that the red or white index mark moves toward the top of the camera.

✦ **Flash button.** In P, Tv, Av, M, A-DEP, and C shooting modes, press this button to pop up and use the built-in flash. In automatic modes such as CA, Portrait, Landscape, and so on, pressing the Flash button has no effect because the camera automatically determines when to use the built-in flash.

Top of the camera

Dials and controls on the top of the camera provide access to frequently accessed shooting functions in addition to the hot shoe and diopter control. Here is a look at the top of the 50D.

✦ **Mode dial.** Turning this dial selects the shooting mode, which determines how much control you have over image exposures. Shooting modes are grouped into three zones including the Image, or automatic, Creative, and Camera User Settings zones. Automatic shooting modes are CA (Creative Auto), Full Auto, Portrait, Landscape, Close-up, Sports, Night Portrait, and Flash Off. Creative Zone shooting modes are P (Program AE), Tv (Shutter-priority AE), Av (Aperture-priority AE), M (Manual exposure), and A-DEP (Automatic depth-of-field AE) modes. The third zone, Camera User Settings, encompasses C1 and C2, shooting modes that you can program with your favorite settings. Just turn the dial to line up the shooting mode that you want to use with the white mark to the right of the dial.

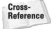 Shooting modes are detailed in Chapter 3, including the noncustomizable shooting modes. Chapter 5 explains how to set up the customizable C1 and C2 modes.

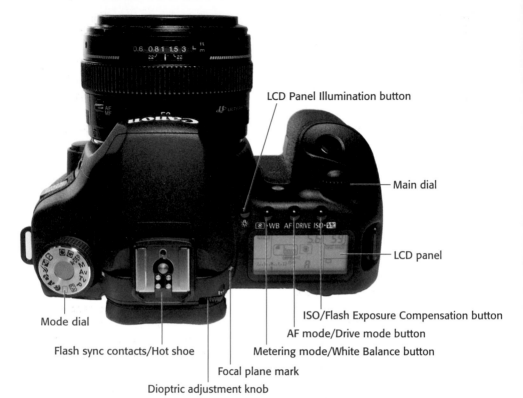

1.4 EOS 50D top of the camera

✦ **Hot shoe.** The hot shoe mounting plate with flash sync contacts is where you mount an accessory flash unit. The 50D hot shoe is compatible with E-TTL II auto flash with accessory Canon EX-series Speedlites and supports wireless multi-flash support. When using a 580 EX II Speedlite, the 50D offers flash configuration from the camera using the Set-up 3 (yellow) menu. The camera also provides Flash Exposure Compensation to decrease or increase the flash output by up to plus/minus 2 stops in 1/3- or 1/2-stop increments.

✦ **Dioptric adjustment knob.** Turn this control forward or backward to adjust the sharpness for your vision by -3 to +1 diopters. If you wear eyeglasses or contact lenses for shooting, be sure to wear them as you turn the dioptric adjustment control. To make the adjustment, point the lens to a light-colored surface such as a piece of white paper or a white wall, and then turn the control until the AF points are perfectly sharp and crisp for your vision.

✦ **Focal plane mark.** The mark indicates the equivalent of the film plane and is useful in macro photography when you need to know the exact distance from the front of the image sensor plane to the subject.

✦ **LCD Panel Illumination button.** This button is tucked to the far left of the buttons above the LCD panel. Pushing the LCD Panel Illumination button turns on an amber light to illuminate the LCD panel for approximately 6 seconds. This is a handy option for making LCD panel adjustments in lowlight or in the dark.

✦ **Main dial.** The Main dial selects a variety of options. Turn the Main dial to change first named option on the dual-function buttons, cycle through camera Menu tabs, cycle through autofocus (AF) points when selecting an AF point manually, set the aperture in Av and C modes, set the shutter speed in Tv and Manual (M) modes, and shift the exposure in Program (P) mode.

Note *Although the features are discussed with the dials, you can check out Table 1.1 for a quick reference for using the Main dial and Quick Control dial with the LCD Panel buttons.*

✦ **Metering mode/White Balance button.** Press this button to change the Metering mode and/or the White Balance settings. To change the Metering mode, turn the Main dial, or to change the White Balance, turn the Quick Control dial. The options for each are as follows:

• **Metering modes.** The choices include Evaluative (35-zone TTL full-aperture metering), Partial (9 percent at center frame), Spot (3.8 percent at center frame), and Center-weighted Average.

• **White Balance.** Choices include Auto (3000-7000 degrees Kelvin (K)), Daylight (5200 K), Shade (7000 K), Cloudy (6000 K), Tungsten (3200 K), White Fluorescent (4000 K), Flash (6000 K), Custom (2000-10000 K), and K (Kelvin Temperature, 2500-10000 K).

✦ **AF mode/Drive mode button.** Pressing this button enables you to change the Autofocus mode using the Main dial, or to change the Drive mode using the the Quick Control dial. The options for each are listed here:

• **AF modes.** The choices are One-shot AF, AI Focus AF, and AI Servo AF.

• **Drive modes.** The Drive modes you can choose from are Single-shot, High-speed Continuous (6.3 frames per second, or fps), Low-speed Continuous (3 fps), and Self-timer (10- and 2-sec. delays).

✦ **ISO/Flash Exposure Compensation button.** Pressing this button enables you to change the ISO sensitivity setting using the Main dial or the Flash Exposure Compensation using the Quick Control dial. The options for each are as follows:

- **ISO.** You can choose from Auto, 100, 125, 160, 200, 250, 320, 400, 500, 640, 800, 1000, 1250, 1600, 2000, 2500, 3200, and with C.Fn I-3 turned on, you can also choose H1: 6400, and H2: 12800.

- **Flash Exposure Compensation.** You can choose to adjust this plus or minus 2 stops (EV) in 1/3-stop increments. Or you can make changes in 1/2-stop increments by setting C.Fn I-1 to Option 1.

Table 1.1
Using the Main and Quick Control Dials with the LCD Panel Buttons

Main Dial	Quick Control Dial
LCD Panel Button: Metering Mode-WB (White Balance)	
Metering Modes:	**White Balance Options:**
Evaluative (35-zone TTL full-aperture metering)	Auto (3000-7000 K)
	Daylight (5200 K)
Partial (9 percent at center frame)	Shade (7000 K)
Spot (3.8 percent at center frame)	Cloudy (6000 K)
Center-weighted Average	Tungsten (3200 K)
	White Fluorescent (4000 K)
	Flash (6000 K)
	Custom (2000-10000 K)
	K (Kelvin Temperature, 2500-10000 K)
LCD Panel Button: AF-Drive (Autofocus mode/Drive mode)	
Autofocus Modes:	**Drive Modes:**
One-shot AF (locks focus with a half-press of the Shutter button)	Single-shot
	High-speed Continuous (6.3 fps)
AI Focus AF (half-pressing the shutter initiates AF subject movement tracking using the center AF point)	Low-speed Continuous (3 fps)
	Self-Timer (10- and 2-sec. delays)
AI Servo AF (monitors subject movement and switches to AI Servo if the camera detects subject movement)	

Main Dial	Quick Control Dial
LCD Panel Button: ISO-Flash Exposure Compensation	
ISO Options:	*Flash Compensation:*
Auto	Plus/minus 2 stops (EV) in 1/3- or 1/2-stop
100	increments (chosen using C.Fn I-1)
125	
160	
200	
250	
320	
400	
500	
640	
800	
1000	
1250	
1600	
2000	
2500	
3200	
H1: 6400 (with C.Fn I-3 Expansion turned on)	
H2: 12800 (with C.Fn I-3: ISO Expansion set turned on)	

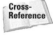 See Chapter 5 to learn about set-ting Custom Functions (C.Fn's), Chapter 4 for details on setting the White Balance, and Chapter 3 for detailed information on the ISO settings.

Back of the camera

The back of the camera includes the 3-inch, 920,000 dots (VGA) LCD monitor that provides a very smooth display of multicolored menus and shooting information. The LCD includes a new multi-coating that reduces glare, reduces smudges, and protects against scratches. The coating is visible with the blue reflection on the monitor. Here is a look at the back of the 50D.

✦ **Menu button.** Pressing the Menu button displays the most recently accessed camera menu and menu option. To move among different menu tabs, turn the Main dial or tilt the Multi-controller. The nine menus are detailed later in this chapter.

✦ **Live View shooting/Print/Share button.** When Live View shooting is enabled (using the Set-up 2 menu), pressing this button raises the camera's reflex mirror to display a live view of the scene on the LCD monitor. Or when the camera is connected to a printer and all print options are set, pressing this button starts image printing. The button blinks a blue light to indicate the

print is being made. When the camera is connected to a computer, pressing this button displays the Direct transfer screen from which you can select which images to transfer to the computer and in what order. During image transfer, the button blinks a blue light. When the transfer is finished, the button is lit continuously in blue.

Cross-Reference *Downloading images to a computer is detailed in Chapter 2. Live View shooting is detailed in Chapter 6.*

✦ **Viewfinder eyepiece and Eyecup.** The EOS 50D viewfinder is an eye-level pentaprism with approximately 95 percent vertical and horizontal coverage, and that means that you see 5 percent less of the scene than the sensor captures. The viewfinder uses the Ef-A focusing screen. With the Eyecup pressed against your eye, the flexible rubber cup helps prevent stray light from entering the viewfinder.

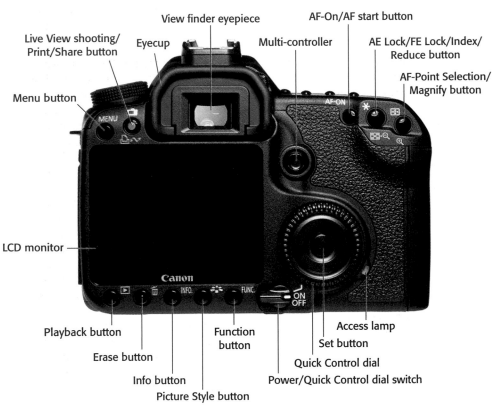

1.5 Back of the EOS 50D

✦ **AF-On/AF start button.** Canon also labels this button as the AF start button. Pressing the AF-On button initiates autofocusing in P, Tv, Av, M, and the C shooting modes in the same way as half-pressing the Shutter button. In automatic shooting modes such as Portrait and Landscape, pressing this button has no effect. When you're shooting in Live View, pressing this button focuses on the subject in any of the three Live View focusing modes.

✦ **AE Lock/FE Lock/Index/Reduce button.** When you're shooting, pressing this button sets and locks exposure at the selected AF point. When you're using the built-in or an accessory Speedlite flash, pressing this button sets and locks flash exposure at the selected AF point. When you're playing back images, pressing this button displays four images at a time, and pressing the button a second time displays an index of nine images on the LCD monitor. In Playback mode with an image magnified, pressing, or pressing and holding this button reduces the image magnification. When you're printing images, pressing this button reduces the size of the trimming frame.

✦ **AF-Point Selection/Magnify button.** During shooting, pressing this button and turning the Main dial enables you to select a single AF point or to have the camera automatically select AF point.

(Automatic AF-point selection is indicated when all the AF points are lit in red.) You can also turn the Quick Control dial or tilt the Multi-controller to select AF points. The selected AF point or points are displayed in red in the viewfinder and by marks on the LCD panel. As you turn the Main dial, the camera cycles through the AF points in the direction you turn the dial. When playing back images on the CF card, pressing this button magnifies the image by 1.5 to 10x on the LCD monitor so that you can check focus or details in the image. To move around a magnified image, tilt the Multi-controller.

✦ **Multi-controller.** The eight-way Multi-controller functions as a button when pushed and as a joystick when tilted in any direction. During shooting, you can use it to select an AF point after pressing the AF-point Selection button. Or you can press the Multi-controller at the center to display the Quick Control screen — a screen that provides access to primary shooting and exposure options. Then tilt the Multi-controller to move through the functions on the screen. To change a setting, turn the Quick Control or Main dial, or press the Set button to access the function's setting screen. When working with camera menus, the Multi-controller is used to set White Balance shift settings and to select menu options.

Note *If you set C.Fn III-3 AF-point selection method to use the Multi-controller, then you cannot display the Quick Control screen.*

✦ **Quick Control dial.** The Quick Control dial selects a variety of settings if the power switch is set to the topmost position (the position above On). The Quick Control dial selects the second named function for the buttons above the LCD panel. When the camera menus are displayed, turning the Quick Control dial cycles through the options on each menu. When shooting, you can use the Quick Control dial to manually select an AF point after pressing the AF-point Selection button.

✦ **Setting (Set) button.** Pressing this button confirms menu selections, opens submenu screens, and, on the Quick Control screen, it opens function screens from which you can change settings such as the ISO, Exposure Compensation, and Exposure Bracketing.

✦ **Access lamp.** This light, located to the lower right of the Quick Control dial, lights or blinks red when any action related to taking, recording, reading, erasing, or transferring images is in progress. Anytime that the light is lit or blinking, do not open the CF card slot door, turn off the camera, remove the battery, or jostle the camera.

✦ **Playback button.** Pressing this button when images are stored on the CF card displays the last captured or viewed image. To cycle through images on the card, turn the Quick Control counterclockwise to view images from last to first, or turn the dial clockwise to view images from first taken to last.

✦ **Erase button.** Pressing the Erase button during image playback displays options to Cancel or Erase the currently displayed image as long as it has not had protection applied to it. Batches of images can be erased together by selecting and check marking images.

✦ **Info button.** During shooting, pressing the Info button displays the Info screen that details the current camera settings including the shooting mode registered for C1 and C2, color space, White Balance shift and bracketing settings, color temperature, auto power off setting, auto image rotation, Red-eye reduction status, image transfer status, free space on the CF card, and the date and time. When playing back images, pressing the Info button one or more times cycles through four different playback display modes.

Cross-Reference *Chapter 2 covers reviewing and erasing images as well as the different playback and display modes.*

✦ **Picture Style button.** Pressing this button displays the Picture Style screen where you can choose one of six preset Picture Styles or three customizable styles that you can create and register. A Picture Style determines how an image is rendered in terms of color, saturation, and contrast. The Picture Style screen shows the currently selected

Picture Style along with the sharpness, contrast, saturation, and color tone settings that are in effect. You can press the Info button to access the Detail Set. (settings) screen to adjust the settings.

Cross-Reference *Picture Styles and customizing them are covered in Chapter 5.*

✦ **FUNC. (Function) button.** Pressing the Function button displays a screen where the LCD monitor brightness can be adjusted. This screen includes a thumbnail image stored on the CF card, as well as a gray scale chart on the right. To change the brightness, turn the Quick Control dial to the left to darken or to the right to brighten the screen, and then press the Set button to confirm the change. As you adjust the brightness, you should be able to clearly distinguish differences between each of the grayscale bars on the right. Custom Function IV-7: Assign FUNC. button, enables you to reset the Function button so that it displays the Image Quality, Exposure Compensation/Bracketing, Image Jump, or Live View Function settings screen instead.

✦ **Power/Quick Control dial switch.** The power switch offers three settings. Off does just what you expect it to do. The On setting turns on the power but limits the use of the Quick Control dial to make direct adjustments to some LCD panel functions. The topmost setting

denoted by a hockey stick-type symbol enables direct use of the Quick Control dial for setting the Flash Exposure Compensation amount, drive mode, and so on, on the LCD panel and in the viewfinder.

Side of the camera

On one side of the EOS 50D is the CompactFlash (CF) card slot door. Opening the door reveals the slot for the CF card and the card eject button. The opposite side of the camera houses two sets of camera terminals under individual rubber covers. The rubber covers are embossed with descriptive icons and text to identify the terminals.

Here is an overview of each camera terminal.

✦ **Digital terminal.** This terminal enables you to connect the camera directly to a computer to download images from the camera to the computer, or to a PictBridge-compatible printer to print images from the CF card.

✦ **PC terminal.** This threaded, no-polarity terminal enables connection between the camera and studio flash units that have a sync cord. While Canon recommends using a sync speed of 1/30 to 1/60 sec., I've found that the camera syncs with my studio strobes at 1/125 sec. with no problem, although you should test your system first. With corded non-Canon flash units, the synch speed is 1/250 sec.

PC terminal

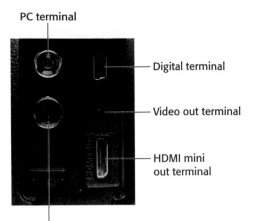

Digital terminal

Video out terminal

HDMI mini out terminal

Remote control terminal

1.6 EOS 50D terminals

Transferring images is detailed in Chapter 2 while Chapter 7 covers working with flash units.

✦ **Video Out terminal.** Use this terminal when you want to connect the camera to a non-HD TV. Be sure to use only the supplied video cable to make the connection.

✦ **Remote Control terminal.** This N3-type terminal connects with the accessory Remote Switch RS-80N3 or other N3-type EOS accessory.

✦ **HDMI mini Out terminal.** This terminal, coupled with the accessory HDMI Cable HTC-100, enables you to connect the camera to an HD TV. You cannot use the HDMI mini Out terminal simultaneously with the Video Out terminal.

Displaying images on a TV is covered in Chapter 2.

Bottom of the camera

The bottom of the camera houses the battery compartment cover, tripod socket, and the Extension system terminal for connection with the Wireless File Transmitter WFT-E3/WFT-E3A.

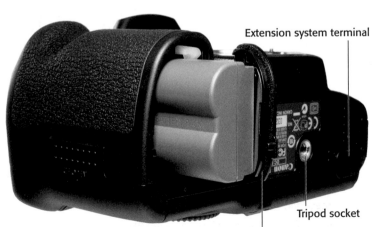

Extension system terminal

Tripod socket

Battery compartment cover

1.7 EOS 50D bottom-of-the-camera components shown with the BP-511A battery pack

Lens Controls

Lens controls differ according to the lens that you're using. One aspect that all Canon lenses have in common is full-time manual focusing. You can switch to manual focusing by setting the switch on the side of the lens to MF, or Manual Focusing. Manual focusing includes focus assist. As you adjust the focusing ring on the lens, the focus confirmation light in the lower right side of the viewfinder lights steadily and the camera sounds a focus confirmation beep when sharp focus is achieved.

While lenses are covered fully in Chapter 8, navigating the camera includes the lens, so I include lens controls here. Additional lens controls may include the following depending on the lens.

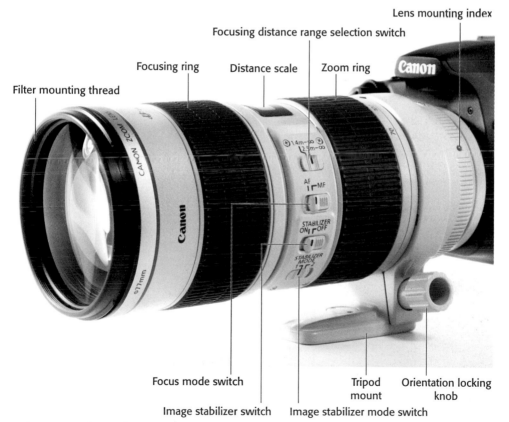

1.8 Lens controls, as shown on an EF 70-200mm f/2.8L IS USM lens

✦ **Focusing distance range selection switch.** This switch limits the range that the lens uses when seeking focus. For example, if you choose the 2.5m to infinity focusing distance option on the EF 70-200mm, f/2.8L IS USM lens, then the lens does not seek focus at 2.5m and closer. Choosing the appropriate focusing range speeds up autofocus speed. The focusing distance range options vary by lens.

✦ **Image stabilizer switch.** This switch turns on or off optical image stabilization. Optical Image Stabilization (IS) corrects vibrations at any angle or at only right angles when handholding the camera and lens.

✦ **Image stabilizer mode switch.** On some telephoto lenses, this switch enables image stabilization for standard shooting and for stabilization when you're panning with the subject movement at right angles to the camera.

✦ **Focusing ring.** Turning the focusing ring enables manual focusing or focus tweaking at any time even if you're using autofocusing. If the lens switch is set to MF, turn this ring to focus on the subject.

✦ **Zoom ring.** Turning this ring zooms the lens to the focal length marked on the ring. On some older lenses such as the EF 100-400mm f/4.5-5.6L IS USM lens, zooming is accomplished by first releasing a zoom ring, and then pushing or pulling the lens to zoom out or in.

✦ **Distance scale and infinity compensation mark.** The distance scale shows the lens's minimum focusing distance through infinity. The scale includes an infinity compensation mark that can be used to compensate for shifting the infinity focus point that results from temperature changes.

Viewfinder display

The eye-level pentaprism viewfinder shows you 95 percent of the scene that the camera captures. The viewfinder includes nine AF points superimposed on the focusing screen, as well as key exposure and camera setting information.

Looking through the viewfinder during shooting allows you to verify that camera settings are as you want, or to alert you if they need to be changed. In addition, you are alerted when any exposure element you've chosen is beyond the exposure capability of the light in the scene. For example, if you see the aperture blinking in the viewfinder, it means that the image will be underexposed (too dark) and that you need to set a slower shutter speed or a higher ISO. Or if you were using Exposure Compensation for previous shots and don't need it for the current shot, the viewfinder is a reminder to reset the compensation.

The following diagram shows the viewfinder information and what each element represents.

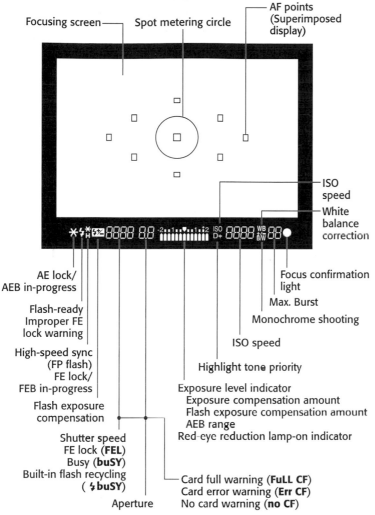

Focusing screen

Spot metering circle

AF points
(Superimposed
display)

ISO
speed

White
balance
correction

AE lock/
AEB in-progress

Flash-ready
Improper FE
lock warning

High-speed sync
(FP flash)
FE lock/
FEB in-progress

Flash exposure
compensation

Shutter speed
FE lock (**FEL**)
Busy (**buSY**)
Built-in flash recycling
(**⌁buSY**)

Aperture

Focus confirmation
light

Max. Burst

Monochrome shooting

ISO speed

Highlight tone priority

Exposure level indicator
Exposure compensation amount
Flash exposure compensation amount
AEB range
Red-eye reduction lamp-on indicator

Card full warning (**FuLL CF**)
Card error warning (**Err CF**)
No card warning (**no CF**)

1.9 EOS 50D viewfinder display

Camera menus

The EOS 50D offers nine menus grouped as tabs in the categories of Shooting, Playback, Setup, Custom Functions, and a customizable My Menu. Accessing the menus is as easy as pressing the Menu button on the back of the camera.

The first thing that's important to understand about the camera menus is that the menus and options change based on the shooting mode you select. In the automatic, or Basic Zone, shooting modes such as CA, Full Auto, Portrait, Landscape, and so on, the menus are abbreviated because you can

make only limited changes to the exposure and camera settings. But in semiautomatic and manual modes such as Tv, Av, M, A-DEP, and the C modes, the full menus and options are available. If you find a technique described in this book, but you can't find the menu option mentioned on the menu, be sure to check which shooting mode you've set on the camera. By changing to a semiautomatic or manual mode, the option you need will be displayed.

Table 1.2 shows the camera menus and options.

Table 1.2
Camera Menus

Commands	Options
Shooting 1 menu	
Quality	Large/Fine, Large/Normal, Medium/Fine, Medium/Normal, Small/Fine, Small/Normal, RAW, sRAW 1, sRAW 2, or RAW or sRAW and any of the JPEG image quality settings
Red-eye On/Off	Off/On
Beep	On/Off
Shoot without a card	On/Off
Review time	Off, 2 sec., 4 sec., 8 sec., Hold
Peripheral illumin. Correct.	Enable/Disable
Shooting 2 menu	
Expo. comp/AEB (Exposure Compensation/ Auto Exposure Bracketing)	1/3-stop increments by default, up to plus/minus 2 stops of Exposure Compensation and up to plus/minus 4 stops of AEB
White Balance	Auto (AWB), Daylight, Shade, Cloudy, Tungsten, White Fluorescent, Flash, Custom (2500 to 10000K), Color Temperature (2500 to 10000K)
Custom WB	Set a manual White Balance
WB SHIFT/BKT (White Balance shift/bracketing)	White Balance correction using Blue/Amber (B/A) or Magenta/Green (M/G) color bias; White Balance Bracketing using B/A and M/G bias, available at plus/minus 3 levels in one-level increments
Color space	sRGB, Adobe RGB
Picture Style	Standard, Portrait, Landscape, Neutral, Faithful, Monochrome, User Defined 1, 2, and 3

Commands	Options
Shooting 2 menu	
Dust Delete Data	Locates and records dust on the image sensor so you can use the data in Canon's Digital Photo Professional program to erase dust spots on images
Playback 1 menu	
Protect images	Marks and protects selected images from being deleted
Rotate	Rotate the selected vertical image clockwise at 90, 270, or 0 degrees
Erase images	Select and erase images, All images in folder, All images on [CF] card
Print Order	Select images to be printed (Digital Print Order Format or DPOF)
Transfer order	Select images to download to a computer
External media backup	Available when the accessory Wireless Transmitter (WFT-E3/E3A) is used along with external media such as a storage device or computer
Playback 2 menu	
Highlight alert	Disabled, Enable. When enabled, overexposed highlights blink in all image-playback displays
AF-point disp.	Disabled, Enable. Superimposes the AF point that achieved focus on the image during playback
Histogram	Brightness, RGB. Brightness displays a tonal distribution histogram. RGB displays separate Red, Green, and Blue color channel histograms
Slide show	Setup (Play time and Repeat (On/Off)), Start a slide show of all images on the CF card
Image jump with Main dial	Move through images by: 1, 10, 100 [images at a time], Screen, Date, or Folder
Set-up 1 menu	
Auto power off	1, 2, 4, 8, 15, 30 minutes, Off
Auto Rotate	On for camera and computer, On for camera only, Off (Turns vertical images to upright orientation for the camera's LCD and computer display, or only for the camera's LCD display)
Format	Format and erase images on the CF card
File numbering	Continuous, Auto reset, Manual reset
Select folder	Create and select a folder
WFT Settings	Displays the wireless file transfer settings when an accessory Canon WFT-E3/E3A is in use
Recording func.+media select	Displayed when an accessory Canon WFT-E3/e3A is in use

continued

Table 1.2 *(continued)*

Commands	Options
Set-up 2 menu	
LCD brightness	Seven adjustable levels of brightness
Date/Time	Set the date (year/month/day) and time (hour/minute/second)
Language	Choose from 25 language options
Video system	NTSC, PAL
Sensor Cleaning	Auto cleaning (Enable, Disable), Clean now, Clean manually
Live View function settings	Live View shoot—Options: Enable, Disable
	Expo. simulation—Options: Disable, Enable
	Grid display—Options: On, Off
	Silent shoot—Options: Mode 1, Mode 2, Disable
	Metering timer—Options: 4, 16, 30 sec., 1, 10, 30 min.
	AF mode—Options: Quick mode, Live mode, Live "L" mode referred to as face detection
Set-up 3 menu	
Info button	Normal disp., Camera set. (Camera Settings), Shoot func. (Shooting function); Normal display displays the Camera Settings screen when you press the INFO. button once, and the Shooting function screen when you press the INFO. button again; Selecting Camera set. option toggles only the Camera Settings screen when you press the INFO. button; the same behavior applies if you select the Shooting func. option
Flash control	Flash firing, Built-in flash func. setting, External flash func. setting, External flash C.Fn setting, Clear ext. flash C.Fn set
Camera user setting	Register or clear camera settings to C1 or C2
Clear settings	Restores the camera's default settings, Delete copyright information; Does not restore Custom Function to their original default settings
Firmware Ver. (Firmware Version)	Displays the existing firmware version number, and enables you to update the firmware

Custom Functions menu

C.Fn I: Exposure	Displays Custom Functions related to exposure such as exposure level increments, ISO increments, ISO expansion, bracketing auto cancel, bracketing sequence, safety shift, and flash sync speed in Av mode
C.Fn II: Image	Displays Custom Functions related to the image noise and tone including long exposure noise reduction, high ISO speed noise reduction, highlight tone priority, and Auto Lighting Optimizer
C.Fn III: Autofocus/Drive	Displays Custom Functions related to autofocus and drive operation including lens drive when AF is impossible, lens AF stop button function, AF-point selection method, superimposed display, AF-assist beam firing, mirror lockup, AF Microadjustment
C.FN IV: Operation/Others	Displays Custom Functions related to camera controls including Shutter button/AF-ON button, AF-ON/AE lock button switch, assign Set button during shooting, dial direction during Tv and Av modes, changing to a different focusing screen, adding original data decision data, and assign FUNC. button
Clear all Custom Func. (C.Fn)	Restores all of the camera's default Custom Function settings

My Menu

My Menu settings	Save frequently used menus and Custom Functions

Setting Up the EOS 50D

This chapter on setting up the EOS 50D includes an assortment of tasks and digital imaging concepts that are important to consider when you initially set up the 50D and as you continue shooting with it.

Some people think of camera setup as a one-time task, and never or seldom return to change camera settings such as file format and image quality, file numbering, and so on. While that strategy works well for some, the range of shooting situations often demands more frequent changes. The changes are easy to make on the 50D, so it's worthwhile to evaluate individual shooting sessions for the camera setting changes that may be beneficial. As always, understanding the tradeoffs involved in making one choice versus another will benefit you now and in the future.

 Cross-Reference *I encourage you to read Chapters 4 and 5 as companion chapters to this chapter. Chapter 4 covers setting up the 50D to get the most accurate color, and Chapter 5 covers setting up Custom Functions, C-modes, and My Menu.*

Choosing Image Format and Quality

Any photographer who has been shooting digital images for a goodly amount of time can attest to the wisdom of thinking through the entire image workflow before building a large image library. Image workflow begins, of course, with camera setup.

First-line workflow considerations include setting up the image file format, image quality level, file numbering, and folder organization. These decisions should be made to support the way that you work with images on the computer and the way in which you organize and store images on your computer and on backup media. If you are new to digital imaging, you'll find that the time you spend setting up image workflow — from capture through editing to printing and archiving — pays big dividends as your image collection grows.

The 50D offers a choice of JPEG, RAW, or sRAW (small RAW) files. Unless you're convinced that you want to shoot only JPEG images, then I encourage you to consider the differences, as well as the advantages and disadvantages among RAW, sRAW, and JPEG. You may ultimately decide to set up the camera to shoot both RAW or sRAW and JPEG images. Before you choose, consider the options and how they apply to your photography. As you evaluate the options, remember that the options you choose affect the overall image quality and the size at which you can print the images.

JPEG

Without question, JPEG is the most prevalent image file format, and it is the default file format on the 50D. As a file format, JPEG offers efficient and high-quality compression as well as quick reading, or decoding, of the image file on the camera's LCD monitor and on the computer.

Note *As background, JPEG is an acronym for Joint Photographic Experts Group, a group with representatives from a wide variety of companies and academic institutions worldwide that creates industry-wide standards for still-image file compression.*

A hallmark of the JPEG file format is the small file sizes it produces. The small file sizes allow you to store many images on the CompactFlash (CF) card. To reduce image file size, JPEG compresses files by discarding some image data. The higher the compression level chosen, the more image data that's discarded, and the smaller the image file size and vice versa. Because of this loss of data, JPEG is known as a lossy file format. While data loss isn't ideal, at a low compression level, the loss of data is typically not noticeable in image prints.

Note *If you edit JPEG images on the computer, and then save them as JPEGs, the data loss continues to occur. To preserve image data during editing, be sure to save JPEG images as TIFFs or in another lossless file format before you begin editing. A lossless file format does not discard image data to save space.*

Additionally, JPEG images enjoy an almost universal portability. JPEG files can be displayed on different computer platforms without the need for special viewing programs or preprocessing. The images can also be displayed on the Web and in e-mail without additional image processing except perhaps to reduce the file size.

When you shoot JPEG images, the software inside the 50D processes the images before storing them on the CF card. This processing amounts to in-camera editing. The processing sets the color rendering, contrast, and sharpness so that you get a finished file that you can use as is or do further editing to on the computer. With the 50D, you can control JPEG image rendering to some extent by choosing among six Picture Styles.

Cross-Reference *Picture Styles and color spaces are detailed in Chapter 4.*

A final advantage is that JPEG capture provides the 50D's maximum burst rates when you're shooting in Continuous drive mode. For example, shooting at the highest-quality JPEG setting and largest image size, the burst rate using a standard 2GB CF card is 60 frames per second (fps), or 90 fps using an Ultra DMA (UMDA) card at 6.3 frames per second (fps). So if you're shooting action of any type, JPEG capture has a definite edge for continuous shooting.

The EOS 50D offers two JPEG compression levels, either high or low. And you have the option to choose one of three image-recording sizes — 15.1, 8, or 3.7 megapixels. The greater the compression and the smaller the image size, the more images you can capture in a burst when you're shooting continuously, and the more images you can store on the CF card. The downside of high compression and low image size is that image quality suffers proportionally and noticeably.

While JPEG offers clear advantages, there are other tradeoffs to consider. Every 50D image is captured as a 14-bit file that delivers 16,384 colors in each of the three color channels: Red, Green, and Blue. Because the JPEG file format doesn't support 14-bit files, the 50D automatically converts JPEG images to 8-bit files that have only 256 colors per channel. While the conversion from 14- to 8-bit is done judiciously via internal camera algorithms, there is no escaping the fact that the lion's share of image color information is discarded in this process. Combine this data loss with the automatic in-camera editing and JPEG compression, and you get a file that has one-third or more of the image data discarded before it's written to the CF card. Certainly the JPEG image files are smaller, but with the data loss, they are not as rich as the original image, and, as a result, they offer less latitude during editing on the computer.

For photographers who seldom edit images on the computer and want small file sizes with maximum portability, JPEG is the best option. However, for photographers who want to preserve all the image data that the EOS 50D captures, then the RAW and sRAW options are worth exploring.

RAW and sRAW

RAW capture is the option of choice for photographers who want the best images that the 50D can deliver, and who want to control the rendering of images from capture through to editing and printing. RAW is a designation for image files that are captured and stored on the CF card with little in-camera manipulation and with no loss of data from file compression or bit-depth conversion. Further, the 50D does not preprocess RAW files with the color rendering, contrast, saturation, and sharpness options set on the camera. Instead, those types of settings are noted in the image file and can be changed when you process or convert the RAW file in a RAW conversion program such as Canon's Digital Photo Professional or Adobe's Camera Raw or Lightroom. In fact, the only settings that are applied to RAW images in the camera are the aperture, ISO, and shutter speed. Brightness, contrast, color rendering and saturation, White Balance, tonal rendering, and even Picture Style can all be adjusted during conversion of the RAW file.

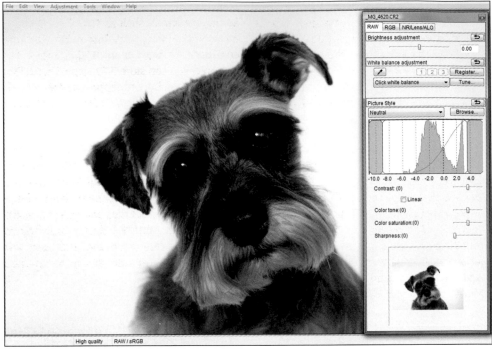

2.1 Canon's Digital Photo Professional, included on the EOS Digital Solution Disk and shown here, provides a full-featured program for converting RAW images.

The compelling advantage of RAW capture is getting an image file that contains all that the 50D — a full, rich 15.1-megapixel, 14-bit file — can provide. The file size is larger than JPEG, but that's one advantage of owning a high-resolution camera. The second advantage is that you determine precisely how the color and tones will be interpreted, and you can reset the White Balance and sharpness, and apply noise reduction if necessary.

And when the conversion is complete, you have a hearty and robust file. Having a robust file is important because virtually all image editing is destructive — whether you adjust levels, set a tonal curve, or adjust the color balance. Nonrobust image files can suffer posterization, or the loss of smooth gradation among tonal levels, from stretching tonal ranges and the loss of image detail from compressing tonal ranges. By way of contrast, with RAW files, you begin with a rich 14-bit file that you can save as a 16-bit file in a RAW conversion program. This 16-bit file has much more latitude to withstand destructive image edits than an 8-bit JPEG file.

Until the 50D was introduced, you could only shoot RAW capture in P, Tv, Av, M, and A-DEP shooting modes. But recognizing the growing popularity of RAW capture, the EOS 50D is the first camera that offers RAW and sRAW files in all shooting modes including the automatic shooting modes such as CA , Portrait, Landscape, and so on.

Along with growing popularity, RAW is gaining in flexibility as well. For example, you can opt to shoot using Canon's sRAW image-recording option, which offers the same advantages as RAW, but at a smaller image size. The 50D offers sRAW in two sizes: sRAW 1 at 7.1 megapixels or sRAW 2 at 3.8 megapixels.

While RAW files give you the best images that the 50D can deliver, RAW capture has drawbacks. First, RAW files lack the portability of JPEG files. RAW files cannot be edited unless you've installed Digital Photo Professional, Canon's RAW conversion program, or another compatible program such as Adobe Lightroom or Camera Raw. Second, unless you enjoy working with images on the computer, RAW is not a good option because the files must be converted in a conversion program and saved in another format such as TIFF, PSD, DNG, or even JPEG. Finally, RAW image file sizes are considerably larger than JPEG images. For example, you can store 370 Large/Fine JPEGs on a 2GB card, but only approximately 91 full-size RAW files, 140 sRAW 1 files, or 200 sRAW 2 files.

With the background on the advantages and disadvantages of JPEG and RAW capture, you are in a better position to choose the file format. You can choose to take advantage of both types of files and select the size for each type. Table 2.1 details the options that you can select on the 50D and the effect on the burst rate during continuous shooting.

The High Bit Depth Advantage

Bit depth offers important advantages including finer detail and smoother transitions between tones in the image. In a digital image, each pixel is represented by a number of bits — the smallest unit of information that a computer can handle. And digital images use the Red/Green/Blue (RGB) color model. Thus the range of colors in an image is represented by color definitions that represent shades of red, shades of green, and shades of blue. In an 8-bit image, 8 bits are used to represent each pixel with a possible 256 tonal values from 0 (black) to 255 (white). As a result, the image can have a total of $256 \times 256 \times 256$, or 16.7 million, unique color definitions.

By comparison, if you save a 14-bit file in Adobe Photoshop's Camera Raw as a 16-bit image, you get 32,769 values from 0 (black) to 32,768 (white). Note that Photoshop's implementation of 16-bit uses 32,769 rather than 65,536 levels—which although it translates to something closer to 15-bit, it gives a definite midpoint between black and white.

While the distinctions among trillions of color definitions are more than the human eye can see, this plethora of color definitions comes into play during image editing. Because image edits are destructive and reduce the number of colors and tonal levels within the image, in addition to providing finer detail and smoother transitions, high bit-depth files provide significantly more latitude as you edit images on the computer.

Getting the best of both JPEG and RAW

To get the best of both types of files, you can choose to shoot both JPEG and RAW or sRAW. With this option, you gain the advantage of getting a pre-edited Large/Fine JPEG file that you can print directly with no editing, as well as a RAW file, either full-size or small, that you can convert and edit. So when you get a great shot that you want to perfect, or when you get a shot that needs some adjustments such as recovering blown highlights, opening shadows, tweaking the contrast, or correcting the color, the RAW file gives you the latitude to make adjustments.

The downside of shooting JPEG+RAW is the increased space needed on the CF card. For example, on a 2GB card, you can store 72 full-size RAW + Large/Fine JPEGs, whereas if you shoot only Large/Fine JPEGs, you can store 370 images on the card. If you capture both JPEG and RAW, both images are saved with the same file number in the same folder. They are distinguished by the file extensions of .jpg for the JPEG image and .CR2 for RAW and sRAW 1 or sRAW 2. The options, approximate file sizes, and effect on continuous shooting burst rate are shown in Table 2.1 (estimates are approximate and vary according to image factors including ISO, Picture Style, Custom Function settings as well as card brand, type, and speed).

Table 2.1
Image Quality, Size Options, and Burst Rates

Image Quality		Approximate Size in Megapixels	File Size in Megabytes	Maximum Burst Rate (Ultra DMA card)
JPEG	Large/Fine	15.1	5	60 (90)
	Large/Normal		2.5	150 (740)
	Medium/Fine	8	3	110 (620)
	Medium/Normal		1.6	390 (1190)
	Small/Fine	3.7	1.7	330 (1090)
	Small/Normal		0.9	1050 (2040)
RAW	RAW	15.1	20.2	16 (16)
	sRAW 1	7.1	12.6	16 (16)
	sRAW 2	3.8	9.2	19 (19)

Image Quality		Approximate Size in Megapixels	File Size in Megabytes	Maximum Burst Rate (Ultra DMA card)
RAW + JPEG	**RAW + Large/Fine**	15.1 each	20.2 + 5 (25.2)	10 (10)
	sRAW 1 + Large/Fine	7.1 and 15.1	12.6 + 5 (17.6)	10 (10)
	sRAW2 + Large/Fine	3.8 and 15.1	9.2 + 5 (14.2)	11 (11)

Note *The maximum number of images that you can shoot during continuous shooting is displayed at the bottom right of the viewfinder. If the burst rate is higher than 99 images, only 99 is displayed in the viewfinder. This limitation holds true for other settings. For example, if you're shooting Small/Normal JPEGs on a non-UDMA 2GB card, the highest number displayed in the viewfinder is only 99 although you get approximately 1,050 images.*

Note *You can choose to apply High ISO noise reduction to images by setting C.Fn II-2 to Standard, Low, or Strong. If you choose Standard or Low, the noise reduction doesn't affect the maximum burst rate for RAW capture.*

Setting the image file format and image quality can be a little tricky at first. Canon divides the screen between RAW and sRAW and JPEG options. You can select RAW options by turning the Main dial and JPEG options by turning the Quick Control dial.

To set the image format and quality, follow these steps.

1. **Press the Menu button, highlight the Shooting 1 tab, highlight Quality, and then press the Set button.** The Quality screen appears.

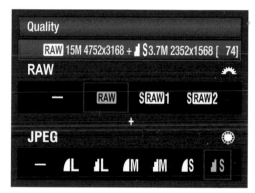

2.2 The Quality screen enables you to select RAW file options using the Main dial and JPEG options by using the Quick Control dial.

2. **Turn the Main dial to highlight the RAW or sRAW option you want. Or, if you don't want to choose a RAW or sRAW option and you want to shoot only JPEG images, then select the minus sign and move to Step 3.**

3. **Turn the Quick Control dial to highlight the JPEG option you want. Or if you're shooting only RAW images and you don't want a JPEG option, then select the minus sign.**

4. **Press the Set button.** The options you choose remain in effect for all shooting modes until you change them.

Working with Folders and File Numbering

One of the first steps in setting up a consistent and efficient workflow is thinking through folder structure and file naming. Ultimately, the major component is the folder organization and file naming that you use on the computer and on backup media such as DVDs and stand-alone hard drives.

A first step in making the workflow work for you is selecting the way in which the files are named in the camera and setting up folders to organize images on the media card. The EOS 50D offers three file-numbering options and enables multiple folders.

Creating and selecting folders

One handy feature of the EOS 50D is the ability to create up to 999 folders on each CF card to store images, and each folder holds up to 9999 images. (Technically, if you count the default folder that the camera creates automatically, then you can create 998 additional folders.) New folders must be created within the main DCIM folder either on the camera or on the computer. Here are the folder guidelines using either option.

✦ **Creating folders in the camera.** Folders created on the camera are numbered sequentially from the highest number of the existing folder. The camera automatically creates folder 100CANON, so if you create a new folder the next folder name will be 101CANON. When you create folders on the camera, the folder naming structure is preset and cannot be changed.

✦ **Creating folders on the computer.** You can alternately create folders on the computer and gain slightly more flexibility in folder names. But you must follow the general naming conventions. Folder names must be pre-pended with a unique three-digit number from 101 to 999. Then you can also include five upper- and/or lowercase alphanumeric characters from A to Z plus an underscore. No spaces are allowed in folder names, and the same three-digit number cannot be used more than once. Thus, you can create a folder named 102CKL_1, but you cannot create a folder named 102SKL_1.

Unlike image numbering, the 50D does not remember the last highest number when you insert a different CF card and create a new folder on the CF card. And if you format the CF card, the folders you created either in the camera or on the computer are erased along with all images. The only folder that isn't erased is the default 100CANON folder.

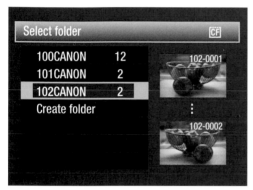

2.3 This folder was automatically created by the 50D and numbered as 102CANON when I used Auto reset to reset file numbering. And the image file numbering was reset to 0001.

When you format the CF card, all existing folders except 100CANON are deleted. Thus you need to create new folders after you format the card.

Tip *When image 9999 is recorded within a folder on the CF card, the camera displays an error message, and you cannot continue shooting until you replace the CF card regardless of whether the card contains additional free space or not. This may sound innocuous, but from personal experience I know that it can cause missed shots. So try to remember that if the camera won't shoot, try replacing the CF card.*

To view an existing folder or create a new folder, follow these steps.

1. **Press the Menu button, highlight the Setup 1 tab, and then highlight Select Folder.**

2. **Press the Set button.** The Select folder screen appears with folders displayed on the left side and a preview of the first two images in the folder.

3. **To view an existing folder, turn the Quick Control dial to highlight the folder you want.**

4. **To create a new folder, highlight Create folder, and then press the Set button.** The camera displays the Select folder screen with a message to create a folder with the next incremented number.

5. **Select OK, and then press the Set button.** The Select folder screen appears wlth the newly created folder selected.

Setting file numbering

On the 50D, each image that you take is given a filename that begins with the prefix, IMG_, followed by a four-digit number. The first image is named IMG_0001, and subsequent files are numbered sequentially up to 9999.

Changing the way that the camera numbers files may not seem like a top priority to you, but you may find that one of the other file-numbering methods helps you delineate files in different shooting situations to make your workflow more efficient. Let's look at each option and some of the shooting scenarios where each option could offer you an advantage.

Tracking Actuations on the 50D

As most photographers know, it is helpful to know the number of shutter clicks, referred to as actuations, on a camera in the event that the camera needs service, or if you decide to sell the camera. In addition, knowing the number of actuations helps you gauge the relative wear and tear on the shutter mechanism.

Because the file numbers are not a good way to track actuations and because the camera may rollover the 9999 mark one or more times during its life, you can get an accurate count of actuations by downloading any of several EXIF Viewers. If you shoot JPEGs and use a Mac, then I recommend downloading Erik M. Johnston's EXIF Viewer for Mac OSX from homepage.mac.com/aozer/EV/index.html. For Windows, you can download Opanda IExif at www.opanda.com/en/iexif/index.html. Alternately, you may want to buy Photo Mechanic for Mac and Windows from Camera Bits. You can download an evaluation copy at www.camerabits.com/site/downloadarchives.html.

Continuous file numbering

Continuous file numbering is the default on the 50D, and every file is numbered sequentially beginning with 0001 through 9999. Image files are stored in a subfolder named 100Canon that is located within the top-level DCIM folder on the CF card. The camera automatically creates the 100Canon folder. File numbering continues uninterrupted unless you insert a CF card that has images stored on it. If the highest number on the card is higher than the last image number on the 50D, then file numbering typically continues from the current highest numbered image on the CF card. That numbering continues even after inserting an empty formatted card. For example, although I had taken only 143 images with the 50D, when I insert a CF card from another Canon camera, my next image file number is 4521, the number following the highest numbered image on the CF card.

Likewise, if a CF card contains multiple folders, created either by the camera or by you, with images in them, then the numbering sequence begins with the highest numbered existing image in the folder being used. But if you insert a card that has a file number that is lower than the last highest file number taken on the 50D (stored in the camera's internal memory), then the file numbering continues from the last highest file number recorded on the 50D.

In short, the camera uses the last highest number from either the card or the number stored in memory. If you want to continue pristine Continuous file numbering, then always insert a formatted card and do not swap in cards from other Canon bodies that have images stored on them.

The advantage of Continuous file numbering, provided that you don't interrupt the sequence, is having unique filenames on the computer, which helps avoid the potential of overwriting images with the same filename and same file extension. Of course, if you have a second Canon camera body, and you put files from both bodies in the same folders, then there is the potential that you

could have duplicate filenames with the same extension. Hence, good folder and image management is essential for peace of mind.

Auto reset

After reading about the Continuous file numbering option, you may be inclined to choose another option such as Auto reset. As the name implies, this option resets image file numbering every time you insert a CF card, and if you create a new folder on the CF card. Using Auto reset, image file numbers begin at 0001.

For my work, Auto reset is handy for keeping images organized by shoot when I shoot multiple different subjects on the same day. In this scenario, I create separate folders on the CF card or cards, and then I save images from different shoots to individual folders. Because the file numbers reset in each folder, it's easy to check each folder to see the number of images I've taken for the assignment. Additionally, the images are appropriately segregated when I download them to the computer.

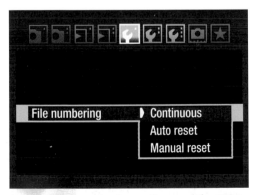

2.4 The File numbering options on the 50D

But again, the Auto reset option isn't infallible. If you insert a CF card with existing images stored on it, then the camera uses the highest existing image number and continues numbering from there. So if you want this file-numbering option to work, be sure to format the CF card in the camera before shooting with it. In short, it pays to start a shooting day with freshly formatted cards, and it pays to not swap cards between camera bodies if you want to make this and other file numbering methods work for you.

Manual reset

This option seems like the way to work around the limitations of the two previous options. By its name, it seems that you could force file numbering to reset for a fresh start. And that's true if the default 100CANON folder is empty. When you select Manual reset, the next image number is set to 0001. But if the 100CANON folder has images in it, then when you choose Manual reset, the camera creates a new folder, 101CANON, and starts image numbering at 0001 within that folder. And that behavior is true for CF cards that have multiple folders with images in each folder.

Manual reset is an option to consider in any shooting situation where you want to quickly start fresh with a new folder and a 0001 file number within that folder. For example, if you're shooting a wedding, and a member of the wedding party asks you to photograph his family during a break, you can quickly select Manual reset, and know that the family shots will be kept in a folder separate from the wedding image folder. Of course, you'll likely want to remember to switch back to the wedding folder when you resume shooting the wedding.

After you choose Manual reset, the 50D then returns to the File numbering option that was in effect before the numbering was manually reset, either Continuous or Auto reset. Also, the new folder that the camera creates is the next higher number from the existing highest folder number on the CF card.

Changing the File numbering option on the 50D is straightforward, as long as you remember the limitations and behavior of each option. Follow these steps:

1. **Press the Menu button, highlight the Setup 1 tab, and then highlight File numbering.**

2. **Press the Set button.** The camera displays three File numbering options.

3. **Highlight the option you want, and then press the Set button.** The option remains in effect until you change it except for Manual reset, which creates a new folder if there are images in the current folder and in any other folders. If there are no images in the current or other folders, then image numbers in the folder begin with 0001. In both instances, the camera then returns to the previously selected File numbering option.

Transferring Images to the Computer

There are a number of different methods for transferring images from the 50D to the computer, and you may already have a method and program that works best for your workflow. But the 50D provides a Direct transfer option if you want or need to transfer images using the USB cable. This technique is handy because you can choose which images and in what order to transfer them.

Before you begin, ensure that you've installed the programs on the EOS Digital Solution Disk. To transfer images to the computer, follow these steps.

1. **Turn off the camera, attach the USB cable to the Digital terminal of the camera, and then connect the other end of the cable to a USB port on the computer.**

2. **Turn the camera's power switch to the ON position.** The EOS Utility screen appears on the computer, and the Direct transfer screen appears on the camera's LCD monitor.

3. **On the camera, highlight:**

 - **All images.** Downloads all images to the computer.

 - **New images.** Downloads images that haven't previously been transferred to the computer.

 - **Transfer order images.** Select a group of images to transfer. See Step 4 for more information.

- **Select & transfer.** Individually select the images you want to transfer.

- **Wallpaper.** The image that you select and transfer displays as the background for your computer monitor.

4. **Press the Print/Share button on the back left top of the camera.** This button is lit in blue. Depending on the option you choose, a secondary screen appears to allow you to select or confirm the transfer. If you chose Select & transfer, then the most recent image appears on the LCD monitor. Press the Set button to transfer the image, or turn the Quick Control dial to move to another image. Continue this process for all the images you want to select and transfer.

5. **When the transfer is complete, press the Menu button, turn off the camera, and then disconnect the USB cable from the camera and computer.**

Miscellaneous Setup Options

There is a laundry list of setup options on the 50D that can make your shooting life easier and make the camera work better for you. You may have already implemented these settings, but in case you missed some, a list of setup options that are helpful is included.

Note *Beyond setting up the camera, you'll want to maintain good image quality and camera performance by keeping the image sensor clean and by keeping the firmware up to date. See Appendix C for details on these tasks.*

General setup options

The options that I categorize as "general" are typically options you set up only once, although there are some that you may revisit in specific shooting scenarios. For example, I

prefer to turn on the beep that confirms autofocus in most shooting situations. But when I'm shooting a wedding or a business conference, the beep is intrusive, so I turn it off.

Likewise, you may prefer to have vertical images automatically rotated on the LCD to the correct orientation. Doing so displays the image at a smaller size, so you may opt to rotate vertical image only for computer display.

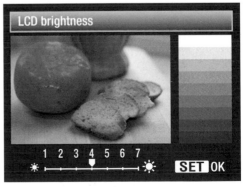

2.5 The LCD brightness screen enables you to monitor brightness with the preview image and the grayscale display on the right.

The following table provides a guide for most of these easy setup options. If you don't see an option that you expected to see, that's because it's covered elsewhere in this or upcoming chapters.

To change general setup options, press the Menu button, and then follow the instructions in Table 2.2.

Table 2.2
Selecting General Setup Options

Turn the Main dial to choose this Menu tab.	Turn the Quick Control dial to select this Menu Option.	Press the Set button to display these Menu Sub-options or screen.	Turn the Quick Control dial to select the option you want, and then press the Set button.
Shooting 1	Beep	On/Off	Choose Off for shooting scenarios where noise is intrusive or unwanted.
	Shoot w/o [without] card	On/Off	Choose Off to prevent inadvertently shooting when no card is inserted. The On setting is marginally useful, and then only when gathering Dust Delete Data.
	Review Time	Off, 2, 4, 8 sec., and Hold	Longer durations of 4 or 8 sec. to review LCD images have a negligible impact on battery life except during travel when battery power is at a premium. I use 4 sec. unless I'm reviewing images with a client or subject, then I choose 8 sec.
Playback 2	Highlight alert	Disable/Enable	Choose Enable to see overexposed areas (blown highlights) as blinking highlights on the preview image in all playback displays. This alert is a quick way to see areas of localized overexposure.
	AF point disp. [display]	Disable/Enable	Choose Enable to superimpose a red AF point (or points with automatic AF point selection) on images in Playback mode to show the AF point(s) that achieved focus. Enabling this option aids checking sharp focus because you can magnify the image and know where to check for the point of sharpest focus.

Turn the Main dial to choose this Menu tab.	Turn the Quick Control dial to select this Menu Option.	Press the Set button to display these Menu Sub-options or screen.	Turn the Quick Control dial to select the option you want, and then press the Set button.
Setup 1	Auto power off	1, 2, 4, 8, 15, 30 min. and Off	Choose an option to determine the amount of time before the 50D turns off automatically. Shorter durations conserve battery power. Just press the Shutter button half-way to turn on the camera again.
	Auto rotate	On for the LCD and computer, On for the computer only, Off	Choose an On option to automatically rotate vertical images to the correct orientation on the LCD and computer monitors, or only on the computer monitor. If you choose the first option, the LCD preview image is displayed at a reduced size. Or choose Off for no rotation on the camera or computer.
Setup 2	LCD brightness	7-levels of brightness	Watch both the preview image and the grayscale chart as you turn the Quick Control dial to adjust the LCD brightness. As you adjust brightness, ensure that all tonalities on the grayscale chart are clearly distinguishable.
Setup 3	INFO. button	Normal disp., [display] Camera set. [settings], Shoot. func. [Shooting functions]	Choose an option to determine which screen is displayed by pressing the INFO. button. Camera settings displays the current exposure and camera settings on a static screen. Shooting functions displays a summary of exposure and camera settings where you can activate the screen to change settings by pressing the Multi-controller. The Normal disp. option switches between Camera settings and Shooting functions display each time you press the INFO button.

Add copyright information

One of the basic workflow steps that you can accomplish on the camera is adding your copyright information to the image metadata so that it is carried with each image you shoot with the 50D. Including your copyright is a great first step to identify ownership of the images you make. And if your name changes or you need to delete or change the information for any reason, you can do so.

Tip

Metadata is simply information about the image. The copyright information is included in the Creator field of the user-defined IPTC metadata. IPTC is a standardized metadata format initially developed by the Newspaper Association of America (NAA) and the International Press Telecommunications Council (IPTC). IPTC metadata is displayed in many image-editing programs and is stored with the image.

Before you begin this task, ensure that you have:

✦ Installed the Canon EOS Utility that is included with the EOS Digital Solution Disk that comes in the 50D box.

✦ The USB Interface cable handy.

✦ A good charge on the camera battery.

To include your copyright and the camera owner's name on your images, follow these steps.

1. **Turn off the camera, and insert the USB Interface cable to the Digital terminal on the side of the camera.**

2. **Insert the other end of the Interface cable to a USB port on the computer.**

3. **Turn on the camera.** The Canon EOS Utility screen appears and the Direct Transfer screen appears on the 50D LCD.

2.6 The Canon EOS Utility screen

4. **On the Camera Control tab of the EOS Utility, click Camera settings/ Remote shooting.** The EOS 50D control panel appears.

5. **Click the Set-up button.** This is the middle of three buttons below the exposure meter on the panel. The Set-up menu appears.

Set-up button —

2.7 The Canon EOS Utility Set-up menu with completed copyright information entered into the fields.

6. **Click the Owner's name field, type your name in the box, and then click OK.**

7. **Click the Copyright notice field, type your name next to the Copyright: text, and then click OK.** The information is recorded on the 50D and is included in the IPTC Creator field for each image.

8. **Click the Close button on the EOS Utility panel, turn off the 50D, and then detach the Interface cable.**

To change the copyright name, repeat these steps and type a new name in Step 6.

Tip *You can supplement copyright information from the camera in a program such as Adobe Bridge by including information such as your address, telephone number, Web site URL, and keywords.*

To view or delete the copyright information on the camera, follow these steps.

1. **Press the Menu button, highlight the Setup 3 tab, and then highlight Clear settings.**

2. **Press the Set button.** The Clear settings screen appears.

3. **To display the existing copyright information, press the Info button. The Display copyright info. screen appears with the copyright name. Or to delete the copyright information, highlight Delete copyright information, and then press the Set button.** The Delete copyright information screen appears.

4. **Highlight OK, and then press the Set button.**

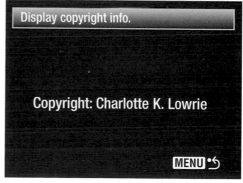

2.8 The copyright display on the 50D

Image Playback Options

A fair amount of image management can happen as you shoot and review images. As you shoot and playback images you can check the focus, evaluate the image histogram, and evaluate the composition — all before leaving the scene. As a result, you know when you need to adjust exposure, recompose the image, or tweak the focus, and when to delete images. The controls provided on the 50D enable you to verify individual characteristics of the image.

Certainly the ability to instantly review images is an advantage of digital photography. But playing back images also means that you can magnify the preview image to check for sharpness, review the brightness (luminance) histogram for localized areas of overexposure, and review the color histogram to evaluate color saturation, and White Balance accuracy.

The ability to gauge exposure, color, and composition on the spot, image evaluation can quickly solidify the settings for a studio shooting session and alert you to the need for a camera setting change in other settings.

Playing back images on the 50D is a straightforward task. Just press the Playback button to display the most recently captured image. In Single image display, basic shooting information appears above the image. If you've turned on the Highlight alert and AF point display options, detailed earlier in this chapter, then the preview image shows these as well.

To cycle through multiple images on the CF card, turn the Quick Control dial counterclockwise to view the next most recent image or clockwise to view the first image

on the CF card. You can change the playback display by pressing the Info button once to cycle through each of these four image-playback displays:

✦ **Single image with basic shooting information.** This default mode displays a large preview image with the shutter speed, aperture, folder number and file number, and media type (CF denoting CF card). If you're showing subjects or friends the images you've captured, this display option provides a clean, uncluttered view of the image.

✦ **Single image display with image recording quality.** This option includes information in the previous display option and the recording quality and the image number relative to the number of images captured; for example, 10/11, or image 10 of 11 stored images.

✦ **Shooting information display.** This display includes exposure, file information, flash exposure, capture time, the histogram you've selected, either brightness or RGB, and more. The image preview is necessarily reduced in size to accommodate the additional information. This option is invaluable for checking the histogram, exposure, color, and just about every other shooting setting that you want to verify.

✦ **Histogram.** This display option shows a Brightness histogram, and three RGB color channel histograms. In addition to the ribbon at the top that provides basic shooting information, this view includes the shooting and metering mode, White Balance, file size, image recording quality, and the current image number relative to the total number of shots on the CF card.

Note *If you're new to using a histogram, be sure to read Chapter 3, where evaluating exposure using histograms is detailed.*

looking for the one or series you want to find. Second, you can jump through images by criteria such as a specified number of images at a time, screens, date, or folder.

Here's how to use both options.

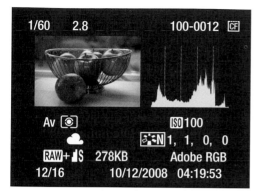

2.9 This is the Shooting information display with a Brightness histogram.

To check focus and specific details within the image, you can magnify the preview image by pressing the AF-point selection button on the back, top-right side of the camera. The button has a magnifying icon under it. If you hold the button, the image magnifies to the maximum 10x. Then tilt the Multi-controller to move around the magnified image. Press and hold the AE Lock button on to reduce the image magnification. This button has a magnifying button (with a minus sign in it) under it.

Display and move through multiple images

When you need to quickly find one or a series of images on a CF card that has many stored images, you have two options. First, you can display images as an index with either four or nine images displayed as an index and move through the images quickly

✦ **Display as an index.** To display images as an index, just press the AE Lock/Reduce button once for a four-image display or twice for a nine-image display. Then you can turn the Quick Control dial to move through index pages, or press the Magnify button to return to single-image display.

2.10 This is Index display with four images displayed.

✦ **Jump through images.** Select the Playback 2 camera menu, select Image jump w/[Main dial], and then press the Set button. On the Image jump w/[Main dial] screen, select the method for jumping: 1 image, 10 images, 100 images, Screen, Date, or Folder, and then press the Set button. Now press the Playback button to begin image playback, and then turn the Main dial to display the jump scroll bar and to jump by the method you selected.

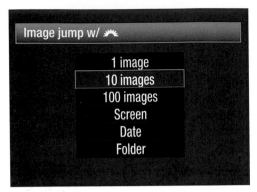

2.11 The Image jump options screen

Displaying images on a TV

Viewing images stored on the CF card on a TV is a convenient way to review images at a large size, particularly when traveling. The video cable to connect the camera to a TV is included in the 50D box. Before connecting the camera to the TV, you need to set the video system format using the Set-up menu on the camera. The following instructions are for both non-Hi-Definition (HD) and HD TVs.

1. **Press the Menu button, and then highlight the Set-up 2 menu.**

2. **Select Video system, and then press the Set button.** The camera displays the NTSC and PAL options.

Note *NTSC is the analog television system in use in the United States, Canada, Japan, South Korea, the Philippines, Mexico, and some other countries, mostly in the Americas. PAL is a color encoding system used in TV systems in parts of South America, Africa, Europe, and other countries.*

3. **Highlight the system you want, and then press the Set button.**

4. **Turn off the TV set and the camera.**

5. **Attach the video cable or the HDMI cable.** You cannot use the camera's Video Out and HDMI Out terminals simultaneously.

 - **For a non-HD TV.** Attach the video cable to the camera's Video Out terminal, and then connect the other end of the video cable to the TV set's Video In terminal.

 - **For an HD TV.** Connect the HDMI cable to the camera's HDMI OUT terminal with the plug's logo facing the front of the camera, and then connect the other end to the TV's HDMI IN port.

6. **Turn on the TV set, and then switch the TV's input to Video In or the connected terminal.**

7. **Turn the camera's power switch to the ON position.**

8. **Press the Playback button.** Images are displayed on the TV but not on the camera's LCD monitor. When you finish viewing images, turn off the TV and the camera before disconnecting the cables.

Tip *You can use the previous steps to display not only images stored on the CF card on the TV, but you can also use the TV to display what would appear on the LCD during both general shooting and when you're shooting in Live View.*

Protecting images

To prevent accidental erasure of images on the CF card, you can apply protection to one or more images. Setting image protection is much like setting a document on the computer to read-only status. When you download a protected image, you're asked to confirm that you want to move or copy one or more read-only files, which indicates that the images have protection applied.

 Caution *Setting protection means that protected images can't be deleted using the Erase options detailed in the next section. However, protected images are erased when you format the CF card.*

You can apply protection to an image by following these steps:

1. **Press the Menu button, and then highlight the Playback 1 menu.**

2. **Highlight Protect images, and then press the Set button.** The last image captured appears on the LCD. A small key icon and the word Set appears at the top of the image.

3. **Press the Set button again to protect the displayed image, or turn the Quick Control dial to move to the image you want to protect.** A key icon appears in the information bar above the image to show that it is protected. To protect additional images, turn the Quick Control dial to scroll to the image you want to protect, and then press the Set button to add protection.

If you later decide that you want to unprotect an image, you can remove protection by repeating Steps 1 to 5 and pressing the Set button to remove protection for each image. When protection is removed, the key icon in the top information bar disappears.

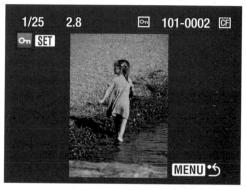

1/25 2.8 101-0002

2.12 The protection key icon is displayed at the top and to the left of the folder and file numbers.

Erasing images

With the large, high-resolution LCD monitor, evaluating images is easier and more accurate than on previous cameras. This makes it easier to decide whether to erase images on the CF card, although caution is still in order. It's often wiser to look at images on the computer monitor to evaluate the merits or demerits of images before permanently deleting them.

Tip *Erasing images permanently deletes them, so be sure to read the previous section on protecting images to help avoid accidental erasure.*

The 50D offers two ways to delete images: one image at a time or by check marking multiple images and deleting all marked images at once.

If you want to permanently erase a single image, just navigate to the image you want to delete during image playback, press the Erase button, highlight Erase, and then press the Set button.

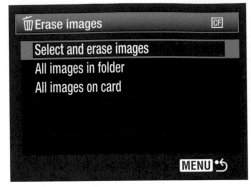

2.13 The Erase images screen

Note *It's a good idea to periodically format the CF card, and you should always format it in the camera, not on the computer. Before formatting the card, download all the images from the card to the computer. To format the CF card, go to the Setup 1 menu, and then select Format. Press the Set button. The camera displays a Format confirmation screen. Turn the Quick Control dial to select OK, and press the Set button. The camera displays a progress screen as the card is formatted.*

To select and erase multiple images at a time, follow these steps. As you go through these steps, you can optionally choose to erase all images on the card or in a specific folder.

1. **Press the Menu button, and then highlight the Playback 1 menu.**

2. **Turn the Quick Control dial to highlight Erase Images, and then press the Set button.** The Erase images screen appears.

3. **Highlight the Select and erase images option, and then press the Set button.** The 50D displays the image playback screen with options at the top left of the LCD to check mark the current image for deletion.

4. **Press the Set button to add a check mark to the current image, or turn the Quick Control dial to move to the next image.** Continue selecting all of the images you want to mark for deletion. You cannot add a check mark to images with protection applied.

5. **Press the Erase button.** The Erase images screen appears.

6. **Turn the Quick Control dial to highlight OK, and then press the Set button.** The 50D erases the marked images, and the Erase images screen appears.

Controlling Exposure and Focus

This chapter gets to the heart of shooting with the EOS 50D and taking creative control over your images. Beginning with the shooting modes, which give you control over one or all elements of exposure, and moving through setting the ISO sensitivity, you'll learn what the camera offers and when to use the various modes and options. You'll also learn how to modify the exposure in scenes with challenging lighting.

This chapter also explains the 50D's autofocus features and when to use the different options. Finally, the chapter details selecting various drive modes that determine the number of shots you can get during shooting.

By the end of this chapter, you'll have a good foundation in using the 50D's exposure and focus controls and drive modes for everyday shooting. Throughout this chapter, I encourage you to shoot with the 50D as you read about different aspects of the camera. While I provide examples throughout the chapter, the images are subject to commercial printing variables that may not reproduce them as accurately as a photographic print. As a result, there is no substitute for your personal experience with the camera and examining the results in your printed images.

Working with Exposure

These days it's easy to look at an image on the camera's LCD monitor, notice an exposure problem, and think, "I'll fix it in Photoshop." The result is that exposure takes a backseat to image editing. Certainly a lot of things can be improved in

image editing, but seasoned photographers know that no amount of Photoshop editing can rival the beauty of a spot-on in-camera exposure.

I hope that your goal in reading this book and in shooting with the 50D is to master exposure in the camera. After all, the better the exposure in the camera, the less time you have to spend in front of the computer editing images, and the less time you spend at the computer, the more time you can spend making new images in the field.

Defining exposure goals

With the goal of getting excellent in-camera exposures, we should begin by defining what a perfect exposure is. Aesthetically, a perfect exposure captures and expresses the scene as you saw and envisioned it. Technically, and assuming skillful composition, a perfect exposure maintains image detail through the bright highlights — or the most important highlights — and dark shadows, displays a full and rich tonal range with smooth tonal transitions, renders visually pleasing and accurate color with good saturation, displays visually pleasing contrast, and has tack-sharp focus.

Given the challenges of the scene or subject as well as the camera and lens, perfect exposures are a challenge, but the fundamental goal of every exposure is to capture the best, and hopefully, a perfect, exposure.

Practical exposure considerations

Does that mean that every exposure will meet all the technical criteria of a perfect exposure? Not necessarily. Rather, the exposure ideally

serves the purpose of the photographer's creative vision and/or the needs of the subject. A classic example of an intentional imperfect exposure is when a photographer intentionally overexposes a portrait of an older woman by a full f-stop or more to minimize facial lines and wrinkles. While the exposure is intentionally imperfect, it compliments the subject and provides a pleasing image. Other examples of imperfect but acceptable exposure are scenes where the range from highlight to shadow is so great that you can properly expose only the most important part of the scene.

3.1 In this image, I wanted to spotlight the blossom while lighting the top leaves with a bit of edge light and leaving a hint of the bottom leaves, which required an exposure with open shadows. Exposure: ISO 100, f/18, at 2 seconds with a -1/3-stop exposure compensation.

Certainly no discussion of exposure is complete without reviewing how exposure is determined. Exposure is a mathematical expression of a balance among light, intensity (lens aperture), sensitivity (ISO), and time (shutter speed). Of these elements, photographers most commonly control ISO, aperture, and shutter speed. In making exposure adjustments, changing any one element such as aperture (f-stop) or shutter speed represents a doubling (increase in a setting) or halving (decrease in a setting) of the light reaching the image sensor or, in the case of ISO, of the sensor's sensitivity to light. For example, changing the aperture from f/8 to f/5.6 doubles the amount of light reaching the sensor while a change from f/5.6 to f/8 halves the amount of light. At the same ISO sensitivity setting, an exposure change in aperture requires a concurrent and proportional change in shutter speed to achieve a proper exposure.

Cross-Reference *For a more detailed look at photographic exposure elements, see Appendix A.*

The starting point for calculating any exposure, of course, is metering the light in the scene. Then you can control one or all of the exposure settings based on the shooting mode that you choose on the 50D.

Equivalent Exposures

For any exposure, there are alternate exposure settings that produce the same, or an equivalent, exposure. For example, if the camera meters the light and suggests f/5.6 at 1/60 second as the ideal exposure at any given ISO setting, then there are other aperture and shutter speed combinations that are equivalent, or will provide the same exposure. In this example, two equivalent exposures are f/4 at 1/125 second and f/8 at 1/30 second at the same ISO.

For any specific camera and lens combination, the number of possible equivalent exposures is fixed. To find that number, just multiply the number of shutter speeds by the number of possible lens apertures. As a simple illustration, consider a camera with nine shutter speeds (1/4 through 1/1000 second) combined with a lens with nine full aperture settings (f/1.4 through f/22). In this example, there are 81 total aperture shutter-speed combinations. Of the 81, a maximum of nine equivalent exposures provides an accurate exposure for a given lighting situation. However, while the exposures are equivalent, the rendering of the image will be quite different.

The 50D, of course, automatically calculates equivalent exposures for you in Tv, Av and A-DEP shooting modes. But P (Program) shooting mode is specifically designed to provide equivalent exposures as you "shift" the metered exposure. Understanding equivalent exposures also comes in handy when you're shooting in M (Manual) mode and want to get a faster shutter speed or to change the depth of field from the suggested metered exposure.

Choosing a Shooting Mode

The EOS 50D offers shooting modes that give you everything from full manual control over the exposure elements to fully automatic shooting. And as the scenes and subjects that you encounter change, you can switch shooting modes to control the exposure element that is most important to control. For example, if you're shooting a portrait, you want control over the aperture so that you can control the depth of field, so Av mode is best. But if you're shooting a soccer match, then you'll want control over the shutter speed so you can set a fast enough shutter speed to freeze the motion of players. That makes Tv mode the best choice. For quick snapshots, you may want to let the camera control everything, so one of the automatic modes is a good choice.

The 50D Mode dial segregates shooting modes by the amount of control over exposure and other camera controls that they offer you. Figure 3.2 shows the two categories of shooting modes.

Creative Zone shooting modes

The Creative Zone shooting modes offer the greatest degree of exposure control. You can choose among shooting modes that are semiautomatic, fully manual, user-programmable, and one mode that is a cross between semiautomatic and automatic. These are the modes that give you the most creative expression over your images whether your objective is controlling the depth of field or controlling how subject motion is rendered in action shots.

The following sections offer a summary of the Creative Zone shooting modes.

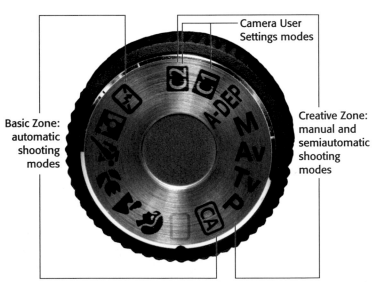

3.2 The Mode dial is divided into automatic and semiautomatic and manual shooting modes, as shown here.

Program AE (P) shooting mode

P mode, or Program AE, is Canon's "shift-able" shooting mode. In this mode, the 50D gives you its suggested exposure settings when you press the Shutter button halfway down. But if you want a different, but equivalent, aperture and shutter speed, you can temporarily change or "shift" the camera's suggested settings by turning the Main dial. For example, if the camera initially sets the exposure at f/4.0 at 1/125 second, and you turn the Main dial one click to the left, the exposure shifts to f/3.5 at 1/200 second, which is equivalent to the initial exposure. Turning the Main dial to the right results in a shift to f/5.0 at 1/100 second, and so on. The exposure shifts are made in 1/3-stop increments by default.

Tip *If you set Custom Function (C.Fn) I-1 to Option 1, aperture and shutter speed increments are adjusted in 1/2-stop increments. Custom Functions are detailed in Chapter 6.*

As a result, P mode enables you to alter the shutter speed to freeze or blur subject motion, or to exercise creative control over the depth of field — all with a minimum of camera adjustments. And it provides other practical benefits. For example, if you're shooting in low light with the EF 50mm f/1.4 lens, and the camera's suggested exposure is f/5.6 at 1/3 second (ISO 100), you can turn the Main dial to the left to change the aperture to f/1.4 at 1/50 second — a shutter speed that allows you to handhold the camera and get a sharp image.

To use P mode, set the Mode dial to P, and then half-press the Shutter button. The camera focuses on the subject and calculates the exposure weighting it toward the

active autofocus point that's displayed in red in the viewfinder. If you want to shift the camera's suggested exposure, turn the Main dial to the left to make the aperture smaller and the shutter speed longer or to the right to make the aperture larger and the shutter speed shorter.

Exposure shifts are temporary. If you shift the exposure, and then release the Shutter button without making the picture within several seconds, the viewfinder display turns off, and the next time you half-press the Shutter button, the camera returns to its original exposure.

3.3 In P mode, the 50D's recommended exposure was f/4 at 1/125 second (ISO 100). The image has a shallow depth of field, which I wanted, but the distinct detail of the background leaves was distracting.

3.4 I shifted from the recommended exposure to f/2 at 1/500 second (ISO 100), and was better able to bring the front leaves visually forward in the frame with the very shallow depth of field.

Of course, exposure "shifts" are limited by the ambient light. If the shutter speed 30" and the maximum aperture are blinking in the viewfinder, it means that the image will be underexposed. You can change the ISO to a higher sensitivity setting or use the built-in or accessory flash. Conversely, if the shutter speed shows 8000 and it along with the lens's minimum aperture blinks, the image will be overexposed. In this case, lower the ISO sensitivity setting or use a neutral density filter to decrease the amount of light coming into the lens.

Along with the ability to quickly change to an equivalent exposure, P mode gives you full control over all aspects of the camera

including setting the autofocus mode and AF point, setting the metering and drive modes, selecting a Picture Style, and modifying exposure using Exposure Compensation and Auto Exposure Lock (AE Lock).

Shutter-priority AE (Tv) mode

When your primary concern is controlling the shutter speed, then Shutter-priority AE mode, denoted as Tv on the Mode dial, is the shooting mode to choose. This semiautomatic shooting mode enables you to set the shutter speed while the camera automatically calculates the appropriate aperture based on the current ISO setting and the light-meter reading.

Tv is the mode of choice for sports and action shooting ranging from football and soccer to rodeos, for rendering the motion of a waterfall as a silky blur or capturing a single water drip in midair, for panning, or moving the camera, with the motion of the subject to create a streaked and blurred background, and for night shooting among others.

By controlling the shutter speed, you can control how subject motion is rendered — either as frozen using a fast shutter speed, or with motion blur using a slow shutter speed. And as a practical tool, Tv mode can also ensure that the shutter speed remains constant and fast enough to handhold the camera and get sharp images — provided that there is enough ambient light to give a shutter speed fast enough to handhold the camera and lens.

In Tv mode, you can select shutter speeds from 30 seconds to 1/8000 second. To use Tv mode, set the Mode dial to Tv, half-press the Shutter button, and then turn the Main dial to change the shutter speed. When

3.5 A slow shutter speed of 1/10 second and a crowd nice enough to stand still enabled this image that shows the motion of a state fair ride. Exposure: ISO 250, f/16, 1/10 second.

you set the shutter speed, the camera simultaneously calculates the appropriate aperture based on the current ISO.

Tip *If you're shooting sports or action, then you can also use AI SERVO AF mode, an autofocus mode that maintains focus on a moving subject. And you can switch to High-speed Continuous drive mode to capture the maximum number of images in a burst. Both autofocus and drive modes are detailed later in this chapter.*

The 50D alerts you if the exposure is outside the range of acceptable exposure in Tv shooting mode. If you see the maximum

aperture blinking in the viewfinder, it's a warning that the image will be underexposed. Just turn the Main dial to set a slower shutter speed or set a higher ISO sensitivity setting. Alternately, if the lens's minimum aperture blinks, it's an overexposure warning. Just set a faster shutter speed or a lower ISO sensitivity setting.

To show fractional shutter speeds in the viewfinder, the 50D shows only the denominator of the fraction in the viewfinder. Thus, 1/8000 second is displayed as 8000 and 1/4 second is displayed as 4. However, the Quick Control screen shows shutter speeds as fractions. Shutter speeds longer than 1/4 second are indicated with a double quotation mark that represents a decimal point between two numbers or following a single number. For example, 1"5 is 1.5 seconds while 4" is 4 seconds (4.0). This system is used both in the viewfinder and on the Quick Control screen.

Tip *To display the Quick Control screen on the LCD monitor, press the center of the Multi-controller. From this screen, you can change the most frequently used camera settings.*

In Tv mode, you can control all the functions on the 50D including AF, metering, and drive modes, manually selecting an AF point, Picture Style, and modifying exposure using Exposure Compensation, AutoExposure Lock (AE Lock).

Tip *If you want to ensure that the exposure is proper in scenes where light changes quickly, you can enable C. Fn I-6, Exposure Safety Shift. The 50D automatically shifts to a suitable exposure if the light on the subject changes enough to make the current shutter speed or aperture unsuitable. Safety shift works in both Tv and Av shooting modes.*

In the default 1/3-stop increments, the following shutter speeds are available:

1/8000, 1/6400, 1/5000, 1/4000, 1/3200, 1/2500, 1/2000, 1/1600, 1/1250, 1/1000, 1/800, 1/640, 1/500, 1/400, 1/320, 1/250, 1/200, 1/160, 1/125, 1/100, 1/80, 1/60, 1/50, 1/40, 1/30, 1/25, 1/20, 1/15, 1/13, 1/10, 1/8, 1/6, 1/5, 1/4, 0.3, 0.4, 0.5, 0.6, 0.8, 1, 1.3, 1.6, 2, 2.5, 3.2, 4, 5, 6, 8, 10, 13, 15, 20, 25, and 30 seconds.

Shutter speed increments can be changed from the default 1/3-stop to 1/2-stop increments using C.Fn I-1. Also in regard to shutter speeds, the 50D flash sync speed is 1/250 second or slower for Canon flash units. If you use the 50D with a studio lighting system, Canon recommends using a 1/30 to 1/60 flash synch speed. However, I've used 1/125 second with my 4-strobe Photogenic system with no problems and good results. Just be sure to test the sync speed to see which works best with your studio strobes.

In Tv mode, you have full control over camera controls such as autofocus and drive modes, AF point, Picture Style, and flash settings.

Shutter Speed Tips

Tv mode is handy when you want to set a shutter speed that is fast enough to hand-hold the camera and still get a sharp image, especially if you're using a long lens. If you're *not* using an Image-Stabilized (IS) lens, then the fastest shutter speed at which you can handhold the camera and lens and get a sharp image is 1/[focal length]. Thus if you're shooting at a 200mm focal length, the slowest shutter speed at which you can handhold the camera and get a sharp image is 1/200 second.

And if you're shooting action scenes and want a shutter speed fast enough to stop subject motion with no motion blur, then the following guidelines provide a good starting point.

✦ Use 1/250 second when action is coming toward the camera.

✦ Use 1/500 to 1/2000 second when action is moving side to side or up and down.

✦ Use 1/30 to 1/8 second when panning with the subject motion. Panning with the camera on a tripod is a really good idea.

✦ Use 1 second and slower shutter speeds at dusk and at night to show a waterfall as a silky blur, to capture light trails of moving vehicles, to capture a city skyline, and so on.

You can also use a polarizing or neutral-density filter to capture moving water as a blur earlier in the day, both of which reduce the amount of light to give you a slower shutter speed. Besides reducing the light by 2 stops, a polarizer has the additional benefit of reducing reflections on the water.

Aperture-priority AE (Av) mode

When you want to control the depth of field — how much of the background is in acceptably sharp focus — then use Aperture-priority AE (Av) shooting mode. In Av mode, you select the aperture (f-stop) that you want, and the 50D automatically sets the appropriate shutter speed based on the current ISO and the light meter reading.

Selecting an aperture (f-stop) determines how large or small that the lens diaphragm blades open to let light strike the sensor. The range of apertures available to you depends on the lens that you're using. Aperture increments are shown by default in 1/3-stop values. However, if you prefer to make larger aperture changes, you can set C.Fn I-1 so that aperture changes are made in 1/2-stop increments.

Av is the mode of choice for most everyday shooting whether it's landscape, nature, portraits, architecture, or still life because photographers most often want to control the depth of field. By turning the Main dial to a wide aperture such as f/5.6 or f/2.8, you get a shallow depth of field, or a narrow aperture such as f/11 or f/16 to get an extensive depth of field.

To use Av mode, set the Mode dial to Av, and then half-press the Shutter button to set the exposure and focus. Then turn the Main dial to the left to set a narrower aperture or to the right to set a wider aperture. The camera automatically calculates the appropriate shutter speed based on the light meter reading and the ISO.

3.6 For this image, I wanted to maintain as extensive a depth of field as possible so that the coffee beans retained good sharpness in the foreground to the cup, so I used a narrow f/20 aperture, and it gave me the effect that I envisioned. Exposure: ISO 100, f/20, 1/125 second.

Practically speaking, you can also control the shutter speed using Av mode, just as you can control aperture in Tv mode. For example, if I'm shooting outdoors in Av mode and see a flock of birds coming into the scene, I can quickly open up to a wider aperture and watch in the viewfinder until the shutter-speed is fast enough to stop the motion of the birds in flight. The principle is simple — as I choose a wider aperture, the camera sets

a faster shutter speed; as I move to a wider aperture, I can quickly get to motion-stopping shutter speeds. Thus I don't need to switch to Tv shooting mode to change the shutter speed. The same thing is true for Tv mode, albeit by adjusting the shutter speed to get to the aperture you want.

In 1/3-stop increments, and depending on the lens you use, the apertures are:

f/1.2,1.4, 1.6, 1.8, 2.0, 2.2, 2.5, 2.8, 3.2, 3.5, 4.0, 4.5, 5.0, 5.6, 6.3, 7.1, 8.0, 9.0, 10, 11, 13, 14, 16, 18, 20, 22, 25, 29, 32, 36, 40, and 45.

In Av mode, you have full control over all the camera settings, Picture Style, White Balance, flash settings, and so on.

If you select an aperture and the exposure is outside the camera's exposure range, the shutter speed value blinks in the viewfinder and on the LCD panel. If 8000 blinks, the image will be overexposed. If 30 blinks, the image will be underexposed. If this happens, adjust to a smaller or larger aperture respectively or set a lower or higher ISO setting. If no lens is attached to the camera, 00 is displayed for the aperture setting.

You can preview the depth of field by pressing the Depth of Field preview button on the front of the camera located below the Lens Release button. When you press the Depth of Field preview button, the lens diaphragm stops down to the current aperture so that you can preview the range of acceptable focus. The more extensive the depth of field, the more of the foreground and background that will be in acceptably sharp focus, the larger the area of darkness in the viewfinder, and vice versa.

Tip *To preview differences in depth of field among different apertures, press and hold the Depth of field preview button as you turn the Main dial to change apertures.*

Manual (M) mode

As the name implies, Manual mode eliminates the automatic aspects of setting exposure so that you set the aperture, shutter speed (and ISO) yourself. This mode is useful when you determine image exposure by metering on a middle-gray area in the scene. (This exposure method is detailed in Chapter 9.) In addition, you can use Manual mode when you have a predetermined exposure for shooting fireworks, astral photography, for studio shooting, when you want to intentionally underexpose or overexpose a part of the scene, or when you want a consistent exposure across a series of photos such as for a panoramic series.

To use Manual mode, set the Mode dial to M. Press the Shutter button halfway to meter the light. The camera's ideal exposure is indicated when the tick mark is at the center of the exposure level indicator shown in the viewfinder and on the LCD panel.

Then to set the exposure, turn the:

✦ Main dial to select the shutter speed

✦ Quick Control dial to select the aperture

To determine the exposure settings, watch the Exposure Level meter displayed in the viewfinder as you adjust the aperture and shutter speed. The camera's ideal exposure — based on the light meter reading — is shown when the tick mark under the meter is at the center point.

If you want a specific aperture, then you can adjust the shutter speed and/or ISO setting until you get the aperture you want. The same is true if you want a specific shutter speed where you then adjust the aperture and ISO as necessary.

Alternately, you can overexpose or underexpose up to +/- 2 Exposure Values (EV) and the amount of exposure variance from the metered exposure displayed on the exposure level indicator. If the amount of exposure is out of this range, then the exposure indicator tick mark blinks. Then you can adjust the aperture, shutter speed, or ISO sensitivity setting until the exposure is within range.

The aperture and shutter speed values detailed in the preceding sections are also available in Manual mode, and you have full control over all the camera controls, Picture Style, and flash settings.

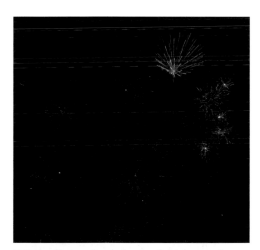

3.7 For fireworks and celestial images, I always switch to M mode because I know ahead of time what exposure I want to use, although I usually adjust it slightly after a few test shots. Exposure: ISO 100, f/11, 1/8 second.

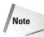 *For digital cameras in general, an Exposure Value is an expression of the ISO, shutter speed, and aperture taken together as the amount of light given the sensor. In traditional terms, EV is the amount of exposure required by the subject luminance and the ISO. EVs are represented by whole numbers with each sequential step doubling or halving the exposure. For example, if you halve the amount of light that reaches the image sensor by either reducing the aperture or increasing the shutter speed, the EV increases by 1.*

Bulb exposures

When you're in Manual shooting mode, you can also set the shutter speed to Bulb. Bulb keeps the shutter open as long as the Shutter button is fully depressed. Bulb is handy for some night shooting, fireworks, celestial shots, and other creative long-exposure renderings.

Bulb exposure times can be as long as 2.5 hours, so be sure that you have a fully charged battery before you begin an extended exposure. To ensure rock-solid stability during Bulb exposures, you can use the RS-80N3 Remote Switch or the TC-80N3 Timer Remote Control to hold the shutter open. You can also enable mirror lockup to reduce the chance of blur caused by the reflex mirror action. Mirror lockup can be set by setting C.Fn III-6 to Option 1: Enable.

To select Bulb, set the Mode dial to M, then turn the Main dial to buLb, the setting after the 30" shutter speed setting. With the camera on a tripod, select the aperture you want by turning the Quick Control dial, and then

press and hold the Shutter button for the length of time you want. Alternately, you can use a remote release to hold the shutter open. The elapsed exposure time is shown in seconds on the LCD.

Because long exposures introduce digital noise and increase the appearance of grain, consider setting C.Fn II-1, Long exposure noise reduction to Option 2: On.

A-DEP mode

A-DEP shooting mode is designed to calculate the optimum depth of field between near and far elements in a scene to get maximum sharpness from front to back in the image. The camera uses the nine autofocus (AF) points to detect near and distant objects and distances. To do this, the camera automatically identifies what it thinks are the primary subjects in the scene, chooses the AF points that are on them, and then it sets an aperture that will provide optimum depth of field. It also sets the shutter speed based on the aperture and ISO.

Automatically setting the optimum depth of field is very handy, but it comes with two caveats:

✦ The camera automatically determines what the primary elements are in the scene, and the elements it chooses may or may not be what you consider to be the primary elements. You can verify the camera's choice of elements by watching which AF points light in red when you press the Shutter button halfway down to focus. If the camera isn't selecting the correct elements in the scene, then move your position slightly and refocus. Repeat as necessary.

✦ Often achieving the optimum depth of field requires setting a narrow aperture, and that can result in a slow shutter speed depending, of course, on the ambient light and the ISO. Keep an eye on the shutter speed in the viewfinder and use a tripod when necessary.

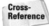 *If you want to know more about depth of field and the other elements of photographic exposure, be sure to read Appendix A.*

To use A-DEP mode, set the Mode dial to A-DEP, then press the Shutter button halfway down to focus. The AF points that the camera selects light in red in the viewfinder showing you the points on which the camera is calculating the optimum depth of field. If the shutter speed is too slow to handhold the camera, then use a tripod, monopod, and/or an IS lens to avoid getting a blurry picture, or increase the ISO sensitivity setting.

In A-DEP mode, you relinquish some of the control that you have in other Creative Zone shooting modes. Specifically, you can't control the autofocus mode, AF-point selection, or the shutter speed. The camera also automatically uses One-shot AF mode with automatic AF-point selection. You can, however, set the ISO. If you use the flash, you lose the maximum depth of field, and A-DEP mode behaves much like P mode instead.

The same overexposure and underexposure warnings appear in the viewfinder for A-DEP mode as for Av and Tv modes except that the aperture and shutter speeds warnings do not blink. You can increase or decrease the ISO respectively to adjust the exposure.

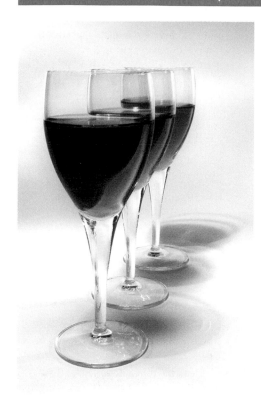

settings and preferences. The C1 and C2 modes on the Mode dial enable you to set up the camera with your most commonly used settings including a shooting mode, White Balance setting, color space, Picture Style, Custom Functions, and more, and then register those settings as either C1 or C2 mode. Then when you want to use those specific settings again, you just turn the Mode dial to C1 or C2.

Your strategy for setting up C1 and C2 modes can range from registering settings for a specific location that you often shoot in such as a gymnasium for basketball games, a chapel or church for shooting weddings, or even your living room where you photograph your children. Alternately, you can set up the C modes on the fly for specific scenes. Regardless of approach, C modes help you spend more time shooting and less time adjusting camera settings. They are also fully customizable, and are detailed in Chapter 5.

3.8 A-DEP calculates the aperture that provides the most extensive depth of field, as it did with these wine glasses. The camera set to f/22. I was shooting with low-intensity tungsten modeling lights, and the resulting shutter speed of 1.6 seconds at ISO 100.

Additionally, if the aperture blinks in the viewfinder, it means that the camera cannot achieve the optimum depth of field at the lens's smallest aperture. In this case, zoom to a wide-angle lens setting or use a wide-angle lens, or move farther away from the subjects.

C1 and C2 (Camera User Settings) modes

One of the handiest options that the EOS 50D offers is the ability to program two shooting modes with your favorite shooting

Basic Zone shooting modes

For anyone who's moving from a point-and-shoot digital camera to the 50D, the Basic Zone modes, often called automatic modes, will be familiar and work similarly, albeit with the ability to change lenses. A new addition to this group is Creative Auto, a shooting mode designed to help photographers transitioning from using fully automatic cameras to digital SLR cameras by providing simple descriptions and controls for traditional photographic functions.

Basic Zone modes range from Creative Auto to Flash Off modes on the Mode dial. Here's a look at the 50D's automatic shooting modes.

Creative Auto mode

If you're new to using a digital SLR, and you want to get creative effects that are commonly associated with digital SLR shooting, Creative Auto mode, designated as CA on the Mode dial, is designed for you. CA shooting mode displays an LCD screen with visuals and text to help you understand the results that you get from making various adjustments. This shooting mode also offers more control than the other automatic modes, but it offers less control than the semiautomatic and manual modes in the Creative Zone.

To use CA mode, turn the Mode dial to CA to display the CA screen. Press the center of the Multi-controller to activate the screen. Then tilt the Multi-controller to highlight an option, and then turn the Quick Control or Main dial to adjust the setting. To move to the next control, tilt the Multi-controller to select the control, and then repeat the process. You do not need to press the Set button to confirm changes.

You can adjust the following elements from the CA screen:

✦ **Flash control.** With this control, you can choose to have the built-in flash fire automatically when the light is too low to get a sharp, handheld image; choose to have the flash fire for every image, or choose to turn off the flash completely. If you choose to turn off the flash, and if the light is low, be sure that you stabilize the camera on a tripod or solid support before shooting. Also know that if you turn off the flash, the flash unit may pop up anyway so the camera can use the flash's autofocus assist light to help the camera focus in low light. Even if this happens, the flash will not fire during the exposure.

✦ **Background control.** This control enables you to determine whether the background is softly blurred or rendered with more distinct detail by adjusting the slide control to the left or right, respectively; in other words, it controls the aperture (f-stop) so you can control the depth of field.

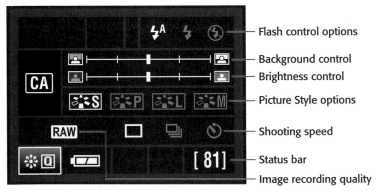

Flash control options
Background control
Brightness control
Picture Style options
Shooting speed
Status bar
Image recording quality

3.9 The Creative Auto screen offers a visual gateway to make exposure and other camera changes without needing to understand photographic exposure concepts.

✦ **Brightness control.** As the name implies, this control enables you to modify the standard exposure to a lighter or darker rendering by adjusting the slide control to the right or left, respectively. In effect, the control sets Exposure Compensation to +/- 1 1/3 EV. The brightness control is also affected by Auto Lighting Optimizer, a feature that brightens images that are too dark and adjusts contrast. Auto Lighting Optimizer, detailed later in this chapter, is turned on by default in all Basic Zone shooting modes.

✦ **Picture Style options.** You can choose among four of the seven total Picture Styles offered on the 50D. A Picture Style determines the look of images much as different films have characteristic looks. Picture Styles are covered in detail in Chapter 4. In CA mode, you can choose Standard, Portrait, Landscape, or Monochrome (black-and-white) styles.

✦ **Image recording quality.** You can change the image recording quality and the file format by highlighting this control, and then pressing the Set button. The 50D displays the Quality screen to adjust quality and file format as detailed in Chapter 2. Just make the changes you want by turning the Quick Control dial after selecting this control. In this mode, you can choose all the image qualities offered on the 50D including RAW and sRAW+JPEG combinations.

✦ **Shooting speed.** The speed at which the camera shoots is determined by the drive mode. You can choose Single-shot mode, where each press of the Shutter button makes one image; Low-speed

Continuous drive mode, where pressing and holding the Shutter button shoots at 3 frames per second (fps); or the 10-second Self-timer drive mode that delays shooting by 10 seconds so that you can be in the picture; or avoid shake by pressing the Shutter button when you're shooting long exposures, macro images, or using a long telephoto lens.

The remaining Basic Zone or automatic modes are designed to provide point-and-shoot functionality, with the camera automatically setting the exposure and other camera settings. The advantage of automatic modes is that you don't have to understand exposure or camera settings to get good images. The disadvantage of automatic modes is that you cannot control exposure and focus.

Each automatic mode is designed to give you classic photographic results for specific subjects or scenes. For example, Portrait mode delivers images with a softly blurred background to help avoid background distractions that draw the viewer's eye from the subject. In Sports mode, the camera gives you the fastest shutter speed possible given the available light so that the motion of the subject is frozen.

In Basic Zone modes, the camera automatically selects the following:

✦ **Auto ISO.** In all Basic Zone shooting modes except Portrait and when using the flash, the camera sets the ISO sensitivity from 100-1600. While the high-ISO performance of the 50D is good, ISO 1600 unquestionably increases digital noise. Digital noise appears as multicolored flecks in shadow areas and can create a grainy

appearance. This is not a setting that you can control in Basic Zone modes, so be forewarned that at high ISO settings, the image quality might suffer from digital noise.

✦ **sRGB color space**

✦ **Auto White Balance**

✦ **Autofocus mode and autofocus-point selection.** This varies according to the shooting mode that you choose.

✦ **Evaluative metering.** This analyzes scene light from 35 zones located throughout the viewfinder.

✦ **Automatic flash operation.** This depends on the shooting mode and the ambient light.

✦ **Auto Lighting Optimizer.** This function automatically brightens images that are too dark and adjusts the image contrast.

It's also important to know the following when you're in Basic Zone modes:

✦ The number of tabs and options on the camera menus are abbreviated offering you fewer choices and less control.

✦ You can't shoot in Live View mode.

✦ You can select the image recording quality at any of the JPEG, sRAW, or RAW settings.

In automatic modes, the camera chooses the AF point or points automatically. When the camera chooses the AF point, it looks for several things including the points in the scene where lines are well defined, the object that is closest to the lens, and points of strong contrast. As you can guess, a portrait subject's eyes do not fit these criteria, but the subject's eyes are where the point of sharpest focus should be. Likewise, in a

close-up shot, the camera may miss the point where the sharpest focus should be set. Occasionally, you can force the camera to select different AF points by moving the camera and refocusing. Often, however, it is easier to choose a Creative Zone mode such as Av, set a wide aperture, and then manually select the AF point.

Full Auto mode

This mode's name says it all — full automation leaving nothing for the photographer to do but point and shoot. Everything from exposure to drive mode is automatically set by the camera.

In Full Auto mode, the camera uses the Standard Picture Style, AI Focus AF, which means that if you focus on the subject and the subject begins to move, the camera automatically switches to AI SERVO AF, an autofocus mode that tracks focus on a moving subject. The camera automatically selects the AF point or points as well. In this shooting mode, the camera uses Single-shot drive mode, but you can choose to use the 10-second Self-timer mode. The camera fires the flash automatically based on ambient light.

Portrait mode

In Portrait mode, the 50D sets a wide aperture so that the background is softly blurred to help obscure distractions. The wide aperture results in a shallow depth of field that brings the subject visually forward in the image. The EOS 50D also uses Portrait Picture Style to enhance skin tones. This mode works well for quick portraits in good light. In lowlight scenes, the camera automatically fires the flash, which may or may not be the effect you want in the portrait. You can optionally turn on Red-eye reduction. In Portrait mode, the camera automatically selects Low-speed continuous drive

mode so you can press the Shutter button and shoot at 3 frames per second (fps). You can choose to use the 10-second Self-timer drive mode.

This mode is suitable for any image in which you want a shallow depth of field (blurred background) and subdued color and contrast because this mode uses the Portrait Picture Style.

Landscape mode

In Landscape mode, the 50D chooses a narrow aperture to ensure that background and foreground elements are in acceptably sharp focus and that the fastest shutter speed possible is based on the amount of light in the scene. In terms of depth of field, Landscape mode is the opposite of Portrait mode because it provides an extensive depth of field.

In lower light, the narrow aperture can cause slower shutter speeds. The 50D may also increase the ISO a little or a lot which increases the chances of digital noise. As the light fades, watch the viewfinder or LCD panel to monitor the shutter speed and ISO. If the shutter speed is 1/30 second or slower, and if you're using a telephoto lens, be sure to steady the camera on a solid surface or use a tripod. In Landscape mode, the camera automatically sets One-shot autofocus with automatic autofocus (AF) point selection, Single-shot drive mode, no flash, and Landscape Picture Style. You can choose to use the 10-second Self-timer drive mode.

Close-up mode

In Close-up mode, the 50D allows a close focusing distance and provides the same wide aperture to create a shallow depth of field as Portrait mode. You can enhance the close-up effect by using a macro lens. If you're using a zoom lens, zoom to the telephoto end of the lens when shooting in Close-up mode.

Also, for the best images, focus at or close to the lens's minimum focusing distance. One way to determine the minimum focusing distance is to focus the lens at the minimum focusing distance, and then move the camera until the image looks sharp and you hear the beep that confirms sharp focus.

In Close-up mode, the camera automatically uses the Standard Picture Style, One-shot autofocus with automatic autofocus (AF) point selection, Single-shot drive mode, and automatic flash with the option to turn on Red-eye reduction. In this mode, you can choose to use the 10-second Self-timer drive mode.

Sports mode

Sports mode sets a fast shutter speed to freeze the motion of a moving subject in midmotion with no motion blur. With Auto ISO ranging up to 1600, the camera should be able to increase the ISO sufficiently to provide fast shutter speeds even in indoor venues. This mode can be useful for shooting events, weddings, and receptions.

Sports mode uses AI SERVO autofocus mode so that you focus on a moving subject, and then the camera tracks subject movement until good focus is achieved, which is confirmed with a low beep. If you continue to hold the Shutter button down, the camera maintains focus for continuous shooting.

In Sports mode, the camera also uses High-speed Continuous drive mode at 6.3 fps, no flash, and Standard Picture Style. You can choose to use the 10-second Self-timer drive mode.

Night Portrait mode

In this mode the 50D combines the flash with a slow synch speed to correctly expose the person and the background. This provides an image with both the subject and the background nicely exposed. However, the background exposure will cause a long shutter speed, so be sure to use a tripod or set the camera on a solid surface to take night portraits.

This isn't a good mode for making general night shots because the camera sets a wide aperture to softly blur the background — the shallow depth of field that you want for portraits of people, and because it fires the flash which would not be appropriate at the distances normally associated with scenery shots. For night scenes without people, use Landscape mode and a tripod.

In Night Portrait mode, the camera automatically sets One-shot autofocus with automatic autofocus point selection, Single-shot drive mode with the option to use the 10-second Self-timer, automatic flash with the ability to turn on Red-eye reduction, and Standard Picture Style.

Flash Off mode

In scenes where you do not want the built-in or an accessory Speedlite flash to fire, Flash Off mode provides this functionality. In low-light scenes, be sure to use a tripod or stabilize the camera on a solid surface, and if you're photographing a person or an animal in lowlight, the subject must remain stock still during the exposure to prevent blur. This mode is handy in venues where flash is prohibited and when the subject is out of range of flash coverage. Just be sure that you have a tripod, monopod, or an IS lens handy in marginal light.

In Flash Off mode, the camera automatically sets AI Focus AF with automatic AF-point selection. This focus mode works like Single-shot mode except that if the subject begins to move, the camera automatically switches to AI SERVO AF to track focus on the moving subject. The 50D also sets Single-shot drive mode. You can choose to use the 10-second Self-timer drive mode.

Setting the ISO Sensitivity

For photographers who want to control image exposure, the first step is choosing a shooting mode such as Tv, Av, P, or M so that you can control two of the elements of exposure, the aperture and/or the shutter speed. The third element in the exposure equation is the ISO that, in simple terms, sets the sensitivity of the image sensor to light.

In less simplistic terms, increasing the ISO amplifies the output of the sensor. Although you can change the ISO sensitivity at any point during shooting, the tradeoff is increased amplification that represents an increase in digital noise. As digital noise increases, depending on the severity and appearance, there is an overall loss of resolution and image quality.

The compelling benchmark in evaluating digital noise is the quality of the image at the final output size. If the digital noise is visible and aesthetically objectionable in an 8-x-10- or 11-x-14-inch print when viewed at a distance of 1-foot or more, then the digital noise has degraded the image quality to an unacceptable level. This standard emphasizes the need to test the 50D at each

of the higher ISO sensitivity settings, and then process and print images at the size you typically use. Then evaluate the prints to see how far and how fast you want to take the 50D's ISO settings.

In all Creative Zone modes, you can set the ISO sensitivity in 1/3-stop increments, or in 1-stop increments by setting C.Fn I-2 to Option 1. The 50D's standard range is ISO 100 to 3200, but you can expand the range to include 6400 and 12800 by setting C. Fn I-3 to Option 1: On. Then ISO 6400 appears as H1 and ISO 12800 appears as H2 on camera displays.

> **Note** The ISO sensitivity setting also affects the range of the built-in flash with higher settings increasing the flash range. For example, at f/5.6, the range changes from 7.5 feet at ISO 100 to 43 feet at ISO 3200.

The EOS 50D features an automatic ISO option that's used in Basic Zone modes and can be used in Creative Zone shooting modes. The automatic ISO range is impressively broad, going from 100 up to 1600 in all shooting modes except Portrait (fixed at ISO 100) and Manual (fixed at ISO 400), and when the flash is used (fixed at ISO 400).

If you are concerned about controlling digital noise in images, and if you use Auto ISO, then be sure to check the ISO setting in the viewfinder to ensure that it is acceptable based on the shooting circumstances and your tolerance for digital noise. If it isn't, you can reduce the ISO by setting it manually. Alternately, you can turn on Standard, Low, or Strong noise reduction at high ISO settings using C.Fn II-2.

3.10 This is a small part of an image where digital noise became more apparent when I lightened the shadows in Adobe Photoshop. The ISO was 400, which isn't especially high, but I check shadow areas on all images so I know if I need to apply noise reduction during image conversion or editing.

Recognizing Different Types of Digital Noise

As the signal output of the image sensor increases, digital noise increases as well. This noise is analogous to the hiss on an audio system turned to high or full volume. In digital images, the hiss translates to random flecks of color in shadow areas as well as a grainy look. Three types of digital noise are most common:

✦ **Random.** This noise is common with short exposures at high ISO sensitivity settings. Random noise appears on different pixels and looks like colorful grain or speckles on a smooth surface. This type of noise increases with fast signal processing.

✦ **Fixed-pattern.** This type of digital noise includes hot pixels that have intensity beyond random noise fluctuations. Hot, or very bright, pixels are minor manufacturing defects that result in unusually high dark current levels. Fixed-pattern noise is caused by an uneven signal boost among different pixel amplifiers. This noise is common with long exposure and is worsened by high temperatures. Fixed-pattern noise gains its name because under the same exposure and temperature conditions, the noise pattern shows the same distribution.

✦ **Banding.** This type of noise is more camera dependent and is introduced as the camera reads data from the image sensor. It becomes visible in the shadow areas of high-ISO images. It's visible especially when shadow tones are lightened during image editing.

In addition, digital noise exhibits fluctuations in color and luminance. Color, or chroma, noise appears as bright speckles of unwanted color in the shadow areas of images. Luminance noise looks more like film grain.

Note *Noise reduction can give fine details such as a person's hair a painted or watercolor appearance. In addition, details and color definition can become indistinct. Be sure to test the different levels of noise reduction by enlarging images to 100 percent on the computer to determine the effect. These tests will help you decide the best level of noise reduction to use at different high ISO settings.*

Many times you need to set a higher ISO because the light is low. And when the light is low, the exposure may also be long even with a higher ISO setting. Long exposures also cause digital noise and may reveal hot pixels. If your shooting scenario lends itself

to using the Long exposure noise-reduction option (C.Fn II-1), I recommend using it along with High ISO speed noise reduction. The Long exposure noise-reduction option slows down shooting because the 50D takes a second dark frame after the first exposure, and then the camera uses this dark frame to remove digital noise in the original image. The dark frame exposure is the same duration as the first exposure, and you cannot continue shooting until the dark frame exposure is completed.

To change the ISO on the 50D, press the ISO speed setting button above the LCD monitor, and then turn the Main dial to the ISO sensitivity setting that you want.

Many of my photography students routinely set ISO 400, 800, and even 1600 for daily shooting in bright and moderately bright light without realizing the implications it has on image quality. My recommendation is to always shoot at the lowest ISO setting possible given the ambient light. My camera is set to ISO 100 as a matter of course. I increase the ISO only when the light conditions force me to, and then I increase it just enough to get the shutter speed that I need to either handhold the camera with the lens I'm using, or to freeze subject motion in action shooting.

> **Note** If you are new to photographic exposure and how aperture, shutter speed, and ISO work together, be sure to read Appendix A.

Here are general recommendations for setting the ISO:

✦ In bright to moderate daylight, set the ISO to 100 unless you need a faster shutter speed to handhold the camera with the lens you're using. If the lens does not have IS, then use the guideline provided in the Tv shooting mode topic earlier in this chapter.

✦ At sunset and dusk and in overcast light set the ISO from 200 and 400. At this time of day, shadows are deep, and you want to minimize digital noise that is inherent in shadow areas. The goal is to always produce an image with the highest quality that the 50D can deliver, and lower ISO settings do that. Again, if you're using a telephoto lens, turn on IS or use a tripod.

✦ Indoors, including gymnasiums and recital halls, at night music concerts, and for night shooting set the ISO from 400 to 1600. If the light is dismally dark and if you must handhold the camera, then you may need to use the H1 (6400) or H2 (12800) ISO expansion options available via C.Fn I-3. Also turn on C.Fn II-2 to reduce high ISO digital noise. Venue light can vary dramatically, so keep an eye on the shutter speed and raise the ISO only enough to give you the shutter speed you need to achieve your shooting needs.

Metering Light and Modifying Exposure

The starting point of all exposures, of course, is the light in the scene. The 50D uses an onboard reflective light meter to measure the light reflected from the subject or scene back to the camera. The camera uses the light meter reading to determine it's ideal recommended exposure and equivalent exposures. When the camera uses the default Evaluative metering mode, it evaluates the light throughout 35 zones within the viewfinder, but weights the reading based on the active autofocus area that's indicated by the active AF point or points. Depending on the scene or subject, you may want the camera to meter less of the light, and the 50D provides three other metering modes for this purpose.

Regardless of the metering mode chosen, it's important to point out that when the camera calculates exposure with its reflective light meter, it assumes that all tones in the scene will average to 18 percent, or middle gray. An average scene is defined as one having a fairly even distribution of light, medium, and dark tones. Certainly some scenes fit neatly within the average classification. But in non-average scenes, the camera continues to average metered values in the scene to neutral gray. Thus, the camera will render a white wedding gown as middle gray just as it will a black tuxedo unless the exposure is modified. To help you get the best exposure in both average and non-average scenes, you can use the 50D's different metering modes as well as exposure modification, all of which are detailed in the following sections.

Using metering modes

Given the range of different scenes and subjects, it's unlikely that a single light metering mode is suitable in all situations. The 50D provides four metering options that you can choose when you're shooting in P, Tv, Av, M, and A-DEP modes. In the automatic modes, the camera always uses Evaluative metering mode, and you can't change it.

Tip *While the camera will give a good exposure in the majority of scenes, if the exposure is critical, then you can also meter on a photographic gray card, which has known reflectance of 18 percent. Gray cards are sold at camera stores and are also handy for setting custom white balance as well. They are small enough to easily fit in your gear bag.*

Here is a look at each of the metering modes that you can choose.

✦ **Evaluative metering.** This is Canon's venerable metering system that partitions the viewfinder into 35 zones from which it evaluates light throughout the scene. However, this mode also biases metering based on the subject position that is indicated by the active AF point or points. It also takes into account the scene or subject brightness, the background, and back or front lighting. This metering mode works well in scenes with an average distribution of light, medium, and dark tones, and it functions well in backlit scenes and for scenes with reflective surfaces such as glass or water.

✦ **Partial metering.** This metering mode hones in on a much smaller area of the scene, or approximately 9 percent of the scene at the center of the viewfinder. By concentrating the meter reading more specifically, this mode gives good exposures for backlit and high-contrast subjects and when the background is much darker than the subject.

✦ **Spot metering.** In this metering mode, the metering concentrates on a small 3.8 percent area at the center of the viewfinder — the circle that's etched in the center of the viewfinder. This mode is great for critical exposures such as retaining highlight detail on a part of a subject's skin, and for metering a middle gray area in the scene or a

photographic gray card to calculate exposure. Spot metering is useful when shooting backlit subjects, and subjects against a dark background.

✦ **Center-weighted Average metering.** This mode weights exposure calculation for the light read at the center of the frame and then evaluates light from the rest of the viewfinder to get an average for the entire scene. The center area encompasses an area larger than the 9 percent Partial metering area. As the name implies, the camera expects that the subject will be in the center of the frame.

As you noticed, Partial, Spot, and Center-weighted Average metering all assume that the subject is at the center of the viewfinder. Thus to meter with these modes, you have to move the camera so that the center AF point is over the area you want to meter, such as a middle gray photographic card or tonal value in the scene, and then use AE Lock (described later) to lock the exposure. This next series of images illustrates the results of using different metering modes.

3.11 This is Evaluative metering. Exposure: ISO 100, f/8, 1/5 second.

3.12 This is Partial metering. Exposure: ISO 100, f/8, 1/6 second.

3.13 This is Spot metering. Exposure: ISO 100, f/8, 1/6 second.

3.14 This is Center-weighted average metering. Exposure: ISO 100, f/8, 1/5 second.

Calculating Scene Contrast

Spot metering can also be used when in high-contrast scenes to determine the best exposure. While keeping the aperture or the shutter speed constant, you can take a meter reading on a highlight area where you want to retain detail, and then take a Spot-meter reading on a shadow area. The difference between the readings is the range of contrast in the scene. Then calculate the average of the two readings to get an exposure. You can then check your calculation against a separate meter reading from a gray card and determine if a compromise between the two is needed if the two values are significantly different.

Evaluating exposures

After you make an exposure, the next task is to evaluate the exposure. The EOS 50D offers both luminance and color histograms to help you gauge exposure.

If you're new to digital photography, a brief look at histograms is helpful. A histogram is a bar graph that shows the distribution and number of pixels captured at each brightness level. The horizontal axis shows the range of values and the vertical axis displays the number of pixels at each location. The 50D offers two types of histograms, a Brightness, or luminance, histogram and an RGB histogram showing individual red, green, and blue color channels.

Brightness histogram

The Brightness histogram is a snapshot of the exposure bias and the overall tonal distribution within the image. The brightness values are shown along the horizontal axis of the Brightness histogram. Values range from black (level 0 on the left side of the histogram) to white (255 on the right side of the graph). Although the 50D captures 14-bit RAW image, the image preview and histogram are based on an 8-bit JPEG rendering of the RAW file.

This histogram quickly shows you whether the image has blown highlights — highlights that go completely white with no image detail — and/or blocked shadows — shadow areas that go completely black with no detail. Blown highlights are indicated by a spike of pixels against the right side of the histogram. Blocked shadows are indicated by a spike of pixels against the left side of the histogram. Likewise, overall underexposure is shown when there is a gap between the highlight pixels and the left side of the

graph, and a crowding of pixels toward the left of the graph. Overexposure is indicated by a gap between the shadow pixels and the left side of the graph and a crowding of pixels toward the right side of the graph. If any of these exposure problems are indicated, you can reshoot using an exposure modification technique described later in this section.

> **Tip** *A quick way to check for blown highlights is to turn on Highlight alert. This shows overexposed areas as blinking areas on the image preview when you play back images. To turn on Highlight alert, press the Menu button, and then turn the Main dial to highlight the Playback 2 menu. Turn the Quick Control dial to select Highlight alert, and then press the Set button. Turn the Quick Control dial to highlight Enable, and then press the Set button.*

In a scene with predominately light tones, pixels shift toward the right side of the histogram. And in scenes with predominately dark tones, pixels shift toward the left side of the graph. However, in an average scene with a good exposure, the highlight pixels just touch the right side of the graph and the shadow pixels just touch the left side, and the remaining pixels are distributed fairly evenly across the graph.

RGB histogram

RGB histograms are separate histograms that show the distribution of brightness levels for the red, green, and blue color channels. Each color channel is shown separately so that you can evaluate the color channel's saturation, gradation, and bias. As with the Brightness histogram, the horizontal axis shows how many pixels exist for each color brightness level and the vertical axis shows how many pixels exist at that level.

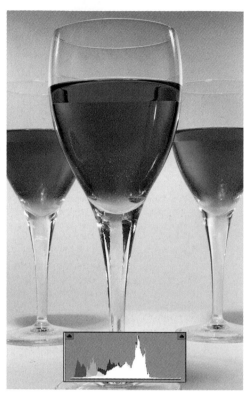

3.15 The histogram for this image shows an excellent exposure with detail in the highlights and open shadows. The low level of highlight pixels on the right side of the histogram reflects the white seamless background. Exposure: ISO 100, f/22, 1.3 seconds.

More pixels to the left indicate that the color is darker and less prominent, while more pixels to the right indicate that the color is brighter and denser. If pixels spike on the left or right side, then color information is either lacking or oversaturated with no detail, respectively. The histograms enable you to review the color's saturation, gradation, and the White Balance inclination.

The histograms are especially accurate for evaluating JPEG images because the histograms are based on the JPEG image. However, if you shoot RAW or sRAW, the histogram is based on the less robust JPEG image because the linear nature of RAW capture doesn't make it feasible to display a histogram of the image data. So if you shoot RAW, just know that the RAW image is richer than the data you see on the histogram. Despite the JPEG rendering, the histogram is still an invaluable tool for evaluating exposure in the field. In fact, you can set the Picture Style setting to a lower contrast to get a better overall sense of the RAW histogram.

Tip *To learn more about the nature of linear capture, Adobe's Web site features an excellent article by the late Bruce Fraser at www.adobe. com/products/photoshop/pdfs/ linear_gamma.pdf.*

Depending on your needs, you can choose to display only the Brightness histogram during image playback, or you can display the RGB and Brightness histograms simultaneously to get a complete view of the tonal and color distribution in the image.

To display a histogram, press the Playback button, and then press Info button one or more times until the Brightness or the Brightness and the RGB histograms are displayed beside the image preview.

You can also set the type of histogram that's displayed by default when you review images during playback, and if you like to see all of the histograms, this can save you a couple of presses of the Info button to change displays.

Differences in JPEG and RAW Exposure

When you shoot JPEG images, it's important to expose to ensure that highlight detail is retained. Just as you can't recover detail that isn't captured on a film exposure, you can't recover highlight detail that isn't recorded in a JPEG exposure. To ensure that images retain highlight detail, you can use exposure modification techniques such as Auto Exposure Lock or Exposure Compensation, which are detailed later in this chapter.

However, for RAW exposure, the goal is to ensure that you capture the first full f-stop of image data. CMOS sensors are linear devices in which each f-stop records half the light of the previous f-stop. The lion's share of image data is recorded in the first f-stop of light. In fact, the first f-stop contains fully half of the total image data. Thus it is very important to capture the first f-stop and to avoid underexposure that sacrifices image data. With RAW capture, exposure should be biased toward the right of the histogram.

This results in a histogram that has highlight pixels just touching, but not crowded against the right edge of the histogram. With a right-biased exposure, the image preview on the LCD may look a little light, but you will adjust the image rendering during conversion — with the assurance that you've captured all of the image data the 50D image sensor can deliver.

In addition, you have more latitude with RAW images because slight overexposures can be recovered during image conversion in Canon's Digital Photo Professional, Adobe Camera Raw, or another conversion program. That means that you can recover some or all of the image detail in blown highlights that would be lost in an image. The amount of recovery varies by image and by conversion program.

To change the default histogram display, follow these steps:

1. **Press the Menu button, and turn the Main dial to highlight the Playback 2 tab.**

2. **Turn the Quick Control dial to highlight Histogram, and then press the Set button.** The Brightness and RGB options appear.

3. **Turn the Quick Control dial to highlight the option you want, and then press the Set button.**

Modifying and bracketing exposures

With the ability to immediately review not only the image appearance, but also the image histogram, you know immediately whether the original exposure is on the money or whether you need to modify the exposure to prevent blown highlights or to open the shadows.

The 50D has both automatic and traditional options to modify exposure including Auto Lighting Optimizer, Highlight tone priority, Auto Exposure Lock, Auto Exposure Bracketing, and Exposure Compensation. These options are detailed in the following sections.

Auto Lighting Optimizer

One of the 50D's automatic exposure adjustments is Auto Lighting Optimizer that brightens images that are too dark and/or that have low contrast. Auto Lighting Optimizer is applied by default to all JPEG images that you shoot in all shooting modes. You can turn it off for images you shoot in P, Tv, Av, and A-DEP modes. The optimization isn't applied to RAW or sRAW images. In addition, you can change the level of optimization or turn it off entirely.

If you most often print images directly from the CF card, then Auto Lighting Optimizer can help get better prints. However, if you prefer to control exposure, then Auto Lighting Optimizer can mask the effects of exposure modifications including Exposure Compensation, Auto Exposure Bracketing (AEB), and Auto Exposure Lock.

You can use C.Fn II-4 to adjust the level of the optimization from the default standard setting to low or strong, or you can turn off optimization entirely for images shot in P, Tv, Av, M, and A-DEP modes. In Basic Zone modes such as CA, Full Auto, Portrait, and Landscape, and so on, Auto Lighting Optimizer is automatically applied at the Standard setting to JPEG images, and you cannot change it.

To change the level used for Auto Lighting Optimizer, or to turn it off, follow these steps:

1. **Press the Menu button, and then turn the Main dial to highlight the Custom Functions menu.**

2. **Turn the Quick Control dial to highlight C.Fn II: Image, and then press the Set button.** The last Custom Function screen you accessed is displayed.

3. **Turn the Quick Control dial until the number 4 appears in the control box at the top right of the screen, and then press the Set button.** The Custom Function 4, Auto Lighting Optimizer is displayed, and the active option is highlighted.

4. **Turn the Quick Control dial to highlight the option you want, and then press the Set button.** The change remains in effect for shooting JPEG images in P, Tv, Av, M, and A-DEP modes. For JPEG images shot in Basic Zone modes such as CA, Full Auto, Portrait, and so on, Auto Lighting Optimizer remains in effect at the Standard level.

Highlight Tone Priority

The category of exposure modification includes Canon's Highlight Tone Priority, a Custom Function that's designed to improve and maintain highlight detail in bright elements in the scene. When you enable this Custom Function, highlight detail is improved by extending the range between 18 percent middle gray to the maximum highlight tones in the image, effectively increasing the dynamic range. Using Highlight Tone Priority provides better gradation between middle gray and the brightest highlight. This option is especially useful when shooting very light objects such as a wedding dress or white tuxedo, bright white sand on a beach, or product shots of light-colored products, for example. If you enable Highlight Tone Priority, the lowest ISO changes from 100 to 200.

Highlight Tone Priority takes advantage of the higher ISO baseline so that the image sensor pixel wells do not fill, or saturate. Also with the 50D's 14-bit analog/digital conversion, the camera sets a tonal curve that is relatively flat at the top in the highlight area to compress highlight data. The result is almost a full f-stop increase in dynamic range (the range of highlight to shadow tones in a scene as measured in f-stops). The tradeoff, however, is a more abrupt move from deep shadows to black — a reduced range of shadow tones and the potential for increased shadow noise.

If you enable Highlight Tone Priority, it is denoted in the viewfinder and on the LCD panel as D+ with the D indicating Dynamic range.

Highlight Tone Priority is disabled by default. To enable it, follow the steps in the previous section, but in step 3, highlight C.Fn II-3, Highlight Tone Priority.

Safety Shift

Safety Shift falls into the category of automatic exposure modifications. Although this function is turned off by default, you can enable Safety Shift so that the camera automatically changes the exposure settings if the light changes dramatically enough to make your current exposure setting in Av or Tv shooting modes inaccurate.

Like Auto Lighting Optimizer, Safety Shift is another of Canon's "goof-proof" functions. Safety Shift may be annoying to photographers who have carefully set up the depth of field and/or shutter speed they want for a shot, so that having the camera change the exposure settings seems intrusive.

But there is virtue in this function in some shooting scenarios such as in action shooting. Sports and action shooting requires the photographer's single-minded concentration on capturing the peak moments, and having the 50D automatically shift the exposure if a break in the clouds suddenly sheds more light on the athlete can be welcome assistance. The photographer can continue concentrating on the action and composition with the assurance that the exposure will be correct. Safety Shift can be equally useful for shooting actors and musicians on a stage.

It's up to you whether to use Safety Shift. If you want to enable it, follow these steps:

1. **Set the Mode dial to P, Tv, Av, or A-DEP shooting mode, press the Menu button, and then turn the Main dial to highlight the Custom Functions menu tab.**

2. **Turn the Quick Control dial to highlight C.Fn I: Exposure, and then press the Set button.** The last accessed Custom Function screen appears.

3. **Turn the Quick Control dial until the number 6 appears in the Custom Function number control on the upper right of the screen.** The C.Fn I: Exposure Safety shift screen appears with two options.

4. **Press the Set button, and then turn the Quick Control dial to highlight the option you want, either Disable or Enable.**

5. **Press the Set button.** The option you select remains in effect until you change it. Safety Shift is used only when you're shooting in Tv and Av shooting modes.

Auto Exposure Lock

The workhorse in the stable of exposure modification options is Auto Exposure Lock, or AE Lock. With AE Lock, you can meter on one area in the scene and focus on a different area.

In Evaluative metering mode, the area of active focus, the active AF point or points, is not only where the camera sets focus, but it is also where the camera weights the light metering to calculate the exposure. In Partial, Spot, and Center-weighted Average metering modes, the camera uses the center area of the viewfinder for metering. With Evaluative metering, the focus and meter weighting works well if the active AF point or points is where you want to meter. In many scenes, this isn't the case.

For example, if you want to meter on a middle tone area in the scene, but you want to focus on an object in another area of the scene, then you need a way to set and retain the metered settings while you focus on the other area. AE Lock enables you to meter and focus on two different points when you using Evaluative metering.

While AE Lock is broadly useful, there are some limitations outlined in Table 3.1. In addition, AE Lock cannot be used in Basic Zone modes such as CA, Portrait, Landscape, and so on.

3.16 With the strong backlighting, this scene was an exposure challenge. To retain the detail in the bright backlit leaves, I used Evaluative metering and then metered on a midtone area near the side building, locking the exposure with AE Lock. I brought up the resulting dark areas of the image during editing. Exposure: ISO 100, f/9, 1/80 second.

Table 3.1
Using AE Lock

Shooting Modes	Metering Mode(s)	Using Autofocus with these AF-Point Selection Methods		Using Manual Focus
		Manual AF-point selection	**Automatic AF-point selection**	
P, Tv, Av (note that *A-DEP mode uses only automatic AF-point selection*)	**Evaluative**	AE Lock is set at the selected AF point	AE Lock is set at the AF point or points that achieved focus	AE Lock is set at the center AF point
	Partial, Spot, Center-weighted Averaging	AE Lock is set at the center AF point.		
M, and Basic Zone modes	AE Lock cannot be used			

Here is how to use AE Lock. These steps assume that you are using Evaluative metering, Av or Tv mode, autofocus, and that you select the AF point manually.

1. **Select the AF point, move the camera so the AF point is over the part of the subject or scene that you want to meter such as a middle-tone area, and then press the Shutter button halfway.** For example, if you're metering a photographic gray card or a midtone area in the scene, point the camera so that the active AF point is over the card or midtone area.

2. **Continue to hold the Shutter button halfway down as you press the AE Lock button on the back right side of the camera.** The AE Lock button has an asterisk above it. When you press the AE Lock button, an asterisk appears on the far lower left of the viewfinder indicating that the exposure is locked.

3. **Continue holding the AE Lock button, release the Shutter button, and then move the camera to compose the image.**

4. **Press the Shutter button halfway down to focus, and then make the picture.** As long as the asterisk appears in the viewfinder, you can take additional images using the locked exposure.

Exposure Compensation

Another way to modify the camera's metered exposure is by increasing or decreasing the exposure by a specific amount. Using Exposure Compensation, you can set the compensation up to +/- 2 stops in 1/3-stop increments.

> **Tip** *You can change the increments used from 1/3 stop to 1/2 stop by setting C.Fn I-1 to Option 1.*

A classic use of Exposure Compensation is to render whites and blacks as truly white and black. In scenes with large expanses of

white or dark tones, the camera's onboard meter averages the tones to 18 percent gray so that both white and black objects appear middle gray. You can override the camera meter's averaging using Exposure Compensation. For example, for a snow scene, a +1 or +2 stop of compensation will render snow as white. For a jet-black train engine, a -1- or -2-stop compensation renders it as true black.

Exposure Compensation is also useful any time that you want to modify the metered exposure or one or a series of shots. For example, for a portrait of an older woman, a slight overexposure helps minimize facial wrinkles. Or if you find that the camera consistently overexposes or underexposes images in all images or in specific scenes, you can use Exposure Compensation to compensate. However, if overexposure or underexposure becomes a consistent problem in all scenes, it's a good idea to have the camera checked by Canon.

Here are some points to know about Exposure Compensation:

✦ Exposure Compensation can be used in P, Tv, Av, and A-DEP modes, but it cannot be used in Manual mode or during bulb exposures.

✦ In Tv mode, setting Exposure Compensation changes the aperture by the specified amount of compensation. In Av mode, it changes the shutter speed. In P mode, compensation changes both the shutter speed and aperture by the exposure amount you set.

3.17 This scene was challenging for the range from highlights to shadows. To help retain detail in the water highlights, I set a -1 2/3 Exposure Compensation. Exposure: ISO 100, f/16, 1/80 second.

✦ The amount of Exposure Compensation you set remains in effect until you change it regardless of whether you turn the camera off, change the lens, or replace the battery.

✦ Exposure Compensation is set by turning the Quick Control dial, and, as a result, it's easy to inadvertently set or change compensation. To avoid this, you can set the power switch to the On position instead of to the topmost position. This disables use of the Quick Control dial for making Exposure Compensation changes, but the dial continues to function when working with the camera Menus and making changes on the LCD panel. And if you want to set Exposure Compensation, you can set it on the Shooting 2 menu.

You can set Exposure Compensation by following these steps:

1. **Set the camera's power switch to the topmost position, and set the camera to P, Tv, Av, or A-DEP mode.**

2. **Press and hold the Shutter button halfway down, and watch in the viewfinder or on the LCD panel as you turn the Quick Control dial to the left to set negative compensation or to the right to set positive compensation.** As you turn the Quick Control dial, the tick mark on the Exposure Level meter moves in 1/3-stop increments up to plus/minus 2 stops.

Tip *You can change the increments used for Exposure Compensation and Auto Exposure Bracketing as well as for aperture and shutter speed changes from the default 1/3-stop to 1/2-stop by setting Option 1 for C.Fn I-1.*

To cancel Exposure Compensation, repeat these steps but move the tick mark back to the center position of the Exposure Level meter.

Auto Exposure Bracketing

While not directly modifying the camera's metered exposure, Auto Exposure Bracketing (AEB) fits in the category of exposure modification because it enables you to capture a series of three images at different exposures: one at the camera's standard metered exposure, one 1/3-stop above the standard exposure, and one at 1/3-stop below the standard exposure up to +/- 2 stops. Thus, if the scene has high contrast, highlight detail may be better preserved in the darker exposure than in either the standard or lighter exposures. Conversely, the shadows may be more open in the brighter exposure than in either of the other two.

The 50D adds a new level of flexibility to AEB by allowing you to shift the entire metering range to below or above the zero on the Exposure Level meter. As a result, you can set all three bracketed exposures for negative or positive exposures, or set bracketing for -2, -1, and the standard exposure with no compensation, or a series with -3, -2, and -1. And you can go up to 4 stops darker or brighter than the camera's ideal exposure. Thus you can set up bracketing to get only negative bracketed exposures in addition to the standard exposure.

Exposure bracketing provides a way to cover the bases — to get at least one printable exposure in scenes with challenging lighting, for scenes that are difficult to set up again, and in scenes where there was only one opportunity to capture an elusive subject. But today, exposure bracketing is very often used for high-dynamic range imaging.

High-dynamic range imaging (HDR) captures bracketed frames of the same scene with one exposure set for the highlights, one for the midtones, and one for shadow detail. In some cases, five to seven bracketed frames are made to merge into the final composite image. The images are bracketed by shutter speed rather than by aperture to avoid shifts in focal-length rendering. The final images are composited in Photoshop or another HDR program to create a single 32-bit image that has a dynamic range far beyond what the camera can capture in a single frame.

Additionally, a popular use of bracketing that is less involved than HDR imaging is to simply composite the best areas of the three bracketed exposures in an image-editing program.

Regardless how you use the bracketed exposures, here are some points to keep in mind when using AEB:

✦ AEB is only available in P, Tv, Av, and A-DEP shooting modes.

✦ AEB cannot be used with the built-in or any accessory flash unit.

✦ AEB settings are good only for the current shooting session. If you turn off the camera, attach a flash or pop up the built-in flash, then AEB is cancelled. If you want to retain the AEB settings even after turning off the camera, you can set C.Fn I-4: Bracketing auto cancel to Option 1 to retain the settings.

✦ In Continuous drive mode, pressing the Shutter button once takes all three bracketed exposures. Likewise, in 10- or 2-second Self-timer modes, the bracketed shots are taken in succession after the timer interval elapses.

✦ In One-Shot drive mode, you must press the Shutter button three separate times to get the bracketed sequence.

✦ The order of bracketed exposures begins with the standard exposure, followed by the decreased and increased exposures. You can change the order of bracketing using C.Fn I-5: Exposure Bracketing sequence.

✦ You can change the default 1/3-stop exposure increment to 1/2 stop using C.Fn I-1: Exposure level increments.

To set AEB, follow these steps.

1. **With the camera in P, Tv, Av, or A-DEP shooting mode, press the Menu button, and then turn the Main dial to highlight the Shooting 2 tab.**

2. **Turn the Quick Control dial to highlight Expo. comp./AEB, and then press the Set button.** The Exposure comp./AEB setting screen appears.

3. **Turn the Main dial clockwise to set the exposure difference you want. If you want to shift the bracketing sequence above or below zero, turn the Quick Control dial, and then press the Set button.** As you turn the Main dial, two additional tick marks appear and move outward from the center to show the exposure amount in 1/3 stops.

Using Autofocus

Whether you're shooting one image at a time, or you're blasting out the maximum burst of images as players move across a soccer field, the 50D's quick focus can keep up with you and provide tack-sharp focus. The 50D offers three autofocus modes suited to different types of shooting. In addition, the camera enables you to manually choose any of the nine AF points, or you can have the camera choose the AF points for you.

In addition, Canon's high-precision AF points are suited for use with fast lenses. The nine AF points are sensitive to vertical and horizontal line detection, which is critical to achieving sharp, accurate, fast focus. These cross-type AF points are sensitive at f/5.6 or better, and the center AF point has the added advantage of even better performance when using lenses as fast as f/2.8. Thus, horizontal and vertical line detection is enhanced, as is the ability to focus on hard-to-focus subjects even in dim light.

The following sections will help you get the best performance from the 50D's autofocus system.

Choosing an autofocus mode

The 50D's three autofocus modes are designed to help you achieve sharp focus based on the type of subject you're photographing. Here is a brief summary of the autofocus modes and when to use them. In any of these modes, you can manually select an AF point or have the camera automatically select the AF point(s).

✦ **One-shot AF.** This mode is designed for photographing stationary subjects that are still and will remain still. Choose this mode when you're shooting still subjects including landscapes, macro, portraits, architecture, and interiors. Unless you're shooting sports or action, One-shot AF is the mode of choice for everyday shooting. In this autofocus mode, the camera won't allow you to make the image until the camera has achieved focus.

✦ **AI Servo AF.** This mode is designed for photographing action subjects. Focus is tracked regardless of changes in focusing distance from side to side or approaching or moving away from the camera. The camera sets both the focus and the exposure at the moment the image is made. In this mode, you can press the Shutter button completely even if the focus hasn't been confirmed. You can use a manually selected AF point in this mode although it may not be the AF point that achieves final sharp focus. Or if you use automatic AF selection, the camera starts focus using the center AF point and tracks movement as long as the subject remains within the other eight AF points in the viewfinder. In Creative Zone shooting modes, you can also press the AF-ON button to focus.

✦ **AI Focus AF.** This mode is designed for photographing stationary subjects that may begin moving. This mode starts out in One-shot AF mode, but then it automatically

switches to AI Servo AF (described below) if the subject begins moving. Then the camera tracks focus on the moving subject. When the switch happens, a soft beep alerts you that the camera is shifting to AI Servo AF, and the focus confirmation light in the viewfinder is no longer lit. (The beeper beeps only if you have turned on the beeper on the Shooting 1 menu.) This is the mode to choose when you shoot wildlife, children, or athletes who alternate between stationery positions and motion. In this mode, focus tracking is activated by pressing the Shutter button halfway.

Tip *If you routinely set focus and then keep the Shutter button pressed halfway, you should know that this shortens battery life. To maximize power, anticipate the shot and press the Shutter button halfway just before making the picture.*

While Drive modes and Autofocus modes are set independently — in other words, you can set any Drive mode/Autofocus mode combination — the way the camera performs in any given combination varies. (Drive modes, detailed later in this chapter, determine how many shots you take when you press the Shutter button.)

Table 3.2 shows how autofocus and drive modes behave when used in combination.

Here is how to select an Autofocus mode.

1. **Set the lens switch to AF, and set the camera to P, Tv, Av, M, or A-DEP.**

2. **Press the AF-Drive button above the LCD panel, and then turn the Main dial to select the autofocus mode you want.** Each mode is represented by text displayed to the side of the LCD panel. The selected autofocus mode remains in effect until you change it.

Does Focus-Lock and Recompose work?

A popular focusing technique is focus-lock and recompose, a method used with point-and-shoot cameras. With this technique, you lock focus on the subject by pressing and holding the Shutter button halfway down, and then you move the camera to recompose the shot. However, in my experience, the focus shifts slightly during the recompose step, and, as a result, focus is not tack sharp.

In addition, at distances within 15 feet of the camera and when shooting with large apertures, the focus-lock-and-recompose technique increases the chances of back-focusing. Back-focusing is when the camera focuses on an element that is behind where you set the focus.

For these reasons, I do not recommend using focus-lock-and-recompose. The disadvantage of not using the focus-lock-and-recompose technique is that you're restricted to composing images using the nine AF points in the viewfinder. The placement of the nine AF points isn't the most flexible arrangement for composing some images. But if you want tack-sharp focus, then manually select one AF point, focus on the subject, do not move the camera to recompose, and make the picture.

Table 3.2
Autofocus and Drive Modes

Drive Mode	Focus Mode		
	One-Shot AF	AI Focus AF	AI Servo AF
One-shot shooting	In One-shot AF mode, the camera must confirm accurate focus before you can take the picture. The exposure is also locked at the selected AF point.	Begins in One-shot mode, but if the subject moves, it automatically switches to AI Servo AF to track and maintain focus on the subject. In Continuous mode, focus continues through the burst. The burst rate depends on the nature of subject movement and the lens you're using. When you focus on the subject, the beeper sounds softly, and the focus confirmation light is not displayed in the viewfinder.	You focus on the subject and the camera maintains focus during subject movement. The exposure and focus are set at the moment the image is captured. When you focus on the subject, the beeper does not beep, and the focus confirmation light is not displayed in the viewfinder.
Continuous shooting	Same as above during continuous shooting. In continuous shooting, focusing is not executed when shooting in Low-speed or High-speed Continuous shooting.		Same as above with autofocus continuing during Continuous shooting at the maximum of 6.3 fps during High-speed Continuous shooting. The burst rate depends on the nature of subject movement and the lens you're using.

Choosing an autofocus point

You can have an image with technically perfect exposure, a compelling subject, and stunning lighting, but if the focus isn't tack sharp, and if the sharpest focus is in the wrong place, then the image belongs in the reject pile. In short, if it's not sharp, it's not a keeper. Thus it's important to learn all you can about using the 50D's autofocus system.

The active AF point that you or the camera chooses, determines where the point of sharpest focus is in the image. In P, Tv, Av, and M shooting modes, you can manually select any one of the nine AF points displayed in the viewfinder, or you can have the camera automatically select one or more AF points for you.

3.18 I used Automatic AF-point selection with the camera set the point of sharpest focus on the bridge of the mannequin's nose. Exposure: ISO 100, f/16, 1/80 second.

3.19 I manually selected the AF point that was over the mannequin's left eye, creating a marked difference in sharpness from 3.18. Manually select the AF point as often as is practicable. Exposure: ISO 100, f/16, 1/80 second.

 Note *In A-DEP mode, the camera automatically selects the AF points to provide the optimal depth of field, and you cannot manually select an AF point.*

One option is to manually select an AF point. Using this method, you control the specific AF point that's used to establish sharp focus, and you can place the point of sharpest focus precisely where it should be in the image. From years of personal experience, I know that manual AF-point selection is the single best way to get tack-sharp focus precisely where I want it to be in the image. Manually selecting an AF point takes a little more time than having the camera automatically select the AF point, but with a little

practice, you can quickly switch among the nine AF points.

Tip *You can choose how to select the AF point using C.Fn III-3. For example, you can choose to use only the Quick Control dial or the Multi-controller to select an AF point, which speeds up AF point selection.*

Alternately, you can let the camera automatically select the AF point or points so that the camera identifies the subject and where the point of sharpest focus should be. The camera selects the AF points by detecting the objects in the scene that are closest to the lens and/or the areas that have the highest

readable contrast. Sometimes the camera gets the focus right, and other times it doesn't. For example, if you're shooting a portrait, the camera typically selects the AF point over the subject's nose or mouth rather than on the subject's eyes. In a portrait, of course, the subject's eyes should be the point of sharpest focus. Despite some misses, the advantage of automatic AF-point selection is the ability to shoot quickly.

Improving Autofocus Accuracy and Performance

Autofocus speed depends on factors including the size and design of the lens, the speed of the lens-focusing motor, the speed of the autofocus sensor in the camera, the amount of light in the scene, and the level of subject contrast. Given these variables, here are some tips for getting the best autofocus performance and focus.

✦ **Light.** In lowlight scenes, the autofocus performance depends in part on the lens speed and design. In general, the faster the lens, the faster the autofocus performance. Provided that there is enough light for the lens to focus without an AF-assist beam, then lenses with a rear-focus optical design, such as the EF 85mm f/1.8 USM, focus faster than lenses that move their entire optical system, such as the EF 85mm f/1.2L II USM. Regardless of the lens, the lower the light, the longer it takes for the system to focus.

Low-contrast subjects and/or subjects in low light slow down focusing speed and can cause autofocus failure. With a passive autofocus system, autofocusing depends on the sensitivity of the AF sensor. Autofocusing performance is always faster in bright light than in low light, and this is true in both One-shot and AI Servo AF modes. In low light, consider using the built-in flash or an accessory EX Speedlite's AF-assist beam as a focusing aid using C.Fn III-5.

✦ **Focal length.** The longer the lens, the longer the time to focus because the range of defocus is greater on telephoto lenses than on normal or wide-angle lenses. You can improve the focus time by manually setting the lens in the general focusing range, and then using autofocus to set the sharp focus.

✦ **AF-point selection.** Manually selecting one AF point provides faster autofocus performance than using automatic AF-point selection because the camera doesn't have to determine and select the AF point(s) to use first.

✦ **Subject Contrast.** Focusing on low-contrast subjects is slower than on high-contrast subjects. If the camera can't focus, shift the camera position to an area of the subject that has higher contrast.

✦ **EF Extenders.** EF Extenders reduce the speed of the lens-focusing drive.

✦ **Wide-angle lenses and small apertures.** Sharpness can be degraded by diffraction when you use small apertures with wide-angle or wide-angle zoom lenses. Diffraction happens when light waves pass around the edges of an object and enter the shadow area of the subject producing softening of fine detail. To avoid diffraction, avoid using apertures smaller than f/16 with wide-angle prime (single-focal length) and zoom lenses.

Note *With Evaluative metering, the active AF point is also the point where the camera biases metering to calculate the exposure. Be sure to read the details on using AE Lock earlier in this chapter if you want the metering biased on an area different from where you're focusing.*

To manually select an AF point or to choose automatic AF, follow these steps:

1. **Set the camera to P, Tv, Av, or M shooting mode, and then press the Shutter button halfway.** The currently selected AF point or points light in red in the viewfinder and are displayed on the LCD panel.

2. **Press the AF-point Selection/ Enlarge button on the back top right side of the camera.** The selected AF point lights in red in the viewfinder and is displayed on the LCD panel.

3. **Turn the Main dial until the AF point you want is lit in red, or, to have the camera automatically select the AF point or points, turn the Main dial until all the AF points are lit in red.** Alternately, you can turn the Quick Control dial or tilt the Multi-controller to select the AF point. If you're using the Multi-controller, you can also press the controller in the center to select the center AF point.

4. **Press the Shutter button halfway to focus using the selected AF point or to have the camera select the AF point(s), and then press the Shutter button completely to make the picture.** The camera beeps when accurate focus is achieved and the autofocus light in the viewfinder remains lit continuously. If you don't hear the beep or see the autofocus light, focus on a higher-contrast area.

Tip *If the camera has trouble establishing focus in low light, you can use the camera's built-in flash's focus-assist beam to help establish focus in One-shot AF and AI Focus AF autofocus modes. Just set C.Fn III-5 to Option 0: Enable. On the Setup 3 menu, select Flash control, and then set Flash firing to Disable. Then pop up the built-in flash, focus, and the focus-assist beam fires to help the camera focus, but the built-in flash does not fire.*

You can alternately use manual focusing by sliding the switch on the side of the lens to MF position. Alternately, you can combine autofocus with manual focus using Canon's full-time manual focusing function. With the lens switch set to AF, press the Shutter button halfway to focus as usual, and then you can tweak the focus by turning the focus ring on the lens.

Tip *To verify image sharpness, press the Playback button, and then press and hold the AF-point Selection/ Enlarge button on the back of the camera. The image zooms from 1.5x to 10x on the LCD monitor. To move around the image, tilt the Multi-controller in the direction you want to scroll. To check other images, turn the Quick Control dial to move through images at the current zoom level.*

Interchangeable Focusing Screens

The 50D supports three focusing screens. Depending on your lenses and preference for automatic or manual focusing, swapping out the focusing screen can make focusing clearer and brighter. Alternately, you can opt for a focusing screen with a grid that helps you square up lines during composition. The Standard Precision Matte screen comes installed on the camera, but you have two additional screen options that, as of this writing, cost approximately $35 each.

The three focusing screens supported on the 50D are as follows:

✦ **Ef-A: Standard Precision Matte.** This focusing screen comes installed in the 50D. It offers good viewfinder brightness, accurate manual focusing, and it is optimized for use with EF f/5.6 and slower lenses.

✦ **Ef-D: Precision Matte with grid.** If you shoot architecture, interiors or just want help squaring up vertical and horizontal lines in the frame, the matte screen with a grid helps you do this. This screen features a grid to help you align horizontal and vertical lines. The grid is superimposed over the nine AF points in the viewfinder. This screen offers good viewfinder brightness and is optimized for use with EF f/5.6 or slower lenses.

✦ **Ef-S: Super Precision Matte.** This screen is optimized for manual focusing with f/2.8 or faster lenses. It offers finer microlenses than the other two screens, and it has a steeper parabola of focus to bring the image in and out of focus more vividly in the viewfinder — a benefit with very fast lenses such as the EF 85mm f/1.2 II. Because this screen is darker than the other two screens, it is not recommended for use with lenses slower than f/2.8 or when using an extender on the lens.

If you change focusing screens, you also have to specify the screen you're using by setting C.Fn IV-5 to the proper option. The Ef-A screen is installed and set in C.Fn IV-5 as Option: 0. To set the camera for the Ef-D screen, set the option to 1. For the Ef-S screen, set the option to 2. For details on setting Custom Functions, see Chapter 5.

Selecting a Drive Mode

One of the compelling aspects of the 50D is its speed. For example, with Continuous drive mode shooting at 6.3 frames per second (fps), you can capture 60-90 JPEG images in a burst depending on the type of CF card you use. Or you can opt for a slower speed at 3 fps. Regardless, the EOS 50D offers ample opportunity for capturing action shots depending on the drive mode you choose: Single, Continuous Shooting, or two Self-timer modes. You can choose among the drive modes when you're shooting in P, Tv, Av, M, or A-DEP shooting mode.

Note *In Basic Zone modes, the camera automatically chooses the drive mode, but you can optionally choose the 10-second Self-timer mode.*

Here is a summary of each mode:

✦ **Single Shooting.** In this mode, one image is captured with each press of the Shutter button. This is a good choice for still subjects and any other unhurried shooting scenarios.

✦ **High-speed Continuous.** In this mode, you can keep the Shutter button depressed to capture approximately 60 Large/Fine JPEGs with a standard CF card or 90 JPEGs with a UDMA CF card, 16 RAW images, or 11 RAW + JPEG (Large/Fine) images. The actual number of frames in a burst depends on the shutter speed, Picture Style, ISO speed, and the brand and type of CF card.

✦ **Low-speed Continuous.** This mode also delivers a maximum of 3 fps when you keep the Shutter button completely depressed.

✦ **Self-timer modes (10- and 2-second).** In Self-timer modes, the camera delays making the picture for 2 or 10 seconds after the Shutter is fully depressed. In 10-second mode, the Self-timer lamp on the front of the camera blinks and, if the beep is turned on, a beep is emitted for 8 seconds, and then the speed of the beep increases for the final 2 seconds before the shutter releases. The camera displays the countdown to firing on the LCD panel as well. The 10-second mode is effective when you want to include yourself in a picture. In addition, you can choose a 2-second Self-timer mode. The 2-second mode is useful in nature, landscape, and close-up shooting, and can be combined with mirror lockup (C.Fn III-6) to prevent any vibration from the reflex mirror action and from pressing the Shutter button. You have to press the Shutter button once to lock the mirror, and again to make the exposure.

Tip *If you do not have the camera to your eye during Self-timer modes, slip the eyepiece cover over the viewfinder to prevent stray light from entering the viewfinder that can alter the exposure.*

Canon uses smart buffering to deliver large bursts of images. The images are first delivered to the camera's internal buffer. Then the camera immediately begins writing and offloading images to the CF card. The time required to empty the buffer depends on the speed of the card, the complexity of the image, and the ISO setting. JPEG images that have a lot of fine detail and digital noise tend to take more time to compress than images with less detail and low-frequency content.

Thanks to smart buffering, you can continue shooting in one, two, or three-image bursts almost immediately after the buffer is filled and offloading begins and frees up buffer space. In Continuous shooting mode, the viewfinder displays a Busy message when the buffer is full and the number of remaining images shown on the LCD panel blinks.

You can press the Shutter button halfway and look at the bottom right of the viewfinder to see the current number of available shots in the maximum burst.

The 50D is set to Single-shot drive mode by default in P, Tv, Av, M and A-DEP shooting modes. In automatic shooting modes such as Portrait and Landscape, the camera automatically sets the Drive mode, and you can only select the 10-second Drive mode. In CA shooting mode, you can choose One-shot, Low-speed Continuous, or the 10-second Self-timer mode.

To switch to a different drive mode, follow these steps:

1. **Press the AF-Drive button above the LCD panel.** The camera activates Drive mode selection in the LCD panel. In P, Tv, Av, M, and A-DEP shooting modes, all Drive modes are available. In the automatic modes, only the 10-second Self-timer mode is available.

2. **Turn the Quick Control dial to select a Drive mode.** Turning the Quick Control dial clockwise, the mode sequence begins with Single Shooting and sequences through High-speed Continuous, Low-speed continuous, Self-timer 10 sec., and Self-timer 2-sec. The Drive mode remains in effect until you change it. If you need to cancel a Self-timer exposure, press the AF-Drive button above the LCD panel.

Getting Great Color

Not many years ago, the typical gear bag was packed with rolls of color film, each with a single ISO speed, and each balanced for a specific type of light whether daylight or tungsten. And with the film, there were filters to color-correct film in case you weren't shooting in the light that the film was designed for.

That was then. Today, all you need is the EOS 50D. Period. By comparison, there's giddy freedom knowing that whatever the light in the scene, the 50D can handle it and deliver stunning color. That's not to say that stunning color always comes with no effort from the photographer. But with a few adjustments, you can fine-tune color for any scene, regardless of light, and get accurate and visually pleasing color from the EOS 50D.

This chapter explores controlling color on the 50D and how to get excellent color in any shooting situation.

Working with Color

The 50D has three features that affect image color: color space, White Balance, and Picture Style. To set the stage for working with these color controls on the camera, here is a brief conceptual model for thinking about each one and the general effect it has.

✦ In broad terms, a color space determines the breadth of colors that can be captured in images. Some color spaces encompass a lot of colors, and others encompass fewer colors. Choosing a color space also factors into the overall image workflow because it provides a color space that can be used not only for capturing an image but also for editing images and printing images. The Color Space option is one that most photographers set once, and almost never change.

✦ A White Balance setting is what gets the color in an image right. This setting tells the camera what type of light is in the scene so that the camera can, in turn, deliver accurate color. The White Balance setting is one that you change each time the light in the scene changes.

✦ Picture Styles determine whether the image colors are vivid and saturated, or flatter and more subdued. Picture Styles also affect image sharpness and contrast. Picture Styles are a setting that you may change often or not, depending on your preferences.

As you can see, each feature or setting plays a unique role in determining image color. What settings you choose and how you use these controls depends in large part on your preferences for color appearance, or rendering, and how you prefer to work with images such as whether you like to print images directly from the CF card, or you prefer to edit images on the computer before printing them, and which type of printer or lab you use.

Choosing a color space

If you're new to digital photography, then the concept of color spaces may also be new. A color space defines the range of colors, or gamut, that can be reproduced and the way that a device such as a digital camera, a monitor, or a printer reproduces color. In super-simple terms, color spaces are like a bucket of colors, and different color spaces use different size buckets. When an image moves from a large color space to a smaller color space, the device, a computer or printer, for example, must decide which colors to keep and which to alter or throw out to fit the image into the smaller space. If

you're like me, I want to capture and keep all the image data that the 50D can deliver, so hearing the term "throw out" sounds alarm bells. It doesn't make sense to me to buy a high-resolution camera like the EOS 50D and discard image data for any reason.

The way to avoid color space conversions is by keeping the color space consistent when you capture, edit, and print images — simply put, using the same color space on the camera, in your image-editing program, and on the printer. Then there are fewer chances that colors will be lost or altered in color-space conversions.

On the 50D, there are two color space choices: Adobe RGB and sRGB. Adobe RGB is a color space that supports a wider gamut of colors than sRGB. And, as is true with all aspects of image capture, the more data you capture in the camera, the richer and sturdier the image will be. And the more robust the file, the better it can withstand conversion (for RAW files) and image editing.

Now with the 50D, you get 14-bit analog/digital conversion. That translates to color-rich image files that have 16,384 colors per channel when you shoot in RAW capture. (By way of contrast, 8-bit files offer only 256 values per color channel.) And even if you shoot JPEG, which automatically converts 14-bit files to 8-bit files in the camera, the conversion to 8-bit files is better because it is based on the rich 14-bit files.

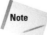 The 50D's 14-bit RAW files can be processed in a conversion program such as Adobe Camera Raw or Lightroom as 16-bit files that offer robust color data, subtle tonal gradations, and a higher dynamic range. Without question, RAW capture delivers the highest-quality files that the 50D can deliver.

To illustrate the difference between color spaces, consider Figures 4.1 and 4.2. They show the effect that changing color space has on the histograms. Also, as I mention in Chapter 3, a spike on the right side of the histogram indicates image data that will be clipped or discarded from the image.

So when would you choose sRGB? Certainly Adobe RGB is a great color space for capturing a rich range of colors, but it isn't the color space that provides the best image color rendering for online use, whether on a Web site or in e-mail. In fact, when you view an image that's in the Adobe RGB color space outside of an image-editing program,

the image colors look dull and flat. For online display, the sRGB color space provides the best color. In addition, some commercial services also require the sRGB color space for printing.

While this may seem like a conflict in color spaces, the solution is simple — capture and edit using the larger Adobe RGB color space, and then make a copy of the image and convert it to sRGB for online use. For example, I use Adobe RGB for capture, editing, and printing. When I need an image for online display, I make a copy of the image and then convert it to sRGB in an editing program such as Adobe Photoshop CS4.

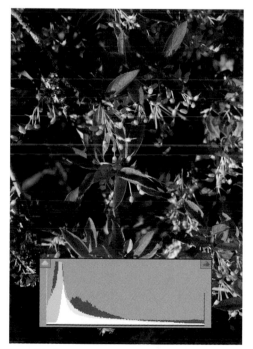

4.1 This is a RAW image with its histogram as displayed in Adobe Camera Raw. Here the image is shown in the Adobe RGB color space. Exposure: ISO 100, f/4.5, 1/60 second.

4.2 This is the same image with the histogram as displayed in Adobe Camera Raw and with the color space set to sRGB.

Here are some things to know about choosing a color space:

✦ You can choose a color space only when you're shooting in P, Tv, Av, M, and A-DEP shooting modes, and the color space is used for JPEG, RAW, and sRAW files.

✦ In automated modes such as CA, Portrait, Landscape, and so on, the 50D automatically sets sRGB for all image files, and you can't change it.

✦ In P, Tv, Av, M, and A-DEP modes, files shot with Adobe RGB are appended with _MG_.

✦ The 50D does not embed the ICC profile in files. ICC is an abbreviation for International Color Consortium, an organization that promotes the use and adoption of open, vendor-neutral, cross-platform color management systems. An ICC profile can be read by monitors and printers that support ICC profiles so that colors are consistent when viewed and printed on different devices. While the 50D doesn't embed the ICC profile, you can embed the ICC profile in Adobe Photoshop 6.0 or later.

To choose a color space, follow these steps.

1. **Set the Mode dial to P, Tv, Av, M, or A-DEP, and then press the Menu button.**

2. **Turn the Main dial to highlight the Shooting 2 menu.**

3. **Turn the Quick Control dial to highlight Color space, and then press the Set button.** The sRGB and Adobe RGB options appear.

4. **Turn the Quick Control dial to highlight the option you want, and then press the Set button.** The color space you choose remains in effect until you change it, or, if you chose Adobe RGB, the color space changes to sRGB if you switch to an automatic mode such as CA, Full Auto, Portrait, and so on.

Setting the White Balance

If you want great out-of-the-camera color, choosing the correct White Balance setting for the light that's in the scene is the best and fastest way to get it. A White Balance setting tells the camera what the color or "temperature" of the light in the scene is so that the camera accurately reproduces the colors in the scene. The 50D offers eight White Balance settings including preset options for common light sources, a custom white balance option to set the light temperature to the specific light in the scene, and an option to set a specific color temperature.

Your choice of White Balance options may be affected by the amount of time you have to shoot a scene, the type and consistency of light, and whether you shoot RAW or JPEG capture. Here are some approaches for setting White Balance.

✦ **Use a preset White Balance option.** This is the option to use when there is a single light source in the scene that clearly matches one of the preset White Balance options. The preset White Balance options, including Daylight, Cloudy, Fluorescent, and Flash, have good color accuracy and saturation.

How Color Temperature is Determined

Unlike air temperature that is measured in degrees Fahrenheit (or Celsius), light temperature is based on the spectrum of colors that is radiated when a black-body radiator is heated. To understand the concept, visualize heating an iron bar. As the bar is heated, it glows red. As the heat intensifies, the metal color changes to yellow, and with more heat, it glows blue-white. In this spectrum of light, color moves from red to blue as the temperature increases.

Although we think of "red hot" as being significantly warmer than blue, in the world of color temperature, blue is, in fact, a much higher temperature than red. Likewise, the color temperature at noon on a clear day is higher (bluer) than the color temperature of a warm red sunset. So as you think about color temperatures, keep this general principle in mind: The higher the color temperature, the cooler (or bluer) the light; the lower the color temperature, the warmer (or yellower/redder) the light.

To express different colors of light, light temperature is measured on the Kelvin scale and is expressed in Kelvin (K). The Kelvin scale starts at absolute zero (-273 degrees Celsius). And on a digital camera, white appears as white only as long as the camera knows the light temperature in the scene. That's why setting one of the White Balance options on the 50D is important in getting accurate color. The 50D's preset White Balance options cover a range of light temperatures, so that rendering white as white is more approximate than specific. Optionally, you can set a custom white balance that is specific to an individual scene and renders more accurate color.

✦ **Set a custom white balance.** A custom white balance sets image color for the specific light in the scene whether it's a single light source or mixed light. This is the option to use with mixed lighting and when the light source doesn't clearly match one of the preset White Balance options. Setting a custom white balance takes more time, but it provides very accurate color, and it's worth the extra steps when you're shooting a series of images in the same light, especially if you're shooting JPEG images. If you're shooting RAW, then shooting a white or gray card and balancing images during RAW image conversion is often faster than setting a custom white balance. (See the accompanying sidebar for details on this technique.)

✦ **Set a specific color temperature.** With this option, you set the specific light temperature on the 50D. This is a good option for studio shooting when you know the temperature of the strobes or continuous lights. And if you are fortunate enough to have a color temperature meter, setting the specific color temperature is a good option.

If you are new to using White Balance, Figures 4.3 and 4.4 illustrate the difference it makes to have the correct White Balance set.

Without question, setting the White Balance to match the light in the scene, or setting a custom white balance, makes all the difference in color accuracy. And you can set the White Balance in P, Tv, Av, M, and A-DEP

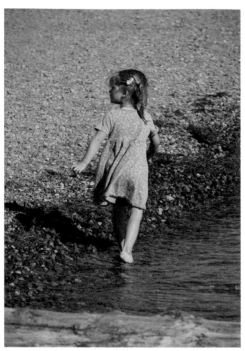

4.3 This image was taken using the Daylight White Balance setting and the Standard Picture Style. The image has accurate color. Exposure: ISO 100, f/8, 1/250 second.

4.4 This image was taken using the Shady White Balance setting. The color shifts to yellow. Exposure: ISO 100, f/8, 1/250 second.

shooting modes. However, in the automatic modes such as Full Auto, Portrait, and so on, the 50D automatically sets the White Balance, and you can't change it.

To change to a preset White Balance option such as Daylight, Tungsten, Shade, and so on, follow these steps:

1. **Set the Mode dial to P, Av, Tv, M, or A-DEP, and then press the WB-Metering mode button above the LCD panel.** The White Balance screen appears.

2. **Turn the Quick Control dial to select a White Balance setting.** The White Balance settings are shown with icons that represent different types of lights. The White Balance option you set remains in effect until you change it or until you switch to an automatic shooting mode such as CA, Full Auto, Portrait, and so on.

Getting Accurate Color with RAW Images

If you are shooting RAW images, a great way to ensure accurate color is to photo-graph a white or gray card that is in the same light as the subject, and then use the card as a reference point for balancing color when processing RAW images on the computer.

For example, when you take a portrait, ask the subject to hold the gray card under or beside his or her face for the first shot, then continue shooting without the card in the scene. If the light changes, take another picture with the gray or white card.

When you begin converting the RAW images on the computer, open the picture that you took with the card. Click the card with the White Balance tool to correct the color, and then click Done to save the corrected White Balance settings. If you're using a RAW conversion program such as Adobe Camera Raw or Canon's Digital Photo Professional, you can copy the White Balance settings from the image you just color balanced, select all of the images shot under the same light, and then paste the White Balance settings to them. In a few seconds, you can color balance 10, 20, 50, or more images.

There are a number of white and gray card products you can use such as the WhiBal cards from RawWorkflow.com (www.rawworkflow.com/whibal). There are also small reflectors that do double duty by having one side in 18 percent gray and the other side in white or silver. The least expensive option, and one that works well, is a plain white, unlined index card.

Setting a custom white balance

In scenes where there is a mix of different types of light, or in scenes where the light doesn't match any of the preset white bal-ance settings, you will get the most accurate color by setting a custom white balance. Setting a custom white balance balances colors for the precise light in the scene. It is relatively easy to set a custom white bal-ance, and it's an excellent way to ensure accurate color.

Another advantage to custom white balance is that it works whether you're shooting JPEG or RAW capture in a Creative Zone mode. Just remember that if the light changes, you have to set a new custom white balance.

Tip *I alternate between setting a cus-tom white balance and shooting a white or gray card. Both techniques work in the same general way and involve roughly the same amount of time and effort, but they differ on when you set the White Balance. With a custom white balance, you set the White Balance while you're shooting. When you shoot a white or gray card, you set the White Balance during RAW image con-version on the computer.*

By now, you may be asking why you can't just use Auto White Balance (AWB) for all images, particularly in mixed light. Certainly AWB works well for many scenes, but it is not as accurate as a custom white balance, nor is the color as visually pleasing in scenes where a preset White Balance setting clearly matches the light in the scene.

4.5 This basket of apples is lit by window light, the built-in flash, and a silver reflector to camera left. The White Balance setting was Shade. Exposure: ISO 100, f/5.6, 1/5 second, -3 Flash Exposure Compensation, and -2 Exposure Compensation.

4.6 In this image, I used a custom white balance, and the color is more neutral and accurate. Exposure: ISO 100, f/5.6, 1/5 second, -3 Flash Exposure Compensation, and -2 Exposure Compensation.

Here is how to set a custom white balance. A word of caution is in order though. You must complete all of these steps to ensure the custom white balance is used by the camera. Most photographers who are new to this technique forget to complete Step 8 in particular.

1. **Set the camera to P, Av, Tv, M, or A-DEP, and ensure that the Picture Style is not set to Monochrome.** To check the Picture Style, press the Picture Style button on the back of the camera. The Picture Style screen is displayed. To change from Monochrome (black and white), turn the Quick Control dial to select another style, and then press the Set button.

Tip *It's best to have the White Balance set to anything except custom white balance when you begin these steps. Occasionally, I've had the 50D refuse to import data from a white card shot when the White Balance was already set to Custom.*

2. **In the light that will be used for the subject, position a piece of unlined white paper so that it fills the center of the viewfinder (the spot metering circle), and take a picture.** If the camera cannot focus, switch the lens to MF (manual focusing) and focus on the paper. Also ensure that the exposure is neither underexposed nor overexposed such as by having Exposure Compensation set.

3. **Press the Menu button, and then turn the Main dial until the Shooting 2 menu appears.**

4. **Turn the Quick Control dial to highlight Custom WB, and then press the Set button.** The camera displays the last image captured (the white piece of paper) with a Custom White Balance icon in the upper left of the display. If the image of the white paper is not displayed, rotate the Quick Control dial until it is.

5. **Press the Set button again.** The 50D displays a confirmation screen asking if you want to use the White Balance data from this image for the custom white balance.

6. **Turn the Quick Control dial to choose OK, and then press the Set button.** A second screen appears reminding you to set the White Balance to Custom.

7. **Press the Set button one last time, and then press the Shutter button to dismiss the menu.** The camera imports the White Balance data from the selected image and returns to the Shooting 2 menu.

8. **Press the Metering Mode-WB button above the LCD panel, and then turn the Quick Control dial to select Custom White Balance.** This is denoted by two triangles on their sides with a black square between them. The custom white balance remains in effect until you change it by setting another White Balance. All of the images you make will be balanced for the custom white balance.

When you finish shooting in the light for which you set the custom white balance, be sure to reset the White Balance option.

Setting a specific color temperature

Anytime you know the color temperature of the light in the scene, then you can set that temperature using the K White Balance option. For example, I know that the temperature of my studio lights is 5300K, so I use the K White Balance setting to set this temperature. I can continue shooting without further adjustments to the White Balance because the light temperature remains constant.

Alternately, if you have a color temperature meter, you can set the specific color temperature on the 50D. You can set a color temperature in the range of 2500 to 10000K.

Here's how to set a specific color temperature for the K White Balance setting.

1. **With the camera set to P, Tv, Av, M, or A-DEP, press the Menu button.**

2. **Turn the Main dial to highlight the Shooting 2 menu, and then turn the Quick Control dial to highlight White Balance.**

3. **Press the Set button. The White Balance screen appears.**

4. **Turn the Quick Control dial to highlight the K 5200 option.** If you've previously changed the temperature for the K setting, the screen reflects the last used temperature.

5. **Turn the Main dial to the left to decrease the color temperature number, or to the right to increase it, and then press the Set button.** The Shooting 2 menu appears with the White Balance K temperature you set displayed.

4.7 In this image, I used the K White Balance setting and set the color to 5300K to match the temperature of my studio strobes. Exposure: ISO 100, f/22, 1/125 second.

If you use a color temperature meter, you may need to do some testing to adjust readings to compensate for differences between the camera's temperature settings and the meter's reading. And if you're setting a known temperature for a venue light, you may need to modify the White Balance toward magenta or green using White Balance Correction, detailed in the next section.

Fine-tuning white balance

With the proliferation of different types of lights both for household use and commercial use, it can be difficult to get color that is spot-on accurate. And even in images where the color is accurate, you may want a warmer or cooler rendering. To compensate for differences in specific light temperatures or to fine-tune a preset White Balance setting, you can use one of two options: White Balance Auto Bracketing or White Balance Correction. Both options enable you to bias image color in much the same way that a color-correction filter does when you're shooting film.

Using White Balance Auto Bracketing

The first option for fine-tuning White Balance is bracketing the White Balance setting to bias the color toward magenta/green or blue/amber. White Balance Bracketing works just as exposure bracketing does: You take a set of three images that vary the color toward a blue/amber or magenta/green bias at +/- 3 levels in one-step increments.

As you would expect, White Balance Bracketing reduces the camera's maximum burst rate by one-third. In fact, you can combine exposure bracketing with White Balance Bracketing. If you do this, a total of nine images are recorded for each shot. This is a way to not only fill up a CF card quickly, but also to slow down shooting to a crawl. However, in scenes that you can't go back to and where image color is critical, both exposure and White Balance Bracketing can be good insurance.

The bracketed sequence gives you a set of three images from which to choose the most visually pleasing color. If you're shooting JPEG capture in Creative Zone modes and use the Standard, Portrait, or Landscape Picture Styles, bracketing can be a good choice to get a visually pleasing color bias in a scene. Setting White Balance Auto Bracketing is similar to setting White Balance Correction and is detailed next.

 Note *White Balance Auto Bracketing and White Balance Correction involve similar steps. See the steps in the next section to set White Balance Auto Bracketing.*

4.8 This and the next two images were shot with window light, the built-in flash, and a silver reflector to camera left. I used the Shade White Balance setting and set White Balance Auto Bracketing at a +3 level. This is the standard White Balance image with no color bias. Exposure: ISO 100, f/5.6, 1/5 second, -3 Flash Exposure Compensation, and -2 Exposure Compensation.

4.9 This is the image with a +3 Blue bias that cools the color warmth that the Shade setting provides. The changes in White Balance Bracketing are reasonably subtle, and with the commercial printing of this book, you may not be able to detect significant differences.

4.10 This is the image with a +3 Amber bias that adds more color warmth than the original image with the Shade White Balance setting.

Using White Balance Correction

Similar to White Balance Auto Correction is White Balance Correction. Both enable you to bias image color, but White Balance Correction sets a single and specific color bias rather than bracketing in multiple directions. This is the technique to use when you

know exactly how much bias or shift is needed to get the image color you want. This technique is similar to using color-compensation and color-correction filters with film with the advantage of not needing to buy and carry multiple filters.

You can correct color in any of four directions: blue, green, amber, and magenta. Each level of color shift is equivalent to 5 mireds of a color temperature conversion filter. A mired is a unit of measure that indicates the density of a color temperature conversion filter. As you make the shift, you can see on the screen the direction and intensity of the correction.

To set White Balance Auto Bracketing or White Balance Correction, follow these steps:

1. **Press the Menu button, and then turn the Main dial until the Shooting 2 menu appears.**

2. **Turn the Quick Control dial to highlight WB SHIFT/BKT, and then press the Set button.** The WB correction/WB bracketing screen appears.

3. **To set White Balance Auto Bracketing, turn the Quick Control dial clockwise to set a Blue/Amber bias, or counterclockwise to set a Magenta/Green bias.** As you turn the dial, three tick marks appear and separate to indicate the direction and amount of bracketing. The bracketing amount is also displayed on the WB correction/WB bracketing screen under the BKT block.

To set White Balance Correction, tilt the Multi-controller in the direction of the shift you want. The direction and amount of shift is displayed in the SHIFT section on the screen.

4. **Press the Set button.** If you change your mind and want to start over, press the Info button. Bracketed images are taken with the standard White Balance first, followed by the blue (or magenta) bias, and then the amber (or green) bias. If you set White Balance Correction, a WB+/- icon is displayed in the viewfinder and on the LCD panel as you shoot.

Working with Picture Styles

Picture Styles are a digital version of the different "looks" that different film provides. For example, Kodak's Portra film is characterized by its subdued color and contrast. By contrast, vivid and saturated blues and greens and snappy contrast characterize FujiFilm's Velvia film. Just as films are chosen for their rendering characteristics, you can choose Picture Styles on the 50D for their unique looks.

Behind each Picture Style are parameters that set the tonal curve, color rendering and saturation, and the sharpness of all the images you shoot with the 50D. The default Picture Style is Standard, and it is characterized by snappy contrast, vivid colors, and

moderate-to-high saturation. Others of the five Picture Styles modify the contrast, color saturation and tone, and sharpness to give images a different look or rendering as detailed in Table 4.1.

You can change the settings for the preset Picture Styles, and you can set up three of your own styles that are based on Canon's preset styles. In addition, you can download new Picture Styles from Canon's Web site.

Whether you modify an existing style or create one of your own, the 50D provides good latitude in setting parameters with seven adjustment levels for sharpness, and eight levels of adjustment for contrast, saturation, and color tone.

While Picture Styles are the foundation of image rendering, they are also designed to produce classic looks that need little or no post-processing so that you can print JPEG images directly from the CF card. If you shoot RAW capture, you can't print images directly from the CF card, but you can apply Picture Styles either in the camera or during conversion using Canon's Digital Photo Professional conversion program. You can also use the Picture Style Editor to modify and save changes to Picture Styles for captured images. The Picture Style Editor is included on Canon's EOS Digital Solution Disk that comes with the camera and is detailed later in this chapter.

Regardless of whether you use direct printing, you can and should consider which Picture Style to use for both JPEG and RAW capture.

Table 4.1
EOS 50D Picture Styles

Picture Style	Description	Contrast	Color Saturation	Default Settings
Standard	Vivid, sharp, crisp	Higher contrast	Medium-high saturation	2,0,0,0
Portrait	Enhanced skin tones, soft texture rendering, low sharpness	Higher contrast	Medium saturation, rosy skin tones	2,0,0,0
Landscape	Vivid blues and greens, high sharpness	Higher contrast	High saturation for greens/blues	4,0,0,0
Neutral	Allows latitude for conversion and processing with low saturation and contrast.	Low, subdued contrast	Low saturation, neutral color rendering	0,0,0,0
Faithful	True rendition of colors with no increase in specific colors. No sharpness applied.	Low, subdued contrast	Low saturation, colorimetrically accurate	0,0,0,0
Monochrome	Black-and-white or toned images with slightly high sharpness	Higher contrast	Yellow, orange, red, and green Filter effects available. Sepia, Blue, Purple, and Green Toning effects available.	3,0, NA, NA

Note *In Basic Zone modes except CA, the camera automatically selects the Picture Style, which you cannot change. In CA shooting mode, you can select Standard, Portrait, Landscape, or Monochrome Picture Styles. Also, if you shoot RAW images, the Picture Style is not applied unless you apply it during conversion in Canon's Digital Photo Professional conversion program.*

Choosing and customizing Picture Styles

Choosing and customizing Picture Styles are how you get the kind of color, contrast, and color saturation results out of the camera that best suit your workflow. If you shoot JPEG, and if you always edit images before printing them, then you can use Picture Style

parameters to help ensure that highlights do not get clipped or discarded by the contrast setting, and to control color saturation.

Following are parameter adjustments that you can modify for each Picture Style in Creative Zone modes.

✦ **Sharpness: 0 to 7.** Level zero applies no sharpening and renders a very soft look (due largely to the anti-aliasing filter in front of the image sensor that helps ward off various problems including moiré, spectral highlights, and chromatic aberrations). At high sharpness levels, images are suitable for direct printing from the CF card. However, if you prefer to edit images on the computer, then a 0-2 level is adequate and helps to prevent sharpening halos when you sharpen images in an image-editing program.

✦ **Contrast: -4 to +4.** The key thing to know about the contrast parameter is that it represents the image's tonal curve. If the setting is too high, then image pixels can be clipped (discarding highlight and/or shadow pixels). A negative adjustment produces a flatter look but helps to prevent clipping. A positive setting increases the contrast and stretches the tonal range. Higher settings can lead to clipping. Clipping is important especially in the highlights because if they are clipped in the camera, there is no way to recover the detail they contained during editing. Thus, I prefer to get a slightly flatter look out of the camera knowing that the highlight data is being preserved. I can always set

a curve in Photoshop to get snappier contrast. You can evaluate the effect of the tonal curve on RAW images in the histogram shown in Canon's Digital Photo Professional program.

✦ **Saturation: -4 to +4.** This setting affects the strength or intensity of the color with a negative setting producing low saturation and vice versa. As with the Contrast parameter, a high Saturation setting can cause individual color channels to clip. A +1 or +2 setting is adequate for snappy JPEG images destined for direct printing. For images you will edit on the computer, a 0 (zero) setting allows ample latitude for post-capture edits.

✦ **Color Tone: -4 to +4.** This setting modifies the hue of the image. Negative settings produce redder and bluer tones while positive settings produce more yellow tones.

> **Note** With the Monochrome Picture Style, only the sharpness and contrast parameters are adjustable, but you can add toning effects, as detailed in the sidebar. Default settings are listed in order of sharpness, contrast, color saturation, and color tone.

> **Note** RAW images captured in Monochrome can be converted to color using the software bundled with the camera. However, in JPEG capture, Monochrome images cannot be converted to color.

Figures 4.11 through 4.16 show the effect of each Picture Style on color, saturation, and contrast. Exposure for these images is ISO 100, f/22, 1/125 second.

4.11 This image is taken using Standard Picture Style.

4.14 This image is taken using Neutral Picture Style.

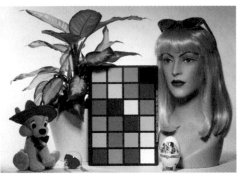

4.12 This image is taken using Portrait Picture Style.

4.15 This image is taken using Faithful Picture Style.

4.13 This image is taken using Landscape Picture Style.

4.16 This image is taken using Monochrome Picture Style.

To set a Picture Style, just press the Picture Styles button on the back of the camera, turn the Quick Control dial to select the style you want, and then press the Set button.

After evaluating and printing with different Picture Styles, you may want to change the default parameters to get the rendition that you want. Alternately, you may want to create your own style. You can create up to three Picture Styles that are based on an existing style.

For almost all my photography, I use a modified Neutral Picture Style. I use this modified style for a couple of reasons: First, I always edit images on the computer and this style gives me latitude for interpreting the color tone and saturation of images to my liking, and second, in portraits, it creates subdued lovely skin tones with a nice level of contrast.

4.17 This image is taken with my modified Neutral Picture Style.

Here is how I modified the Neutral Picture Style for my work. Most of the images in this book are shot with these settings. These settings work best when the lighting isn't flat and the image isn't underexposed.

✦ **Sharpness:** +2

✦ **Contrast:** +1

✦ **Saturation:** +1

✦ **Color tone:** 0

To modify a Picture Style, follow these steps:

1. **With the Mode dial set to P, Tv, Av, M, or A-DEP, press the Picture Styles button on the back of the camera.** The Picture Style selection screen appears.

2. **Turn the Quick Control dial to select the Picture Style you want to modify, and then press the Info button.** The Detail Set screen for the selected style appears.

3. **Turn the Quick Control dial to select the parameter you want to adjust, and then press the Set button.** The camera activates the control.

4. **Turn the Quick Control dial to change the parameter, and then press the Set button.** Negative settings decrease sharpness, contrast, and saturation, and positive settings provide higher sharpness, contrast, and saturation. Negative color tone settings provide reddish tones, and positive settings provide yellowish skin tones.

5. **Turn the Quick Control dial to select the next parameter, and then press the Set button.**

6. **Repeat steps 4 and 5 to change additional parameters.**

7. **Press the Menu button.** The modifications are saved and remain in effect until you change them. The Picture Style selection screen appears.

Using Monochrome Filter and Toning Effects

You can customize the Monochrome Picture Style by following the previous steps, but only the Sharpness and Contrast parameters can be changed. However, you have the additional option of applying a variety of Filter and Toning effects.

✦ **Monochrome Filter effects.** Filter effects mimic the same types of color filters that photographers use when shooting black-and-white film. The Yellow filter makes skies look natural with clear white clouds. The Orange filter darkens the sky and adds brilliance to sunsets. The Red filter further darkens a blue sky, and makes fall leaves look bright and crisp. The Green filter makes tree leaves look crisp and bright and renders skin tones realistically.

✦ **Monochrome Toning effects.** You can choose to apply a creative toning effect when shooting with the Monochrome Picture Style. The Toning effect options are None, Sepia (S), Blue (B), Purple (P), and Green (G).

To apply a Filter or Toning effect, press the Picture Style button on the back of the camera. Turn the Quick Control dial to select Monochrome. Press the Info button, and then turn the Quick Control dial to highlight either Filter effect or Toning effect. Press the Set button. The camera displays options that you can choose. Turn the Quick Control dial to highlight the option you want, and then press the Set button. The effect remains in effect until you change it.

Registering a new Picture Style

If you need a greater range of Picture Styles for your work, then three User-Defined slots are available for you to create custom Picture Styles. Each style is based on one of Canon's Picture Styles, and you can modify it to suit your preferences. With this approach, you can retain the preset styles unchanged, and then have three additional modified styles.

There are several approaches that you can take to create new styles depending on your needs. First you can use each of the three User-Defined styles for specific venues in which you shoot often. For example, you can set up one style for outdoor nature and landscape shooting (a modification of the Landscape or Standard style), one for studio portraits (a modification of the Portrait style), and one for a sports arena (a modification of the Standard style).

Or you can use the User-Defined style for a style that you create using Canon's Picture Style Editor, a program that's included on the EOS Digital Solution Disk that comes with the camera. This technique is detailed in the next section of this chapter.

Here's how to create and register a User-Defined Picture Style.

1. **With the Mode dial set to P, Tv, Av, M, or A-DEP, press the Picture Style button on the back of the camera.**

2. **Turn the Quick Control dial to User Def. 1, and then press the Info button.** The Detail set. User Def. 1 screen appears with the base Picture Style, Standard.

3. **Press the Set button.** The camera activates the base Picture Style control.

4. **Turn the Quick Control dial to select a base Picture Style, and then press the Set button.** You can select any of the preset Picture Styles such as Standard, Portrait, and so on, as the base style.

5. **Turn the Quick Control dial to select a parameter, such as Sharpness, and then press the Set button.** The camera activates the parameter's control.

6. **Turn the Quick Control dial to set the level of change, and then press the Set button.**

7. **Repeat steps 5 and 6 to change the remaining parameters.** The remaining parameters are Contrast, Saturation, and Color tone.

8. **Press the Menu button to register the style.** The Picture Style selection screen appears. The base Picture Style is displayed to the right of User Def. 1. If the base Picture Style parameters were changed, then the Picture Style on the right of the screen is displayed in blue. This Picture Style remains in effect until you change it.

You can repeat these steps to set up User Def. 2 and 3 styles.

Using the Picture Style Editor

Choosing and/or modifying Pictures Styles changes the image rendering, but you have to experiment by setting the style, capturing the image, and then checking the results. Then you make modifications to the style and repeat the process until you get the results you want.

Canon offers a more precise and efficient approach to fine-tuning Picture Styles with the Picture Style Editor program that's included on the EOS Digital Solution Disk. To use this program, you need a RAW image on which you make the adjustments. With the RAW image open in the Picture Style Editor, you can apply a Picture Style and make changes on the computer where you can watch the effect of the changes.

The Picture Style Editor is deceptively simple, but it offers powerful and exact control over the style. For example, you can make color specification changes and minute adjustments to hue, saturation, luminosity, and gamma (tonal curve) characteristics. Up to 100 color points can be selected in the color specifications, and three color display modes — HSL (Hue, Saturation, Luminosity), Lab, and RGB — are available. You can also set the color workspace display, such as Adobe RGB. A histogram shows the distribution of luminance and color in the sample image, and the display can be switched to luminance; RGB; or R, G, and B.

If you are familiar with Canon's Digital Photo Professional program, then the color tones will be familiar because the Picture Style Editor uses the same algorithms for image processing. You can set up to ten points anywhere on the tone curve and watch the effect of the change to the sample image in the main window.

In addition, you can compare before and after adjustments in split windows with magnification from 12.5 to 200 percent.

Because the goal of working with the Picture Style Editor is to create a Picture Style file that you can register in the camera, the adjustments that you make to the RAW image are not applied to the image. Rather, the adjustments are saved as a file with a .pf2 extension, and then you use the EOS Utility to register the file in the camera and apply it to images. You can also apply the style in Digital Photo Professional after saving the settings as a PF2 file.

It is beyond the scope of this book to provide exhaustive instructions for using the Picture Style Editor, but the following section provides a brief introduction to the program. I also encourage you to read the Picture Style Editor descriptions on the Canon Web site at web.canon.jp/imaging/picturestyle/editor/index.html.

Be sure you install the EOS Digital Solution Disk programs before you begin. To use the Picture Style Editor, follow these steps.

1. **Choose Start ➪ All Programs ➪ Canon Utilities ➪ Picture Style Editor. On the Mac, choose Applications ➪ Canon Utilities ➪ Picture Style Editor ➪ PictureStyle Editor.app.** The Picture Style Editor main window appears as shown in figure 4.18.

2. **Click and drag a RAW image onto the main Picture Style Editor window.** RAW files have a .CR2 extension. You can also choose File ➪ Open image, and navigate to a folder that contains RAW images, double-click a RAW file, and then click Open. When the file opens, the Picture Style Editor displays the Tool palette.

3. **Click the arrow next to Base Picture Style to select a Picture Style other than Standard.**

4. **At the bottom of the main window, click one of the split screen icons to show the original image and the image with the changes you make side by side.** You can choose to split the screen horizontally or vertically. Or if you want to switch back to a single image display, click the icon at the far-left bottom of the window.

5. **Click Advanced in the Tool palette to display the Picture Style parameters for Sharpness, Contrast, Color saturation, and Color tone.** These are the same settings that you can change on the camera and are shown in figure 4.19. But with the Picture Style Editor, you can watch the effect of the changes as you apply them.

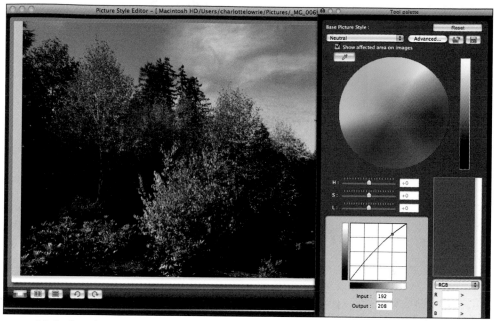

4.18 This is the Picture Style Editor and shows some of the many controls that it provides to modify a Picture Style.

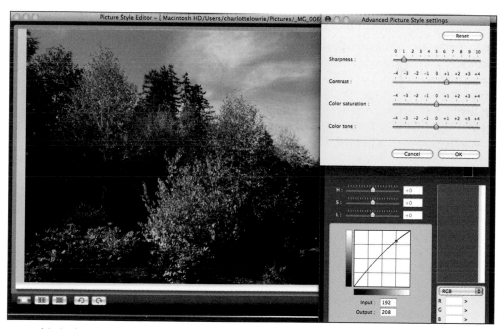

4.19 This is the Picture Style settings screen that allows you to change parameters much as you can do on the camera.

6. **Make the changes you want, and then click OK.**

7. **Adjust the color, tonal range, and curve using the Tool palette controls.** If you're familiar with image-editing programs or with Digital Photo Professional, most of the tools will be familiar. Additionally, you can go to the Canon Web site at web.canon.jp/imaging/picturestyle/editor/functions.html for a detailed description of the functions.

When you modify the style to your liking, you can save it and register it to use in the 50D. However, when you save the PF2 file, I recommend saving two versions of it. During the process of saving the file, you can select the Disable subsequent editing option, which prevents disclosing the adjustments that have been made in the Picture Style Editor as well as captions and copyright information. This is the option to choose when you save a style for use in the 50D and in the Digital Photo Professional program. But by turning on the option, the style file no longer can be used in the Picture Style Editor.

For that reason, you likely want to save a second copy of the PF2 file without turning on the Disable subsequent editing option in the Save Picture Style File dialog box. That way, if you later decide to modify the style, you can use the Picture Style Editor to make adjustments to this copy of the PF2 file.

To save a custom Picture Style, follow these steps:

1. **Click the Save Picture Style File icon at the top far right of the Picture Style Editor tool palette.** The Save Picture Style File dialog box appears.

2. **Navigate to the folder where you want to save the file.**

3. **To save a file to use in the 50D, click the Disable subsequent editing option at the bottom of the dialog box.** To save a file that you can edit again in the Picture Style Editor, do not select this option.

4. **Type a name for the file, and then click Save.** The file is saved in the location you specified with a .PF2 file extension.

To install the custom Picture Style on the 50D, follow these steps. Before you begin, ensure that the EOS Digital Solution Disk programs are installed on your computer and have the USB cable that came with the camera handy.

1. **Connect the camera to the computer using the USB cable supplied in the 50D box.**

2. **Choose Start ⇨ All Programs ⇨ Canon Utilities ⇨ EOS Utility. On the Mac, choose Applications ⇨ Canon Utilities ⇨ EOS Utility ⇨ EOS Utility.app.** The EOS Utility screen appears.

3. **Click Camera settings/Remote shooting under the Connect Camera tab in the EOS Utility.** The capture window appears.

4. **Click the camera icon in the red tool bar, and then click Picture Style.** The Picture Style window appears.

5. **Click Detail set at the bottom of the Picture Style list.** The Picture Style settings screen appears.

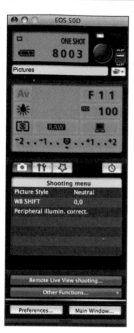

4.20 This is the EOS Utility control panel that is shown when the camera is connected to the computer.

6. **Click the arrow next to Picture Style, and then click User Defined 1, 2, or 3 from the drop-down menu that appears.** If a Picture Style file was previously registered to this option, the new style over-writes the previous style. When you choose User Defined, additional options appear.

7. **Click Open.** The Open dialog box appears.

8. **Navigate to the folder where you saved the Picture Style file that you modified in the Picture Style Editor, and click Open.** The Picture Style settings dialog box appears with the User Defined Picture Style displaying the modified style you opened. If necessary, you can make further adjustments to the file before applying it.

9. **Click Apply.** The modified style is registered in the 50D. It's a good idea to verify that the style was copied by pressing the Picture Style button on the back of the 50D and selecting the User Defined Style you registered to see if the settings are as you adjusted them.

In addition to creating your own styles, you can download additional Picture Styles from Canon's Web site at web.canon.jp/imaging/picturestyle/index.html.

Customizing the EOS 50D

Photographers can often overlook the added efficiency and shooting pleasure that customizing the 50D offers. You can tailor the camera to your specific shooting preferences as well as tailor it to individual scenes and subjects. The 50D offers three major categories of customization. Here's a bird's eye view of the three:

✦ **Custom Functions** enable you to change camera controls and behavior as well as to set up the camera for both general and venue-specific shooting situations.

✦ **C modes**, or, as Canon calls them, Camera User Settings, enable you to set up virtually everything on the camera and then save all the settings as C1 or C2 shooting mode. The advantage is that after you register your settings for everyday shooting or a specific shooting scenario, you can just switch to C1 or C2 on the Mode dial and the camera is instantly set up for shooting.

✦ **My Menu** is a menu tab where you can place your six most frequently used menu items for quick access.

I can tell you from personal experience that all three features will save you time and offer shooting advantages that are well worth the time it takes to make the adjustments.

Exploring Custom Functions

The major advantage of Custom Functions is that they enable you to customize camera controls and operation to suit your shooting style; and, as a result, they save you time and make shooting more enjoyable. For example, if you don't want to press the AF-point Selection/Enlarge button before you manually select an AF point, then you can set Custom Function III-3 and use the Quick Control dial to select an AF point. This function has saved me more time during shooting than any other Custom Function.

Before you begin, you should know that Custom Functions can be set only in Creative Zone modes. Also, after you set a Custom Function option, it remains in effect until you change it.

Note *Canon refers to Custom Functions using the abbreviation C.Fn [group Roman numeral]-[function number]. For example, C.Fn II-3.*

The 50D offers 25 Custom Functions. Some Custom Functions are broadly useful, and others are useful for specific shooting specialties or scenes.

Custom Function groupings

Canon organized the 25 Custom Functions into four groups denoted with Roman numerals, all of which are listed on the Custom Function camera menu. The following tables delineate the groupings and the C.Fn's that fall within each group. It's worthwhile to get familiar with the groupings because you must choose a group from the Custom Functions menu to find and change a specific function.

✦ **Custom Function group I: Exposure.** This group is essentially setting any function that has to do with exposure or flash sync speed. See Table 5.1.

Table 5. 1		
Custom Function Group I: Exposure		
Option Number	*Function Name*	
1	Exposure level increments	
2	ISO speed setting increments	
3	ISO expansion	
4	Bracketing auto cancel	
5	Bracketing sequence	
6	Safety shift	
7	Flash synchronization speed in Av mode	

✦ **Custom Function group II: Image.** I think of this group as the NR (noise reduction) and dynamic range group. See Table 5.2.

✦ **Custom Function Group III: Autofocus/Drive.** The majority of functions in this group are related to working with AF. See Table 5.3.

Table 5.2
Custom Function Group II: Image

Option Number	Function Name
1	Long exposure noise reduction
2	High ISO speed noise reduction
3	Highlight tone priority
4	Auto Lighting Optimizer

Table 5.3
Custom Function Group III: Autofocus/Drive

Option Number	Function Name
1	Lens drive when AF impossible
2	Lens AF stop button function
3	AF-point selection method
4	Superimposed display
5	AF-assist beam firing
6	Mirror lockup
7	AF Microadjustment

✦ **Custom Function Group IV: Operation/Others.** I think of this group as "everything else." If I can't find what I want in the other groups, I choose this option on the Custom Function camera menu. See Table 5.4.

Table 5.4
Custom Function Group IV: Operation/Others

Option Number	Function Name
1	Shutter button/AF-ON button
2	AF-ON/AE lock button switch
3	Assign SET button
4	Dial direction during Tv/Av
5	Focusing screen
6	Add original decision data
7	Assign FUNC. (Function) button

Custom Functions specifics

This section includes a description of each Custom Function and the options that you can set. I'll provide instances where the C.Fn would be useful in general, but also consider how you could use them to simplify or customize your specific shooting situations.

I encourage you to use Custom Functions to the fullest extent. I think that you will be pleasantly surprised at how much more you'll enjoy the 50D after you customize it for your shooting needs.

Note *If you set Custom Functions and later want to return to the camera defaults, you can do that easily by using the Clear all Custom Func. (C.Fn) option on the Custom Functions camera menu.*

C.Fn I: Exposure

The seven Exposure Custom Functions are described here followed by the options that you can choose for each function.

C.Fn I-1: Exposure-level increments

With this function, you can set the amount that is used for shutter speed, aperture, Exposure Compensation, and Auto Exposure Bracketing (AEB) changes. The exposure increment you choose is displayed in the viewfinder and on the LCD as marks at the bottom of the Exposure-level Indicator.

✦ **Option 0: 1/3 stop.** By default, the 50D uses 1/3 stop as the exposure-level increment for changes in shutter speed, aperture, exposure compensation, and Auto Exposure Bracketing.

✦ **Option 1: 1/2 stop.** Sets 1/2 stop as the exposure-level increment for shutter speed, aperture, exposure compensation, and Auto Exposure Bracketing changes. This option gives you a greater exposure change and is useful in bracketing images for compositing.

C.Fn I-2: ISO speed setting increments

With this function, you can set the amount of change that's used when you change the ISO sensitivity setting.

✦ **Option 0: 1/3 stop.** This is the default increment. With this option set, the ISO speeds are Auto, 100,125, 160, 200, 250, 320, 400, 500, 640, 800, 1000, 1250, 1600, 2000, 2500, and 3200, as well as H1 (6400) and H2 (12800) when C.Fn I-3 is set to On.

✦ **Option 1: 1 stop.** Sets 1 f-stop as the ISO adjustment-level increment. With this option set, the ISO speeds are the traditional settings of Auto, 100, 200, 400, 800, 1600, 3200, as well as H1 (6400) and H2 (12800) when C.Fn I-3 is set to On.

C.Fn I-3: ISO expansion

With this function, you can choose additional ISO sensitivity settings H1 and H2, which are equivalent to ISO 6400 and 12800, respectively. To determine if you want to use high ISO settings, including the expansion settings of 6400 and 12800, be sure to shoot test shots at the high levels, then examine the images to ensure that you can get good prints with acceptable noise levels at the size you most often use to make prints. And even then, to always get the highest image quality in terms of color, fine detail, and smooth tones, I recommend shooting at the lowest possible ISO setting given light, lens, and other factors.

✦ **Option 0: Off.** At this default setting, you cannot select the expanded ISO settings of H1 (6400) or H2 (12800).

✦ **Option 1: On.** You can select the expanded ISO settings of H1 (6400) or H2 (12800). With this option set, you can select H1 and H2 as an ISO option in the same way that you select other ISO settings.

C.Fn I-4: Bracketing auto cancel

With this function, you can choose when Auto Exposure Bracketing (AEB) and White Balance Bracketing (WB-BKT) are cancelled. Very often, AEB and WB-BKT are specific to a scene, and, therefore, not settings that you want to retain. It's also easy to forget that

you've set either bracketing option, and you end up shooting with the bracketing inadvertently set. Unless you most often shoot with AEB and WB-BKT, then I recommend using the default option 0.

✦ **Option 0: On.** Both AEB and WB-BKT are cancelled when you turn the camera power switch to Off, have the flash ready to fire, and if you clear camera settings.

✦ **Option 1: Off.** Choosing this option retains AEB and WB-BKT settings even after you turn off the camera. When the camera's flash is ready, the bracketing is cancelled, but the camera remembers the AEB amount.

C.Fn I-5: Bracketing sequence

Use this function when you want to change the sequence of images that are bracketed by shutter speed or aperture. And it enables you to change the sequence for White Balance Bracketing (WB-BKT). For exposure bracketing, I find that the Option 1 sequence makes it much easier to identify which image is which in a series of bracketed images after I download them to the computer.

✦ **Option 0: 0** (Standard exposure or standard white balance), - (Decreased exposure or more blue or more magenta white-balance bias), + (Increased exposure or more amber and more green white-balance bias).

✦ **Option 1: -** (Decreased exposure, or more blur or more magenta white-balance bias), **0** (Standard exposure or standard white balance), + (Increased exposure or more amber and more green white-balance bias).

C.Fn I-6: Safety shift

If you enable this function, the camera automatically shifts the aperture or shutter speed in both Shutter-priority AE (Tv) and Aperture-priority AE (Av) modes if there is a sudden shift in lighting that would cause an improper exposure at the current settings. While photographers are watchful for lighting changes, this function could be very helpful in stage and theater lighting venues where overhead spotlights can dramatically shift as speakers or actors move around the stage in and out of spot-lit areas.

✦ **Option 0: Disable.** Maintains the exposure you've set regardless of whether the subject brightness changes.

✦ **Option 1: Enable (Tv/Av).** In Shutter-priority AE (Tv) and Aperture-priority AE (Av) modes, the shutter speed or aperture automatically shifts if the subject brightness suddenly changes to provide an acceptable exposure.

C.Fn I-7: Flash sync. speed in Av mode

This function sets the flash sync speed automatically or sets it to a fixed 1/250 second in Av mode.

✦ **Option 0: Auto.** Automatically syncs Speedlites at speeds 1/250 second or slower.

✦ **Option 1: 1/250-1/60 sec. auto.** Provides a fast enough shutter speed in Av mode to handhold the camera and get a sharp image depending on the lens you're using. This option does not balance ambient light in night shots and scenes with dark backgrounds, so the background will be dark.

✦ **Option 2: 1/250 sec. (fixed).** Automatically sets the flash sync speed to 1/250 second in Aperture-priority AE (Av) mode. This option is useful if you're shooting with a non-Image-Stabilized telephoto lens up to 250mm, and you want to handhold the camera and get a sharp image. If you use this sync speed for night shots or scenes with dark backgrounds, the background goes dark.

C.Fn II: Image

This group of functions enable you to set noise reduction for long exposures and high ISO sensitivity settings. And you can control the use of Highlight Tone Priority and Auto Lighting Optimizer in this group of functions.

C.Fn II-1: Long-exposure noise reduction

This function offers options to turn noise reduction on or off, or to set it to automatic for long exposures. With noise reduction turned on, the reduction process takes the same amount of time as the original exposure. In other words, if the original image exposure is 1.5 seconds, then noise reduction takes an additional 1.5 seconds. This means that you cannot take another picture until the noise reduction process finishes. I keep the 50D set to Option 1 to automatically perform noise reduction if it is detected in long exposures, which I consider to be good insurance.

✦ **Option 0: Off.** No noise reduction is performed.

✦ **Option 1: Auto.** The camera automatically performs noise reduction when it detects noise from 1-second or longer exposures.

✦ **Option 2: On.** The camera performs noise reduction on all exposures of 1 second or longer regardless of whether the camera detects noise. Obviously, the second exposure duration reduces the continuous shooting burst rate dramatically. But this is a good option for night scenes and lowlight still-life subjects. If you're shooting at a lowlight music concert or a sports event, this option slows down shooting too much for it to be a practical option.

 Note *If you use Live View and you have Option 2 set, then no image displays on the LCD during the time that the camera performs the second noise-reduction exposure.*

C.Fn II-2: High ISO speed noise reduction

With this function, you can choose to apply more aggressive noise reduction to shadow areas in particular when you shoot at high ISO sensitivity settings. (The camera applies some noise reduction to all images.) If you turn this option on, noise in low-ISO images is further reduced. Because Canon has a good noise-reduction algorithm, this setting is more likely to retain fine image details, and reducing shadow noise is advantageous. But it pays to check your images to ensure that the blurring of fine image detail resulting from noise reduction isn't too heavy handed.

✦ **Option 0: Standard.** This is the default setting that applies some color (chroma) and luminance noise reduction to images shot at all ISO sensitivity settings. If you seldom use high ISO settings, this is a good option to choose, and it's effective even at relatively high ISO sensitivity settings.

✦ **Option 1: Low.** The camera performs noise reduction on high-ISO images, as well as all images. You may not see much difference between this option and Option 0: Standard.

✦ **Option 2: Strong.** More aggressive noise reduction is applied, and a loss of fine detail is noticeable. In addition, the burst rate in Continuous drive mode is reduced.

✦ **Option 3: Disable.** No noise reduction is performed.

C.Fn II-3: Highlight Tone Priority

One of the most interesting and useful functions is Highlight Tone Priority, which helps ensure good detail in bright areas such as those on a bride's gown. With the function turned on, the high range of the camera's dynamic range (the range measured in f-stops between deep shadows and highlights in a scene) is extended from 18 percent gray (middle gray) to the brightest highlights. Further, the gradation from middle gray tones to highlights is smoother with this option turned on. The downside of enabling this option is increased digital noise in shadow areas. But if you're shooting weddings or any other scene where it's critical to retain highlight detail, then the tradeoff is justified. If noise in the shadow areas is objectionable, you can apply noise reduction in an editing program.

However, if you turn on Highlight Tone Priority, ISO speed settings are reduced to 200 3200 so that you lose the ISO 100 option. The ISO display in the viewfinder, on the LCD panel, and in the Shooting information display adds a "D+" to indicate that this option is in effect.

✦ **Option 0: Disable.** This is the default setting with no highlight tone expansion.

✦ **Option 1: Enable.** This option turns on Highlight Tone Priority, improving the detail in bright highlights and in gradation of detail from middle gray to the brightest highlights. The lowest ISO setting available is 200. With this option, D+ is displayed on the LCD panel to remind you that Highlight Tone Priority is enabled.

C.Fn II-4: Auto Lighting Optimizer

This function determines whether and how much the 50D automatically corrects exposures that are too dark and/or that have flat contrast. This automatic correction is applied at the Standard setting to all images shot in the automatic shooting modes such as CA, Full Auto, Portrait, and so on.

You can choose to turn off, or to set the level of correction that's applied to JPEG images shot in P, Tv, Av, and A-DEP modes. This function isn't used if you shoot in Manual mode. It also isn't applied to RAW images, but you can use Canon's Digital Photo Professional program if you want to apply it after capture.

This function can mask the effects of setting exposure modifications you make such as Auto Exposure Bracketing, AE Lock, and Exposure Compensation. If you prefer to control exposure and see the effects of exposure modifications, then I recommend setting this function to Disable. However, if you print images directly from the CF card, then this function can help you get better prints for underexposed images.

✦ **Option 0: Standard.** This is the default setting. In my experience, the changes the camera makes are minimal compared to having the option disabled.

✦ **Option 1: Low.** Slightly more correction is applied than with the Standard option.

✦ **Option 2: Strong.** More aggressive brightness and contrast correction is applied. This setting may also reveal shadow noise depending on the scene or subject.

✦ **Option 3: Disable.** No automatic optimization is used.

C.Fn III: Autofocus/Drive

The group of functions enables you to control various lens and camera autofocusing tasks. And this is where you come to set mirror lockup.

C.Fn III-1: Lens drive when AF impossible

This is a handy function to explore if you often shoot in scenes where the lens simply cannot focus. You've likely been in situations where the lens seeks focus seemingly forever and goes far out of focus range while attempting to find focus, particularly with telephoto and super-telephoto lenses. Setting this function to Option 1 stops the lens from seeking to find focus and going into an extensive defocus range.

✦ **Option 0: Focus search on.** The lens drive continues to function as the camera seeks focus.

✦ **Option 1: Focus search off.** Stops the lens drive from going into extreme defocus range.

C.Fn III-2: Lens AF Stop button function

For super-telephoto ImageStabilized (IS) lenses that offer an AF Stop button, the options of this function modify the operation of the focusing, Auto Exposure Lock, and IS. As of this writing, lenses with the AF Stop button include the EF 300mm f/2.8L IS USM, EF 400mm f/2.8L IS USM, EF 400mm f/4 DO IS USM, EF 500mm f/4L IS USM, EF 600mm f/4L IS USM, and EF 800mm f/5.6 IS USM lenses. On lenses that do not have an AF Stop button, changing the options of this function has no effect. Several of these options enable you to control different camera functions with the left and right hands.

✦ **Option 0: AF stop.** Provides normal functioning of the AF Stop button, which stops the lens from autofocusing when the button is pressed. This is a good option for nature and wildlife shooting, and action scenes where the subject is blocked temporarily by another object.

✦ **Option 1: AF start.** Focusing begins only while the AF Stop button is pressed during which time autofocus operation with the camera — by half-pressing the Shutter button or by pressing the AF-ON button — is disabled.

✦ **Option 2: AE lock.** Changes the AF Stop button to function as AE Lock. Like traditional AE Lock (described in Chapter 3), this option decouples metering from autofocusing so that you can meter on one area and focus on another point in the scene.

✦ **Option 3: AF point: M ⇨ Auto/ Auto ⇨ center.** When you're using manual AF-point selection, the camera switches to automatic

AF-point selection when you press and hold the AF Stop button. Or if you're using Automatic AF-point selection mode, holding down the AF Stop button automatically selects the center AF point. This option is useful when you can't track a subject when you're using Manual AF-point selection in the AI Servo AF mode.

✦ **Option 4: ONE SHOT ⇄ AI SERVO.** Switches from One-Shot to AI Servo AF mode when the button is held down. If you are in AI Servo AF, pressing and holding the button switches to One-Shot AF mode as long as the button is held down. This is convenient if the subject starts and stops moving frequently.

✦ **Option 5: IS start.** When the IS switch on the lens is turned on, IS works only while pressing the AF Stop button. With this option, you can use the left hand to control IS and your right hand to control AF-point selection and releasing the Shutter button.

C.Fn III-3: AF-point selection method

The options enable you to choose which camera controls you use for manually selecting the AF point. For anyone who has an aching thumb from pressing the AF-point Selection/Enlarge button and rotating the Main dial or the Multi-controller to select an AF point, this Custom Function is priceless.

✦ **Option 0: Normal.** Press the AF-point Selection/Enlarge button, and then press the Multi-controller, Main, or Quick Control dial to select the AF point.

✦ **Option 1: Multi-controller direct.** This allows you to select the AF point by using only the Multi-controller. If you press the AF-point Selection/Enlarge button, the camera automatically switches to automatic AF-point selection. This can be handy if you typically use automatic AF-point selection for some of your routine shooting. If you don't, then having the camera switch to automatic AF-point selection is annoying, especially if you are in the habit of pressing the AF-point Selection/ Enlarge button to manually select an AF point (per Option 0).

✦ **Option 1: Quick Control Dial direct.** Enables you to select the AF point using the Quick Control dial without first pressing the AF-point Selection/Enlarge button. From my perspective, this is the easiest and fastest method of selecting the AF point. Just be sure that the On switch is always set to the topmost position. If you choose this option, the Quick Control dial can't be used to set exposure compensation. To set exposure compensation, hold down the AF-point Selection/Enlarge button and turn the Main dial to set the amount of compensation.

C.Fn III-4: Superimposed display

The options enable you to turn off the red light that flashes when an AF point is selected in the viewfinder.

✦ **Option 0: On.** The selected AF point flashes in red in the viewfinder when the Shutter button is half-pressed and focus is achieved.

✦ **Option 1: Off.** The AF point does not flash in red in the viewfinder in all autofocus modes. The AF point lights in red when you manually select it, but when you half-press the Shutter button, no AF point lights. I find this option a little like flying blind. And because I like to see which AF point is achieving focus, I don't use this option.

C.Fn III-5: AF-assist beam firing

With this function you control whether the 50D's built-in flash or an accessory EX Speedlite's autofocus assist light is used to help the camera establish focus. The AF-assist beam is very helpful in speeding up and in ensuring sharp focus.

✦ **Option 0: Enable.** The camera uses the built-in flash or an accessory Canon EX Speedlite's AF-assist beam to establish focus. This beam helps the camera establish focus in lowlight or when the subject contrast is low. The flash also fires.

✦ **Option 1: Disable.** The AF-assist beam isn't used.

✦ **Option 2: Only external flash emits.** Only the Speedlite's AF-assist beam is used to help establish focus.

C.Fn III-6: Mirror lockup

Option 1 for this function prevents blur that can be caused in close-up and telephoto shots by the camera's reflex mirror flipping up at the beginning of an exposure. This function is a point of contention among nature and landscape photographers who often use mirror lockup, because the feature is buried in Custom Functions. The easiest

workaround to make this function easily accessible is to add this Custom Function to My Menu. Customizing My Menu is detailed later in this chapter.

✦ **Option 0: Disable.** Prevents the mirror from being locked up.

✦ **Option 1: Enable.** Locks up the reflex mirror for close-up and telephoto images to prevent mirror reflex vibrations that can cause blur. When this option is enabled, you press the Shutter button once to swing up the mirror and then press it again to make the exposure. With mirror lockup, the drive mode is automatically set to Single shot. The mirror remains locked for 30 seconds and then automatically flips down automatically if you don't press the Shutter button to make the image. If you combine mirror lockup with the 10- and 2-second Self-timer modes, the optional Timer Remote Controller TC-80N3 or the Remote Switch RS-80N3, and a tripod, you can ensure rock-solid shooting.

Tip *When you use mirror lockup with bright subjects such as snow, bright sand, the sun, and so on, be sure to take the picture right away to prevent the camera curtains from being scorched by the bright light.*

C.Fn III-7: AF Microadjustment

This function is designed to overcome front- and back-focusing quirks of individual lenses. In other words, it shifts the camera's sharpest plane of focus forward or backward. Then it applies the adjustment to the internal AF system to compensate for front or back focus. The camera identifies lenses by their focal

length and maximum aperture, and 20 lenses can be adjusted. Until now, lens adjustments were made by the factory or by Canon, but this function enables you to approximate that tuning. The process for making microadjustments requires using a target pattern, and the process is not for the faint of heart. If you choose to use AF Microadjustment, then you can set the microadjustment in plus/minus 20 steps forward or backward and register the adjustments for a maximum of 20 lenses in the camera.

✦ **Option 0: Disable.** No adjustment is used.

✦ **Option 1: Adjust all by same amount.** This option adjusts all lenses by the same amount. It seems highly unlikely that all lenses would be off by precisely the same amount given that each lens varies. But if you find that all lenses are off by the same mount, this is the option to select

✦ **Option 2: Adjust by lens.** With this option, you can test individual lenses, make the adjustment, and then register the results in the camera. Then when you mount a lens that has a registered adjustment, the camera automatically applies the focus adjustment.

 Note *You can learn more about AF Microadjustment in Chapter 8.*

C.Fn IV: Operation/Others

This group of functions enables you to change the functionality and behavior of some camera buttons as well as registering the focusing screen if you change it. It also includes options for adding original decision data for security.

C.Fn IV-1: Shutter button/AF-ON button

This function changes the function of the Shutter button and the AF-ON button in starting and stopping autofocus and metering.

✦ **Option 0: Metering + AF start.** This uses the default behavior where you press the Shutter button halfway to focus and meter to set exposure.

✦ **Option 1: Metering + AF start/AF stop.** This allows you to press the AF-ON button to suspend autofocusing while the metering function continues operating. This option can be useful if you want to set the exposure for an area into which the subject will move, but wait to focus until the subject is in the area.

✦ **Option 2: Metering start/ Metering + AF start.** In AI Servo AF mode, pressing the AF-ON button momentarily stops autofocusing to prevent the focus from being thrown off when an object passes between the lens and the subject. Releasing the button resumes autofocusing. The camera sets exposure at the moment the shutter is released.

✦ **Option 3: AE lock/Metering + AF start.** With this option, you can meter one part of the scene but focus on another part of the scene. You press the AF-ON button to meter and focus, and then press the Shutter button halfway to set AE Lock.

✦ **Option 4: Metering + AF start/ Disable.** Disables the use of the AF-ON button.

C.Fn IV-2: AF-ON/AE lock button switch

This function swaps the function of the AF-ON button and the AE Lock button. This may be slightly handier in terms of which button you use with the camera held to your eye.

✦ **Option 0: Disable.** The buttons operate normally with AF-ON setting focus and AE Lock setting exposure on the area of the scene that you meter.

✦ **Option 1: Enable.** The AF-ON button sets AE Lock on the area of the scene that you meter, and the AE Lock button initiates focusing.

C.Fn IV-3: Assign SET button

This function enables you to change the function of the Set button so that it's useful during shooting. Although the options described here duplicate other buttons on the back of the camera, the advantage to programming the Set button is that this button is larger and easier to find than the smaller buttons on the back of the camera.

✦ **Option 0: Normal (disabled).** The Set button is not functional during shooting.

✦ **Option 1: Image Quality.** Pressing the Set button while shooting displays the Image recording quality menu on the LCD. You can then change the image quality setting using the Quick Control or Main dial. The Set button continues to perform its default functions with menus and submenus. If you often change the image quality, then this is a useful option to select.

✦ **Option 2: Picture Style.** Pressing the Set button displays the Picture Style selection screen on the LCD. Then you can use the Quick Control or Main dial to select the Picture Style and press the Set button to confirm the selection. This option is somewhat dubious given the Picture Style button on the back of the camera. Option 1 seems the most sensible use of this function to avoid redundancy with other back-of-the-camera buttons.

✦ **Option 3: Menu display.** Pressing the Set button displays the camera menu on the LCD. This option duplicates the function of the Menu button but may be handier due to the larger size and the location of the Set button.

✦ **Option 4: Image replay.** Pressing the Set button initiates image playback on the LCD. This option duplicates the function of the Playback button.

✦ **Option 5: Quick Control Screen.** Pressing the Set button displays the Quick Control screen. Given the great convenience of the Quick Control screen, this option makes the most sense in terms of having a quick way to change exposure and other camera settings.

 For details on the Quick Control screen, see Chapter 3.

C.Fn IV-4: Dial direction during Tv/Av

The function offers options allowing you to reverse the direction for setting shutter speed and aperture in Tv and Av modes, respectively, when using the Main dial. And in M mode, you can reverse the direction of both the Quick Control and Main dials.

✦ **Option 0: Normal.** When you turn the Main dial clockwise in Tv or Av, the shutter speed or aperture increases. In Manual mode, the same changes occur using the Main and Quick Control dials for shutter speed and aperture, respectively.

✦ **Option 0: Reverse direction.** In Manual mode, the direction of the Main and Quick Control dials are reversed so that turning the Main dial clockwise causes the shutter speed or aperture to decrease, respectively. In other shooting modes, the Main dial direction is reversed.

C.Fn IV-5: Focusing screen

Use this function only if you install one of the two optional interchangeable focusing screens. Note that this is the only Custom Function that is not included if you register camera settings and recall them by switching to one of the C modes on the Mode dial. And if you clear all Custom Functions, this function is not cleared so that the setting matches the currently installed focusing screen at all times.

✦ **Option 0: Ef-A.** Standard Precision Matte. This is the focusing screen that comes installed on the camera, and it offers good viewfinder brightness and good manual focusing.

✦ **Option 1: Ef-D.** Precision Matte with Grid. This screen features five vertical lines and three horizontal lines to help keep lines square during image composition.

✦ **Option 2: Ef-S.** Super Precision Matte. Designed to make manual focusing easier with f/2.8 and faster lenses. The viewfinder is darker using this screen with slower lenses.

C.Fn IV-6: Add original decision data

When this option is turned on, data is appended to verify that the image is original and hasn't been changed. This is useful when images are part of legal or court proceedings. The optional Data Verification Kit DVK-E2 is required.

✦ **Option 0: Off.** No verification data is appended.

✦ **Option 1: On.** Appends data to verify that the image is original. During image playback, a lock icon denotes verification data. To verify the image originality, the optional Original Data Security Kit OSK-E3 is required.

C.Fn IV-7:Assign FUNC. button.

With this function, you can program what appears when you press the FUNC. (Function) button.

✦ **Option 0: LCD brightness.** This is the default screen that appears when you press the Function button. Unless you often change the LCD brightness, the other options will make this button more useful.

✦ **Option 1: Image quality.** Choosing this option displays the Image quality screen when you press the Function button. If you set C.Fn IV-3 so that the Set button displays the Image quality screen, you probably won't want to duplicate that functionality with the Function button.

✦ **Option 2: Exposure comp/AEB setting.** Choosing this option displays the Exposure Compensation/AEB screen so that you can set compensation or bracketing. If you often bracket images so that you can composite them in Photoshop, this is a handy option to choose.

✦ **Option 3: Image jump w/[Main dial].** Choosing this option displays the image jump screen so that you can move through images by 1, 10, or 100 images at a time, or by screen, date, or folder. If you often have many images on the CF card, this option is a handy shortcut to the jump-by screen.

✦ **Option 4: Live View function settings.** Choosing this option displays the Live View function settings screen so that you can set all aspects relating to Live View shooting including exposure simulation, silent shooting, and focusing preferences. For my use, this option or Option 2 makes the most sense.

 Live View shooting is detailed in Chapter 6.

Setting Custom Functions

After reviewing the functions and options, there may be specific functions that are clearly no-brainers, such as C.Fn IV-3 and IV-7 to assign functionality to the Set and Function buttons. Other functions such as mirror lockup are ones that you'll use in scene-specific shooting. Still others you can set and forget about, or change based on specific shooting circumstances.

You may also find that combinations of functions are useful for specific shooting situations. Whether used separately or together, Custom Functions can significantly enhance your use of the 50D.

To set a Custom Function, follow these steps:

1. **Set the Mode dial to P, Tv, Av, M, or A-DEP.**

2. **Press the Menu button, and then turn the Quick Control dial to display the Custom Functions menu.**

3. **Turn the Quick Control dial to highlight the Custom Functions (C.Fn) group you want, and then press the Set button.** The Custom Functions screen with the function group that you selected appears.

4. **Turn the Quick Control dial until the Custom Function number you want is displayed, and then press the Set button.** The Custom Function number is displayed in a small box to the upper right of the screen. When you press the Set button, the Custom Function option control is activated.

5. **Turn the Quick Control dial to highlight the option you want, and then press the Set button.** You can refer to the tables earlier in the chapter to select the function number that you want. Repeat steps 3 and 4 to select other Custom Function groups, functions, and options.

If you want to reset one of the Custom Functions, repeat these steps to change it to another setting or the default setting.

Or if you want to restore all the Custom Functions to the default settings, repeat steps 1 and 2, highlight Clear all Custom Func. (C. Fn), press the Set button, and then choose OK. All Custom Functions except C. Fn IV-5 are restored to the original camera settings.

Registering Camera User Settings

With the addition of the Camera User Settings, denoted as C1 and C2 on the Mode dial, you can preset the EOS 50D with your favorite shooting mode, exposure settings, drive and autofocus modes, and Custom Functions, and then make only minimal adjustments when you're ready to start shooting. C modes enable you to use those specific settings by simply switching to the C1 or C2 mode on the Mode dial. And you're not locked into the setting that you register, because you can still change the settings on the fly.

It doesn't take long to think of a plethora of ways to use C modes. C1 mode could be set up for shooting nature and landscape with the camera preset to Av mode, exposure bracketing, mirror lockup, as well as to your favorite drive, autofocus, and exposure modes, and Picture Style. Then C2 mode is open for presetting the camera for portraits, weddings, concerts — you name it. Without question, C modes are the way to spend less time adjusting camera settings and to spend more time shooting.

One of the nice aspects of the C mode is that you can plan its use for specific venues — for example, if you shoot weddings in the same church or chapel, you can have a C mode set for that venue. Or you can use the mode on an ad hoc basis when you know that you will shoot a series of images using the same group of settings, such as a series of images of an interior, a series of portraits, and so on.

Tip *If you've forgotten what settings you registered for any of the C modes, just press the Info button to display the current camera settings.*

When you register camera settings, the following settings are saved and recalled when you set the Mode dial to the C mode under which you registered them.

✦ **Shooting settings.** These shooting settings can be saved in a C mode:

- Shooting mode (any mode except Basic Zone modes)
- Exposure Settings: ISO, aperture, shutter speed
- AF mode
- AF-point Selection mode
- Metering mode
- Drive mode
- Exposure Compensation
- Flash Exposure Compensation
- White Balance

✦ **Menu settings.** These menu settings can be saved in a C mode:

- Image quality
- Beep on or off
- Shoot with or without a CF card
- AEB
- White Balance Shift/Bracketing
- Custom white balance
- Color temperature
- Color space
- Picture Style

- Review time
- AF points
- Histogram
- Auto power off
- Auto rotate
- LCD brightness
- File numbering method
- Custom Functions

Here's how to register camera user settings to C1 or C2 mode.

1. **With the camera set to P, Tv, Av, M, or A-DEP mode, set all the settings that you want to register.** In addition to shooting, exposure, metering, focus, drive, and menu settings, you can set Custom Functions for specific shooting scenarios as detailed previously in this chapter.

2. **Press the Menu button, and then turn the Main dial to select Set-up 3 menu.**

3. **Turn the Quick Control dial to highlight Camera user setting, and then press the Set button.** The Camera user setting screen appears.

4. **Turn the Quick Control dial to highlight Register, and then press the Set button.** The Register screen appears.

5. **Turn the Quick Control dial to highlight the Mode dial option you want: Mode dial : C1, or Mode dial : C2, and then press the Set button.** A second Register screen appears.

6. **Turn the Quick Control dial to highlight OK, and then press the Set button.** The Set-up 3 menu appears. The camera registers the settings except for the My Menu settings. Lightly press the Shutter button to dismiss the menu.

7. **To shoot with the registered settings, turn the Mode dial to the C1 or C2 mode depending on the option you selected in step 5.** When you shoot in a C mode, the Clear all camera settings on the Set-up 3 menu, and the Clear all custom Func. (C.Fn) option on the Custom Function menu cannot be used. To use these menu options, switch to P, Tv, Av, M, or A-DEP shooting mode first.

If you want to clear the registered Camera user settings, follow these steps:

1. **Repeat steps 1 through 3 in the previous set of steps.**

2. **Turn the Quick Control dial to highlight Clear settings, and then press the Set button.** The Clear settings screen appears.

3. **Turn the Quick Control dial to highlight the C mode that you want to clear, and then press the Set button.** For example, select Mode dial: C2 to clear the C2 Mode dial settings. The Clear settings screen appears.

4. **Turn the Quick Control dial to highlight OK, and then press the Set button.** The camera clears the registered settings for the C mode that you selected.

Customizing My Menu

Customization of the 50D includes the ability to set up My Menu with your most frequently used six menu items and options. In addition to frequently used menu items, you can also add your most-often used Custom Functions to My Menu as well. The payoff is time savings for you.

Adding and deleting items to and from My Menu is quick and easy, and you can change the order of items by sorting the items you register. You can also set the 50D to display My Menu first when you press the Menu button. The only drawback is that you can only register six items. So before you begin registering, evaluate the menu items and Custom Functions and carefully choose your six favorite items.

As an example, here is what I've registered on My Menu: Custom WB, Format, Live View function setting, Flash control, Camera user settings, and High ISO speed noise reduction. And I've set up My Menu as the first menu that's displayed when I press the Menu button.

Here's how to add items to My Menu.

1. **With the camera in P, Tv, Av, M, or A-DEP mode, press the Menu button, and then turn the Quick Control dial to display the My Menu tab.** The My Menu tab is the last tab.

2. **Turn the Quick Control dial to highlight My Menu settings, and then press the Set button.** The My Menu settings screen appears.

3. **Turn the Quick Control dial to highlight Register, and then press the Set button.** The My Menu registered item screen appears. This screen is a scrollable list of all menu items available on the camera. You can scroll through the list by turning the Quick Control dial.

4. **Turn the Quick Control dial to highlight the menu item you want to register, and then press the Set button.** The My Menu registered item screen appears.

5. **Turn the Quick Control dial to highlight OK, and then press the Set button.** The My Menu registered item screen reappears so you can select the next item. To find individual Custom Functions, keep scrolling past the C.Fn group names, and you'll see the individual Custom Functions by name only (the group and option numbers are not listed).

6. **Repeat step 5 until all the menu items you want are registered, and then press the Menu button.** The My Menu settings screen appears. If you want to sort your newly added items, jump to step 2 in the following set of steps.

To sort your registered camera Menu items and Custom Functions, follow these steps:

1. **With the Menus displayed, turn the Quick Control dial to highlight My Menu settings, and then press the Set button.** The My Menu settings screen appears.

2. **Turn the Quick Control dial to highlight Sort, and then press the Set button.** The Sort My Menu screen appears.

3. **Press the Set button if you want to move the first menu item to a different position in the list.** The camera activates the sort control represented by a scroll arrow to the right side of the menu item.

4. **Turn the Quick Control dial to move the item's placement within the menu, and then press the Set button.** Turn the Quick Control dial to the right to move the selected item down one item in the list. Or turn the Quick Control dial to the left to move the item to the end of the list.

5. **Repeat steps 3 and 4 to move other menu items in the order that you want.**

6. **Press the Menu button twice to display your customized menu.** Or lightly press the Shutter button to dismiss the menu.

You can follow these general steps to access My Menu settings where you can delete one or all items from the menu, and to have My Menu displayed each time you press the Menu button.

Now you have a good idea of how you can set up the 50D not only to make it more comfortable and efficient for your preferences but also to have the camera ready in advance for different shooting scenes and subjects.

Doing More with the EOS 50D

Shooting in Live View or Tethered

Whether you're upgrading to the EOS 50D from a point-and-shoot camera or you like the idea of viewing, composing, and focusing images using the large 3-inch LCD monitor instead of the viewfinder, Live View shooting is for you.

More specifically, the 50D Live View feature offers flexibility in framing images, particularly when you have to crouch down to examine the shot through the viewfinder or in other scenes that require unnatural body contortions. In addition, Live View shooting is helpful for macro shooting and for shooting products.

Live View offers a view that can be magnified up to 10x to ensure tack-sharp automatic or manual focus as well as a face-detection focusing option. Live View also offers two Silent modes that reduce shutter noise.

The Live View shooting function is also useful when shooting tethered (where the camera is connected by a cable to a computer) or wireless in the studio. While Live View shooting isn't the best choice for all shooting scenes, it is a good choice in controlled and close-up shooting scenarios as well as in unusual scenes where you simply cannot get the shot by looking through the viewfinder.

About Live View Shooting

The concept of a digital SLR being able to hold the shutter open to give you a real-time view of the scene and yet pause long enough to focus is impressive. And even more impressive is the smooth and detailed quality of the live view that

the 50D provides. Normally, the camera can't see the live scene because the shutter and reflex mirror block the view to the image sensor. The camera overcomes this blind spot with a mechanical shutter that stays completely open during Live View shooting.

This technology enables some very cool side features as well. For example, because the first-curtain shutter is electronic, the shutter cocking noise can be reduced, and the 50D offers face detection to automatically identify a face in the scene and focus on it. If it focuses on the wrong face, you can shift the selection by using the Multi-controller to choose the correct subject. In addition, you can use remote Live View shooting when the camera is connected to a computer giving you a seriously large viewfinder. And you can also use the video or HDMI cable to connect the 50D to a TV and see Live View on the TV screen.

Although Live View shooting has high coolness factor, it comes at a price. With continual use of Live View shooting, the sensor heats up quickly, and the battery life diminishes markedly.

More specifically, here is what you can expect with Live View shooting:

✦ **Temperature affects the number of shots you can get using Live View.** With a fully charged BP-511A battery, you can expect 180 shots without flash use and approximately 170 shots with 50 percent flash use in 73-degree temperatures. In freezing temperatures, expect 140 shots without flash use

and 130 shots with 50 percent flash use per charge. With a fully charged battery, you'll get approximately one hour of continuous Live View shooting before the battery is exhausted.

✦ **High ambient temperatures, high ISO speeds, and long exposures can cause digital noise or irregular color in images taken using Live View.** Before you start a long exposure, stop shooting in Live View and wait several minutes before shooting.

✦ **The live view may not accurately reflect the captured image in several different conditions.** Image brightness may not be accurately reflected in low- and bright-light conditions. If you move from low to a bright light, the live view may display chrominance (color) noise, but the noise will not appear in the captured image. And suddenly moving the camera in a different direction can throw off accurate rendering of the image brightness. If you capture an image in magnified view, the exposure may not be correct.

Live View Features and Functions

Some of the functions and techniques for Live View shooting are very different from non-Live View shooting, and it's good to get a high-level view of the changes before you begin using Live View.

While some key aspects of Live View shooting differ significantly from standard shooting, other aspects carry over to both types of shooting. For example, you can use the LCD panel functions during Live View shooting to change White Balance settings, Drive modes, ISO sensitivity settings, and so on. Likewise, you can press the Info button one or more times to change the display to include more or less shooting information along with an Brightness histogram or RGB histograms.

Live View focus

You can choose among several focusing options for Live View shooting. Here is an overview of the options so that you can decide in advance which you prefer or which is best for the scene or subject that you're shooting.

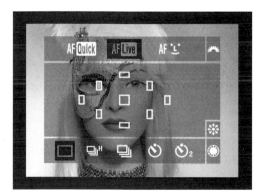

6.1 As you shoot in Live View, you can switch among focusing modes by pressing the AF-Drive button above the LCD panel.

✦ **Quick mode.** This focusing mode uses the camera's autofocus system to focus. For the camera to give you a live view of the scene, it has to keep the reflex mirror locked up. To use Quick mode, you press the AF-ON button, the mirror flips down, and Live View is suspended as long as you hold the button. When focus is established, you release the AF-ON button, wait for Live View to resume, and then press the Shutter button to make the picture. Before you begin shooting in Live View, you can also manually choose any of the nine AF points in the viewfinder for focusing.

✦ **Live mode.** With this focusing option, the camera's image sensor is used and detects subject contrast to establish focus. In this mode, Live View is not interrupted because the reflex mirror remains locked up. However, focusing takes longer with this mode. To set the point of sharpest focus, a focusing point appears on the screen, and you can move it using the Multi-controller. Then you press the AF-ON button to focus. The AF point turns green when focus is achieved.

✦ **Live (Face Detection) mode.** This is the same as Live mode except that the camera automatically looks for and focuses on a face in the scene. If the camera does not choose the face of the subject you want, you can tilt the Multi-controller to move the focusing frame to the correct face. If the camera can't detect a face, then the AF point is fixed at the center of the frame. With this mode, there may be brightness changes during and after focusing, and it may be more difficult to focus when the view is magnified.

Note *You can't use the release button on the optional Remote Switch RS-80N3 and the Timer Remote Controller TC-80N3 with Live (Face Detection) or Quick modes.*

✦ **Manual focusing.** This focusing option is most accurate and you get the best results when you magnify the image. Live View is also not interrupted during focusing. To focus manually, you set the lens switch to MF (Manual Focus), and then move the focusing frame where you want by using the Multi-controller. Turn the focusing ring on the lens to focus.

Note *If you use Live View with Continuous shooting, the exposure is set for the first shot and is used for all images in the subsequent burst.*

Exposure simulation and metering

Live View shooting provides exposure simulation that replicates what the final image will look like at the current shutter speed, aperture, and other exposure settings on the LCD during Live View display.

In terms of exposure, the camera uses focusing frame-linked evaluative metering. Unlike standard shooting, you can determine how long the camera maintains the current exposure by setting the Live View Metering timer from 4 seconds to 30 minutes. A longer meter time speeds up Live View shooting operation overall, but you have to balance the time with changes in the lighting.

Tip *If you're using Auto Lighting Optimizer, a feature that automatically corrects underexposed and low-contrast images, it will mask the effect of negative exposure compensation making the image brighter. If you want to see the effect of exposure modifications, then turn off Auto Lighting Optimizer by setting C.Fn II-4 to Option 3: Disable.*

You can also use the Depth of field preview button on the front of the camera. And if you use Live View with the camera connected to the computer, Canon's EOS Utility Live View remote window also enables you to preview the depth of field using the program's Live View controls.

By using the Live View function settings options on the Set-up 2 menu, you can choose to display one of two grids, a 3 × 3, or a 4 × 6 grid in the viewfinder to help align vertical and horizontal lines.

Silent shooting modes

Live View shooting offers two silent shooting modes, both of which are quieter than normal shooting. Depending on the silent shooting mode you choose, you can either shoot in High-speed Continuous mode at 5.8 fps with quieter-than-normal shooting, or you can choose to shoot one shot at a time and delay the sound of the mirror and shutter return. In either mode, the shutter noise is decreased by roughly 50 percent. Alternately, if you opt to focus manually, the reflex mirror does not flip down for focusing, so mirror noise is not an issue.

Following is a summary of the two silent shooting modes and the Disable option. To set one of these options, go to the Set-up 2 menu, select Live View function settings, select Silent shoot, and then press the Set button to display and choose the option you want.

✦ **Mode 1.** This mode enables High-speed continuous shooting at 5.8 fps by holding down the Shutter button completely. The shutter cocking noise is reduced by approximately half.

✦ **Mode 2.** This mode enables one-shot shooting when you fully press the Shutter button regardless of drive mode setting, and it delays the shutter noise to minimize the disturbance the sound might cause. This mode is initially disconcerting to use simply because of the delay, but it works nicely. In this mode, you cannot shoot in Continuous drive mode because the shutter doesn't recock until you release the Shutter button.

✦ **Disable.** If you're using a tilt-and-shift (TS-E) lens and make vertical shift movement, or if you use an extension tube, then this is the setting to choose to avoid underexposure or overexposure.

Using a flash

When shooting in Live View with the built-in flash using either Silent mode 1 or 2, the shooting sequence after fully pressing the Shutter button is for the reflex mirror to drop to allow the camera to gather the preflash data, and then the mirror moves up out of the optical path for the actual exposure. As a result, you hear two shutter clicks, but only one image is taken.

Here are some things you should know about using Live View shooting with a flash unit.

✦ **With an EX-series Speedlite, FE Lock, modeling flash, and test firing cannot be used, and the Speedlite's Custom Functions cannot be set on the flash unit.**

✦ **With the 580EX II, the wireless setting cannot be changed.**

✦ **If you're using a Canon Speedlite, and have the camera set to Silent mode 1 or 2, the camera automatically switches to the Disable option.** Non-Canon flash units do not automatically switch to Disable, so you must manually set the camera to Disable.

✦ **The LCD display may not reflect very bright or lowlight conditions accurately, but the final image reflects the exposure settings.** A bright light source such as the sun may appear black on the LCD, but the final image shows the bright areas correctly.

Setting up for Live View Shooting

Before you begin using Live View shooting, decide how you want the camera to function for focusing and shooting, and whether you want to use silent shooting. The settings

on the Set-up 2 menu not only activate Live View shooting but also enable you to set your preferences for shooting in this mode including enabling Live View shooting, displaying a grid in the LCD, setting up silent modes, and setting the Exposure metering timer.

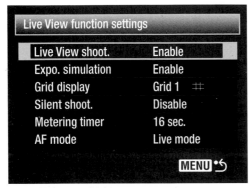

6.2 These are the options that you can set for Live View shooting.

To set up the 50D for Live View shooting and to set your preferences, follow these steps:

1. **With the Mode dial set to P, Tv, Av, M, or A-DEP, press the Menu button, and then turn the Main dial to select the Set-up 2 menu.**

2. **Turn the Quick Control dial to highlight Live View function settings, and then press the Set button.** The Live View function settings screen appears.

3. **Turn the Quick Control dial to select the option you want to set, and then press the Set button to display the options.** After you choose an option, press the Set button, and then continue to the next item. Here is what you can set along with the options:

• **Live View shoot:** Choose Enable to be able to initiate Live View shooting by pressing the Live View button on the back of the camera, or choose Disable to not use Live View shooting by pressing this button.

• **Expo. simulation:** Choose Enable to see an approximation of the final exposure on the screen. Otherwise, choose Disable.

• **Grid display:** Either the 3 × 3, or 4 × 6 grid will help you align horizontal and vertical lines in the scene. You can also choose Off if you don't want to use a grid.

• **Silent shoot:** Choose Mode 1 to reduce the sound of the shutter. Choose Mode 2 to delay the sound of the shutter until you release the Shutter button. Choose Disable if you're using a flash unit, a tilt-and-shift lens, or a lens extender.

• **Metering timer:** Choose 4, 16, or 30 seconds, or 1, 10, or 30 minutes to determine how long the camera retains the exposure when you use AE Lock to set the exposure. If the light changes often, choose a shorter time.

• **AF mode:** Choose Quick mode to focus using the 50D's autofocus system; choose Live mode to use the imaging sensor to focus, or choose Live mode to have the 50D detect a face within the scene. In addition, you can opt to focus manually. Be sure to review the previous section that provides more detail on each focusing option.

Working with Live View

After you set up the options and functions for Live View, then you can begin shooting. As mentioned earlier, Live View is best suited for macro and still-life shooting. With this type of shooting, you are likely to want to use manual focusing or Live mode with manual tweaking. A big help during focusing is to enlarge the view to 5x or 10x to ensure tack-sharp focus.

A second option is to use Live View in a studio tethered to a computer or with the Wireless File Transmitter WFT-ED/WFT-E3A. With the tethered option, you connect the camera to the computer using the supplied USB cable, and you control the camera using the supplied EOS Utility program. You can view the scene on the computer monitor in real time.

Either way, just a few minutes of watching the real-time view convinces you that a tripod is necessary for Live View shooting. With any focal length approaching telephoto, Live View provides a real-time gauge of just how steady or unsteady your hands are.

Shooting in Live View

The operation of the camera during Live View shooting differs from traditional still-view shooting, but the following steps guide you through the controls and operation of the camera. Before you begin, ensure that you've read the previous sections on setting up the camera Live View functions so that you get the performance you want.

To shoot in Live View using autofocus, follow these steps:

1. **With the camera set to P, Tv, Av, M, or A-DEP shooting mode, set the ISO, aperture, and/or shutter speed.** You can also set Auto Exposure Bracketing (AEB), choose a Picture Style, set the White Balance, and use AE Lock in Live View shooting.

If you are new to using P, Tv, Av, M, or A-DEP shooting modes, review Chapter 3.

2. **If you're using Quick focus, you can manually set the AF point by pressing the AF-point Selection button on the top-right back of the camera, and then turning the Main dial to select the AF point you want.**

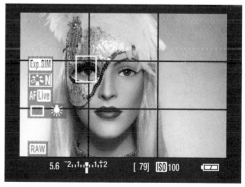

6.3 The Live View screen displays whether exposure simulation is active, as well as the current Picture Style, autofocus mode, drive mode, White Balance setting, image-recording quality, and the exposure information along the bottom of the frame. Here the large 3 × 3 grid is displayed.

3. **Press the Live View shooting button.** This button is on the top-left back of the camera and it has a camera icon above it. The shutter opens and the Live View display begins. A white rectangle appears, and in Quick focus mode, the AF point is shown by a tiny gray rectangle.

4. **Compose the image by moving the camera or the subject.** As you move the camera, the exposure changes and is displayed in the bottom bar under the Live View display.

5. **If you're using Quick mode to focus, press the AF/Drive button above the LCD panel, and then tilt the Multi-controller to move the AF rectangle where you want to set the point of sharpest focus in the image.** You can also press the AF-Drive button above the LCD panel, and then turn the Main dial to switch to a different focusing option. You can press any of the buttons above the LCD to change the functions as you shoot in Live View.

6. **Press the AF-point Selection/ Magnify button on the top far-right corner of the camera to magnify the view.** The first press of the button enlarges the view to 5x, and a second press enlarges the view to 10x. The magnifications are shown on the LCD as X5 and X10.

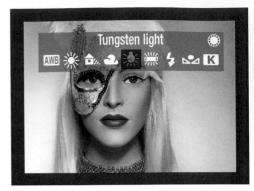

6.4 This shows the White Balance screen during Live View. I displayed this screen by pressing the WB-Metering mode button above the LCD panel.

7. **Press the AF-ON button to focus.** If you're using Quick mode to focus, when you press the AF-ON button, you hear the sound of the reflex mirror dropping down to focus and Live View is suspended. If you're using Live focusing mode, focus takes longer, and it's a good idea to magnify the image to verify sharp focus. In all focus modes, when the camera achieves sharp focus, the AF focus rectangle turns red.

8. **Press the Shutter button completely to make the picture.** The shutter fires to make the picture, the image preview is displayed, and then Live View resumes.

9. **Press the Live View shooting button to go back to standard shooting mode.** If you do not do this step, the camera automatically closes the shutter when the camera Auto Power Off (Set-up 1 menu) delay elapses.

Shooting tethered or with a wireless connection

One of the most useful ways to use Live View shooting is for studio work, particularly when you shoot still-life subjects such as products, food, stock shots, and so on.

You can set up with the 50D connected to a computer using the USB cable supplied with the camera. The extra-long cord allows a good range of movement, particularly if the computer is on a wheeled or swivel table. You can also shoot with the optional Wireless File Transmitter WFT-E3/WFT-E3A. For the following illustration, I use the supplied USB cable.

Before you begin, install the EOS Digital Solution Disk on the computer to which you are connecting the camera. To shoot in Live View with the 50D tethered to the computer, follow these steps:

1. **Turn off the camera and attach the USB cord to the Digital terminal located under the terminal cover on the side of the camera.** Be sure that the icon on the cable connector faces the front side of the camera.

2. **Connect the other end of the USB cable to a USB terminal on the computer.**

3. **Turn on the power switch on the camera.** If this is the first time you've connected the camera to the computer, then the computer installs the device driver software and identifies the camera.

4. **Click Camera settings/Remote shooting in the EOS Utility window.** The EOS 50D control panel appears. You can use the panel to control exposure settings, set the White Balance, set the Picture Style, and set White Balance Shift. To set exposure, double-click the aperture, ISO, and so on, and use the controls to adjust the settings.

6.5 The EOS Utility Remote Shooting control panel

Tip Now is a good time to click Preferences and set the options you want, such as choosing the destination folder in which to save captured images and whether to save the images both on the computer and on the CF card.

5. **Click Remote Live View Shooting at the bottom of the Remote Shooting control panel.** The Remote Live View window appears. In this window, you can set the white point by clicking a white area or neutral gray area in the scene, use the controls to set the focus, preview the depth of field by clicking the On button, and switch between the Brightness and RGB histograms as well as monitor the histogram as the camera moves or as lighting changes.

6. **When the exposure and composition are set, you can magnify the view and then focus using the AF-ON button on the camera or manually using the lens focusing ring.**

7. **Press the Shutter button completely to take the picture.** The Digital Photo Professional main window opens with the image selected.

8. **When you finish, turn off the camera and disconnect the USB cable from the camera.**

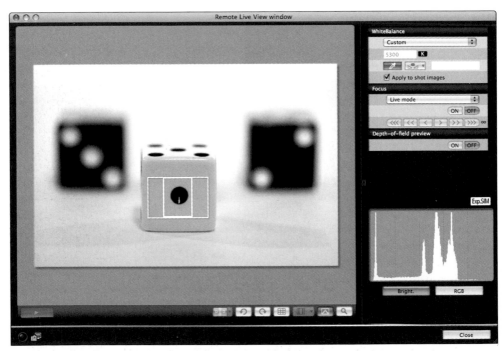

6.6 I sat the White Balance by clicking the White Balance eyedropper and clicking on the white die.

6.7 You can also set a White Balance Shift as the image is displayed on the computer screen.

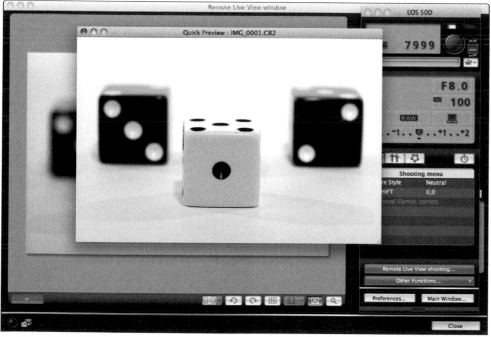

6.8 The EOS Utility also enables you to take a test shot, which is displayed in a Quick Preview, shown here.

6.9 This is the final image taken in Live View shooting with Remote Shooting using the EOS Utility with the camera tethered to a laptop. Exposure: ISO 100, f/11, 1/125 sec.

Working with Flash and Studio Lights

I f you think of flash pictures as images with unnaturally bright, sterile light and with washed-out color and heavy background shadows, then you haven't seen how far the latest Canon built-in and accessory flash units have come. Gone are the startling white skin tones and heavy black background shadows of a few years ago. With the EOS 50D, flash photography becomes much more of a harmonious blend of ambient light with more subtle flash. Even with automatic settings, the 50D flash acts much more like fill flash to lighten shadows and add a touch of brightness than the primary light source. And in Tv, Av, and M shooting modes, you have significant control over the flash so that you can create visually pleasing exposures.

This chapter begins with an introduction to flash technology and terminology, and then it moves into using the 50D's onboard flash and accessory EX-series Speedlites. This chapter is not an exhaustive look at all the ways in which you can use the onboard or accessory flash units. But it provides an overview of using the built-in and accessory flash, and I offer some techniques for both practical application and creative effect.

Flash Technology Basics

Canon flash units, whether it's the built-in or an accessory EX-series Speedlite, use E-TTL II technology. E-TTL stands for Evaluative Through-the-Lens flash exposure control. To make a flash exposure, the flash receives information from the

camera including the focal length of the lens, distance from the subject, and exposure settings including aperture. Then the camera's built-in Evaluative metering system calculates an exposure that balances ambient light with the flash output.

After the Shutter button is fully pressed but before the reflex mirror goes up, the flash fires a preflash beam. Information from this preflash is combined with data from the Evaluative metering system to analyze and compare ambient light exposure values with the amount of light needed to make a good exposure. With some lenses, the preflash data includes distance information so that the flash output can be adjusted accordingly. In addition, the calculations identify and compensate exposure for highly reflective surfaces to ensure that the image is not underexposed due to the reflective object. Then the camera calculates and stores the flash output needed to illuminate the subject while maintaining a natural-looking balance with the ambient light in the background.

The flash also automatically figures in the angle of view for the 50D given its cropped image sensor size. Thus, regardless of the focal length of the lens being used, the built-in and EX-series Speedlites automatically adjust the flash zoom mechanism for the best flash angle and to illuminate only key areas of the scene, which conserves power.

Here is the general sequence the 50D uses for making a flash exposure:

1. Pressing the Shutter button halfway sets focus on the subject and determines the exposure needed given the amount of ambient light based on a preflash firing.

2. Very quickly, the camera compares and evaluates both the ambient and preflash readings and determines the proper subject and background exposure.

3. The reflex mirror flips up, the first shutter curtain opens, and when the sensor is fully exposed, the flash fires exposing the image on the sensor. Having the flash fire at this juncture is called first-curtain sync. Then after a delay ranging from 1/250 second to 30 seconds, the second shutter curtain moves across the sensor plane and closes. The flash can also fire at the point when the second curtain has fully exposed the image sensor, and that's referred to as second-curtain sync. Last, the reflex mirror goes back down.

Whether you use the built-in flash or an accessory EX Speedlite, you can use flash in Tv, Av, and M shooting modes knowing that the exposure settings are taken into account during exposure given the maximum sync speed for the flash. When you use the flash in P shooting mode, you cannot shift, or change, the exposure. Instead, the camera automatically sets the aperture, and it sets the shutter speed between 1/250 and 1/60 second. The same is true for using the flash in A-DEP mode.

Note *In Basic Zone modes except Landscape, Sports, and Flash-Off, the camera automatically fires the flash. The only way to turn off flash use in automatic modes is by switching to Flash-Off shooting mode, or to Landscape or Sports shooting modes provided that the subject is appropriate for the exposure settings made in these two modes.*

7.1 This image of water drop action in a glass dish was made with the built-in flash. Exposure: ISO 100, f/2.8, 1/250 sec.

E-TTL II technology also enables high-speed sync flash with accessory Speedlites. High-speed sync flash enables flash synchronization at a shutter speed faster than the camera's flash sync speed of 1/250 second. The advantage is that you can open up the lens to a wide aperture when shooting a backlit subject to create a shallow depth of field to blur to the background while shooting at faster than X-sync shutter speeds.

> **Note** *While E-TTL II works with all lenses, some Canon lenses, such as those without full-time manual focus, art form motors, and tilt-and-shift lenses, do not properly communicate distance information.*

When shooting with accessory Speedlites, you can use one or more flash units wirelessly to simulate studio lighting. With multiple Speedlites, you can place flash units throughout the scene and set up lighting ratios (the relative intensity of each flash unit). You can use up to three groups of Speedlites and designate a master, or main flash, and slave units that fire in response to the master flash unit. And if you use the Canon Wireless Transmitter ST-E2, you can set up the groups and lighting ratios on the ST-E2 unit. The ST-E2 is a small controller that fits on the hot shoe of the 50D to control one or more Speedlites.

> **Tip** *The Macro Ring Lite MR-14EX and Macro Twin Lite MT-24EX can also serve as master flash units.*

Why Flash Sync Speed Matters

Flash sync speed matters because if it isn't set correctly, only part of the image sensor has enough time to receive light while the shutter curtain is open. The result is an unevenly exposed image. The 50D doesn't allow you to set a shutter speed faster than 1/250 second, but in some modes you can set a slower flash sync speed, as shown in Table 7.1. Using Custom Function C.Fn I-7, you can set whether the 50D sets the flash sync speed automatically (option 0) or always uses 1/250 second (option 1) when you shoot in Av mode.

Shooting with the Built-in Flash

Without question, the built-in flash is very handy in many different shooting scenarios. The unit offers flash coverage for lenses as wide as 17mm (equivalent to 27mm in full 35mm frame shooting). The flash recycles in approximately 3 seconds.

If you're new to flash photography, one aspect that helps you gauge the relative power of the flash is the guide number. While the guide number is not something that you deal with each time you use the built-in flash, if you understand the basics of guide numbers, then you'll be able to use the flash more effectively.

The *guide number* indicates the amount of light that the flash emits. From that number, you or the camera can determine the correct aperture to set given the subject distance and the ISO. The 50D's built-in flash's guide number is 43 (feet)/13 (meters) at ISO 100. Knowing that guide number, you divide the guide number by the flash-to-subject distance to know the aperture to set.

Note *The relationship between the aperture and the flash-to-subject distance is Guide Number ÷ Aperture = Distance for optimal exposure and Guide Number ÷ Distance = Aperture for optimal exposure.*

Thus, if the subject is 15 feet from the camera, then you or the camera divides 43 (the guide number) by 15 feet (camera-to-subject distance) to get f/2.8 at ISO 100 (because the guide number is given at ISO 100). This particular example shows the limit of the flash's power if you're shooting with a lens that has a maximum aperture of f/2.8. If you want a different aperture, you can change the camera-to-subject distance, or you can increase the ISO sensitivity setting on the camera. By increasing the ISO, the camera needs less light to make the exposure, and it simultaneously increases the range of the flash. When you increase the ISO from 100 to 200, the guide number increases by a factor of 1.4x, while increasing from 100 to 400 doubles the guide number. Table 7.2 gives the Canon estimates for flash ranges at various apertures and ISO sensitivity settings. The table is more convenient than calculating the exposure manually.

With this background on how guide numbers indicate the flash's power and range, you can see how the built-in flash with a guide number of 43 is much less powerful than the Canon Speedlite 580EX II with a guide number of 190 (feet)/58 (meters) at 105mm and at ISO 100.

Tip *As the distance increases, the light from the flash falls off. If you double the distance, the light is one quarter as much as before. This is called the Inverse Square Law.*

Working with the built-in flash

While the built-in flash is not as powerful and has a much more limited range than the 580EX II Speedlite, it offers the convenience of having a flash when you need one. The built-in flash features many of the same overrides that you find in EX-series Speedlites including Flash Exposure Compensation (FEC) and Flash Exposure Lock (FE Lock). In addition, flash options can be set on the camera's Flash Control menu when you shoot in P, Tv, Av, M, and A-DEP modes.

Menu options include the ability to turn off firing of the built-in flash and an accessory flash, shutter sync with first or second curtain, Evaluative or Average metering, and Red-eye Reduction. The 50D also allows you to set Custom Functions for an accessory EX-series Speedlite through the Set-up 3 camera menu — a very handy feature given that the size and brightness of the camera menu is bigger and easier to read than the LCD on a Speedlite.

Table 7.1 shows the behavior of the flash in each of the Creative Zone modes. Table 7.2 shows the approximate, effective range of the built-in flash.

Tip

When you use the built-in flash, be sure to remove the lens hood to prevent obstruction of the flash coverage. And if you use a large telephoto lens, the built-in flash coverage may also be obstructed.

Table 7.1
Using the Built-in Flash in Creative Zone Modes

Shooting Mode	Shutter Speed	Automatic Exposure Setting
Tv	30 sec. to 1/250 sec.	You set the shutter speed, and the camera automatically sets the appropriate aperture. If you set a shutter speed faster than 1/250 second, the camera automatically readjusts it to 1/250 with flash use.
Av	30 sec. to 1/250 sec.	You set the aperture, and the camera automatically sets the shutter speed. The 50D uses slow-speed flash sync in lowlight so that the flash provides the subject exposure and the ambient light registers with the slow shutter speed. If you want a faster shutter speed, set C.Fn I-7 to either Option 1, 1/250 to 1/60 second, or to Option 2, 1/250 second fixed. If you use slow-speed flash sync, you may need a tripod depending on the shutter speed and whether you're using an IS lens.
M (Manual)	30 sec. to 1/250 sec.	You set both the aperture and the shutter speed. Flash exposure is set automatically based on the aperture.
P and A-DEP	1/60 sec. to 1/250 sec.	Both the aperture and the shutter speed are set automatically by the camera.

Table 7.2
50D Built-in Flash Range

f-stop	ISO Sensitivity Setting							
	100	200	400	800	1600	3200	H1 (6400)	H2 (12800)
f/3.5	12.1 (3.7)	17.4 (5.3)	24.3 (7.4)	34.4 (10.5)	48.9 (14.9)	68.9 (21)	97.4 (29.7)	137.8 (42)
f/4	10.8 (3.3)	15.1 (4.6)	21.3 (6.5)	30.2 (9.2)	42.7 (13)	60.4 (18.4)	85.3 (26)	120.7 (36.8)
f/5.6	7.5 (2.3)	10.8 (3.3)	15.1 (4.6)	21.7 (6.6)	30.5 (9.3)	43 (13.1)	61 (18.6)	86.3 (26.3)

Information in this table provided by Canon

Red-eye Reduction

One of the first flash controls to set is to turn on Red-eye Reduction. The red appearance is caused when the bright flash reflects off the retina, which reveals the red color of the blood vessels in the reflection. To help contract the pupil, the Red-eye Reduction function fires a preflash that causes the pupils of the subject's eye to contract provided that the subject looks at the preflash.

A couple of additional steps can also help reduce red-eye. Be sure that the room is well lit before you begin or have the subject face window light — again to help contract the pupils. You can also move closer to the subject. Another option is to use an accessory flash, rather than the built-in flash, and hold the flash farther from the axis of the lens, or use bounce flash, a technique described later in this chapter.

You can turn on Red-eye Reduction on the Shooting 1 menu. Just highlight Red-eye On/Off, press the Set button, and then choose On. Then press the Set button to confirm the change.

Modifying Flash Exposure

There are times when the flash output won't produce the image that you envisioned, and there are times when you want a slightly increased or decreased flash exposure, or to avoid a hot spot on the subject. In these situations, you can modify the flash output using either Flash Exposure Compensation or Flash Exposure Lock. Both of these options can be set for both the built-in flash and an accessory Speedlite.

Flash Exposure Compensation

Flash Exposure Compensation enables you to manually tweak the flash output without changing the aperture or the shutter speed. This is a good modification to use when you want to use just a touch of fill flash to supplement the existing light.

Flash Exposure Compensation is much like Auto Exposure Compensation in that you can set compensation for exposure up to plus/minus two stops in 1/3-stop increments. A positive compensation increases the flash output and a negative compensation decreases the flash output. Flash Exposure Compensation can help reduce shadows in the background and to correctly expose darker or lighter than normal subjects.

7.2 For this image, I used one Speedlite to light the front of the flower, and one behind the buds, both set to -2 Flash Exposure Compensation. The long exposure allowed the ambient tungsten light to register in the image. To get only a hint of the background leaves, I darkened the background in Photoshop. Exposure: ISO 100, f/11, 20 sec. Auto White Balance.

If you use an accessory Speedlite, you can set Flash Exposure Compensation either on the camera or on the Speedlite. However, the compensation that you set on the Speedlite overrides any compensation that you set using the 50D's ISO-Flash exposure compensation button above the LCD panel. The take-away is to set compensation either on the Speedlite or on the camera, but not both.

Flash Exposure Compensation can also be combined with Exposure Compensation. If you shoot a scene where one part of the scene is brightly lit and another part of the scene is much darker — for example, an interior room with a view to the outdoors — then you can set Exposure Compensation to -1 and set the Flash Exposure Compensation to -1 to make the transition between the two differently lit areas more natural.

If you have Auto Lighting Optimizer turned on, the effect of Flash Exposure Compensation may not be apparent because Auto Lighting Optimizer automatically lightens images that it thinks are too dark, and it increases contrast in low-contrast scenes. If you want to see the effect of Flash Exposure Compensation, turn off Auto Lighting Optimizer by setting C.Fn II-4 to Option 3: Disable.

To set Flash Exposure Compensation for either the built-in flash or an accessory Speedlite, follow these steps:

1. **Set the camera to P, Tv, Av, M, or A-DEP, and then press the ISO-Flash Compensation button above the LCD panel.** The Exposure Level indicator meter is activated on the LCD panel.

2. **Turn the Quick Control dial to the left to set negative compensation (lower flash output) or to the right to set positive flash output (increased flash output) in 1/3-stop increments.** As you turn the Quick Control dial, a tick mark under the Exposure Level meter moves to indicate the amount of Flash Exposure Compensation. The Flash Exposure Compensation is displayed in the viewfinder and on the LCD panel when you press the Shutter button halfway. The Flash Exposure Compensation you set on the camera remains in effect until you change it.

To remove Flash Exposure Compensation, repeat these steps, but in Step 2, move the tick mark on the Exposure Level meter back to the center point.

Flash Exposure Lock

The second way to modify flash output is by using Flash Exposure Lock (FE Lock). Much like Auto Exposure Lock (AE Lock), FE Lock allows you to meter and set the flash output on any part — typically a middle 18-percent gray area — of the subject. This technique is the technique to use for subjects that are off center frame. And you can use FE Lock to help compensate for the exposure error that can be caused by reflective surfaces such as mirrors or windows.

Another technique is to identify the area of critical exposure, and then lock the flash exposure for that area. In a food setup, the critical exposure is on the dish as opposed to the background. If there is a bright highlight on the food, you can set FE Lock on a highlight to retain detail in that area. Regardless of the approach, FE Lock is absolutely a technique that you want to add to your arsenal for flash images.

To set FE Lock, follow these steps:

1. **Set the camera to P, Tv, Av, M, or A-DEP mode, and then press the Flash button to raise the built-in flash or mount the accessory Speedlite.** The flash icon appears in the viewfinder.

2. **Point the lens at a middle (18% gray) area or on the area of the subject where you want to lock the flash exposure, press the Shutter button halfway, and then press the AE/FE Lock button on the back right side of the camera.** This button has an asterisk above it. The camera fires a preflash. FEL is displayed momentarily in the viewfinder, and the flash icon in the viewfinder displays an asterisk beside it to indicate that flash exposure is locked. The camera retains the flash output in memory.

 Note *If the flash icon in the viewfinder blinks, you are too far from the subject for the flash range. Move closer to the subject and repeat step 2.*

3. **Move the camera to compose the image, press the Shutter button halfway to focus on the subject, and then completely press the Shutter button to make the image.** Ensure that the asterisk is still displayed to the right of the flash icon in the viewfinder before you make the picture. As long as the asterisk is displayed, you can take other images at the same compensation amount.

FE Lock is a practical technique to use when shooting individual images. But if you're shooting a series of images under unchanging ambient light, then Flash Exposure Compensation is more efficient and practical.

Using Flash Control Options

Many of the onboard and accessory flash settings can be set using the Set-up 3 menu on the 50D. This menu offers an impressive array of adjustments for the built-in flash including the first or second curtain shutter sync, Flash Exposure Bracketing, and the choice of Evaluative or Average exposure metering.

If you're using an accessory Speedlite, you can use the Set-up 3 menu to set Flash Exposure Bracketing and choose between Evaluative or Average metering. This menu also enables you to change the Custom Function (C.Fn) settings for compatible Speedlites such as the 580 EX II. The functions on some Speedlites cannot be set on the camera. In those cases, the camera displays a message notifying you that the flash is incompatible with this option. However, you can set the options you want on the Speedlite itself.

To change settings for the onboard or compatible accessory EX-series Speedlites, follow these steps:

1. **Set the camera to P, Tv, Av, M, or A-DEP mode. If you're using an accessory Speedlite, mount it on the camera and turn it on.**

2. **Press the Menu button, and turn the Main dial until the Set-up 3 menu is displayed.**

3. **Turn the Quick Control dial to highlight Flash Control, and then press the Set button.** The Flash Control screen appears with options for the built-in and external flash.

4. **Turn the Quick Control dial to highlight the option you want, and then press the Set button.** Choose a control option from the Flash Control menu that you want, and then press the Set button. Table 7.3 lists the menu settings, options, and sub-options that you can choose from to control the flash.

Table 7.3
Flash Control Menu Options

Setting	Option(s)	Sub-options/Notes
Flash Firing	Enable, Disable	Turns the flash on and off for shooting in P, Tv, Av, M, and A-DEP modes. In automatic shooting modes, the flash still fires automatically.

continued

Table 7.3 *(continued)*

Setting	Option(s)	Sub-options/Notes
Built-in flash func. setting	Flash mode	E-TTL II (Cannot be changed from E-TTL II)
	Shutter Sync	1st curtain: Flash fires at the beginning of the exposure. Can be used with a slow-sync speed to create light trails in front of the subject.
		2nd curtain: Flash fires just before the exposure ends. Can be used with a slow-sync speed to create light trails behind the subject.
	Flash exp. Comp	Press the Set button to activate the Exposure Level meter, and then turn the Quick Control dial to set +/-2 Flash Exposure Compensation.
	E-TTL II	Evaluative. This default setting sets the exposure based on an evaluation of the entire scene. Average: Flash exposure is metered and averaged for the entire scene. Results in brighter output on the subject and less balancing of ambient background light.
External flash func. setting	Flash mode	E-TTL II, Manual flash, MULTI flash. Note that the settings may depend on Speedlite settings.
	Shutter sync	Hi-speed
		1st curtain: Flash fires immediately after the exposure begins.
		2nd curtain: Flash fires just before the exposure ends. Can be used with slow-sync speed to create light trails behind the subject.
	FEB (Flash Exposure Bracketing)	Press the Set button to activate the Exposure Level meter, and then turn the Quick Control dial to set the bracketing amount from +/- 3 EV.
	Flash exp. comp	Press the Set button to activate the Exposure Level meter, and then turn the Quick Control dial to set positive or negative compensation of +/- 2 stops.
	E-TTL II	Evaluative or Average if the Flash mode is set to E-TTL II.
	Zoom	Auto, or turn the Quick Control dial to set the zoom setting from 24mm to 105mm.
	Wireless set.	Wireless func.: Disable or Enable See the flash manual for details on additional settings.

Setting	Option(s)	Sub-options/Notes
External flash C.Fn setting	Custom Functions depend on the Speedlite in use.	
Clear ext. flash C.Fn set.	Turn the Quick Control dial to select OK, and then press the Set button to clear all Custom Functions for the Speedlite.	

Disabling the flash but enabling the flash's autofocus assist beam

In some lowlight scenes, you may want to shoot using ambient light without using the built-in or an accessory flash. But in low light, the camera may have trouble establishing good focus. In those scenes, you can use the autofocus assist beam from the flash to help the camera establish focus. The flash does not fire, but the assist beam shines so the camera can set sharp focus.

To disable flash firing but still allow the camera to use the flash's autofocus assist beam for focusing, follow these steps.

1. **Press the Menu button, and then turn the Main dial to display the Set-up 2 menu.**

2. **Turn the Quick Control dial to highlight Flash control, and then press the Set button.** The Flash control screen appears.

3. **Turn the Quick Control dial to highlight Flash firing, and then press the Set button.** Two options appear.

4. **Turn the Quick Control dial to highlight Disable, and then press the Set button.** Neither the built-in flash nor an accessory Speedlite will fire. To use the flash's autofocus assist beam, either pop up the built-in flash by pressing the Flash button on the front of the camera, or mount an accessory EX-series Speedlite. When you halfway press the Shutter button, the flash's autofocus assist beam fires to help the camera establish focus.

Also, with Custom Function C.Fn III-5, you can choose whether the AF-assist beam is fired by the camera's built-in flash or by an accessory Speedlite. If this function is set to Disable, the autofocus assist beam is not used. If you've set the Custom Function on the Speedlite for autofocus assist beam firing to Disable, the autofocus assist beam is not used. In short, be sure that the Custom Functions on both the 50D and on the accessory Speedlite are not in conflict with each other. If you're using the Wireless Transmitter ST-E2, you can use it to fire the autofocus assist beam in nonflash photos.

 Cross-Reference *For details on Custom Functions on the 50D, see Chapter 5.*

Built-in flash techniques

The big advantage of the built-in flash is that it is available anytime you need a pop of additional light. The scenarios for using the flash in P, Tv, Av, M, and A-DEP modes vary from filling shadows in outdoor portraits — a technique called fill flash — to providing the primary subject illumination in lowlight scenes.

7.3 In this backlit image, I used the built-in flash to bring out the features in the dog's dark face. I set a -2 Flash Exposure Compensation. The dog's facial features are nicely lit, and the backlighting provided a nice rim light. Exposure: ISO 100, f/4.5, 1/60 sec. with -1 Exposure Compensation and -2 Flash Exposure Compensation.

On the 50D, the E-TTL II setting automatically detects when the flash pops up and when the exposure for the ambient light in the scene is properly set. In those cases, the camera automatically provides reduced output to fill shadows in a natural-looking way as opposed to a blasted-with-flash rendering. However, if you want to retain more of the highlight-to-shadow ratio in the scene, you can use a -1 to -1.5 or more Flash Exposure Compensation, as I did in Figure 7.3 to reduce the flash output. Fill flash works well if you're not too far from the subject. And if you're more than 6 or 8 feet from your subject in direct sunlight, fill flash effectiveness is significantly reduced. With an accessory Speedlite, the reach is greater than with the built-in flash.

Flash Exposure Compensation is equally useful for backlit subjects. By setting a positive compensation of +1 or +1.5, you can brighten the dark appearance of the subject while retaining the ambient light exposure in the background. In this type of scene, the flash acts as the primary subject illumination, so you'll need to experiment with the compensation to avoid getting the too-bright look on the subject. I suggest starting with a +2/3-stop Flash Exposure Compensation, and then adjusting as necessary.

And if you want more of the ambient light to register in a flash image, then use Av or Tv mode and shoot with a wide aperture and/or with a slower shutter speed. Alternately in low light, you can increase the ISO to 400 or 800 to increase the sensor's sensitivity to light, and to get faster shutter speeds in lowlight.

Note *You can't use the technique to use more ambient light in the scene if you're using P mode. In P mode, the camera never allows shutter speeds slower than 1/60 second when you're using the built-in flash.*

Shooting with Speedlites and Studio Lighting

If one flash is good, it follows that more flash units would be better. While that logic doesn't hold true for everything, in the case of flash units it does. Multiple Speedlites enable you to set up lighting patterns and ratios that are similar to a studio lighting setup. You also have the option of using one or more flash units as either the main or an auxiliary light source to balance ambient light with flash to provide even and natural illumination and balance among light sources. Plus, unlike some studio lighting systems, a multiple Speedlite system is lightweight and portable.

> **Tip** *For detailed information on using Canon Speedlites, be sure to check out the Canon Speedlite System Digital Field Guide by J. Dennis Thomas (Wiley).*

Using multiple Speedlites and studio lights

The 50D is compatible with all EX-series Speedlites. You can also use other EZ and E-series flash units though you'll need to use the Guide Number to calculate exposure. With EX-series Speedlites, you get focal-plane Flash Sync, Flash Exposure Bracketing, and flash modeling (to preview the flash pattern before the image is made).

FP sync requires the flash unit to provide output over an extended time as the first and second shutter curtains traverse the image sensor plane. As they travel, they reveal a small section of the sensor at a time. As the sections are revealed, the flash pulses multiple times to make the flash exposure. As a result, you can use shutter speeds as high as 1/8000 second, the maximum shutter speed on the 50D.

When I travel to shoot portraits on location, I take three Speedlites with stands and silver umbrellas. This setup is a lightweight mobile studio that can either provide the primary lighting for subjects or supplement ambient light. Like most photographers, I also use a variety of reflectors.

Here is a quick look at various Speedlites and what to expect if you use them on the 50D.

✦ **580EX II, 580EX, and 550EX.** Fully compatible on the camera, provides E-TTL II capability, and can be used wirelessly as a master or slave unit.

✦ **540EZ.** Manual capability only and no wireless compatibility.

✦ **430EX II, 430EX, and 420 EZ.** Fully compatible on the camera, provides E-TTL II capability, and can be used wirelessly only as a slave unit. The 420EZ is also manual operation only with no wireless compatibility.

✦ **420EX.** Fully compatible on the camera and can be used wirelessly only as a slave unit.

✦ **MR-14EX Macro Ring and MT-24EX.** Fully compatible on the camera and can be used wirelessly only as a master unit.

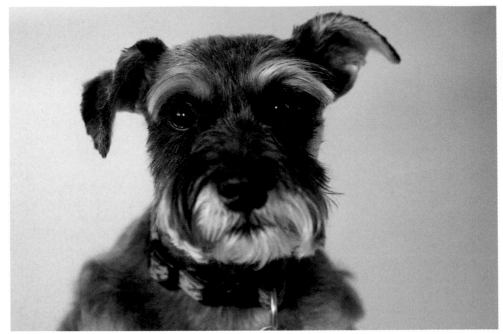

7.4 Here the dog is lit from a large window to the left. I lit the background with one EX Speedlite, and bounced the light from another Speedlite into a silver reflector to the right. The bounce flash filled shadows on the unlit side of the face. Exposure: ISO 100, f/2,8, 1/60 sec. with a -1 Exposure Compensation and a -1 Flash Exposure Compensation on the bounced flash unit.

In addition to the Speedlites, I use Canon's Speedlite Transmitter ST-E2. This transmitter wirelessly communicates with multiple Speedlites set up as groups or individually so that they fire at the same flash output. Alternately, you can set up slave units and vary the flash ratio from 1:8 – 1:1 – 1:8.

In addition, if you have a studio lighting system, the EOS 50D performs like a star with studio light. The PC terminal on the side of the 50D allows you to use wired strobes or wireless systems. I use a four-strobe Photogenic system with umbrellas, softboxes, and a large silver reflector for studio work.

7.5 This is the back of the Canon Speedlite Transmitter ST-E2. It enables you to set up groups of flash units, control the channel in case other photographers are shooting wirelessly nearby, and to set up the lighting ratio.

Canon suggests that with studio systems, you use 1/60 or 1/30 second sync speeds with large studio flash units because the flash duration is longer. I have found that for my strobes, a 1/125 second sync speed works best.

Caution *Do not connect a flash unit that requires 250 V or more to the 50D. If you're unsure about the voltage of the flash unit, use a Wein Safe Sync hot shoe PC adapter to protect the camera.*

7.6 The 50D is a pleasure to use with studio lighting systems. This image was lit by four Photogenic strobes: two on the background, two to camera left, and a large silver reflector to camera right. Exposure: ISO 100, f/22, 1/125 sec.

7.7 The Canon Speedlite 580EX II accessory flash. The 50D includes a waterproof jacket around the hot shoe that matches up to the 580EX II seal to keep water from getting into the electrical connection in wet weather.

Exploring flash techniques

While it's beyond the scope of this book to detail all the lighting options that you can use with one or multiple Speedlites, I'll cover some common flash techniques that provide better flash images than using straight-on flash.

Bounce flash

One frequently used flash technique is bounce flash, which softens hard flash shadows by diffusing the light from the flash. To bounce the light, turn the flash head so that it points diagonally toward the ceiling or a nearby wall so that the light hits the ceiling or wall and then bounces back to the subject. This technique spreads and softens the flash illumination as illustrated in figure 7.4.

If the ceiling is high, then it may underexpose the image. As an alternative, I often hold a silver or white reflector above the flash to act as a "ceiling." This technique offers the advantage of providing a clean light with no colorcast.

Adding catchlights to the eyes

Another frequently used technique is to create a catchlight in the subject's eyes by using the panel that is tucked into the flash head of some Speedlites. Just pull out the translucent flash panel on the Speedlite. At the same time a white panel comes out, and that is what you can use to create catchlights. The translucent panel is called the "wide" panel and it's used with wide-angle lenses to spread the light. Push the wide panel back in while leaving the white panel out. Point the flash head up, then take the

7.8 This image was lit by window light, the light from the chandelier, and the built-in flash with no flash exposure modification. The view from the window is a mixture of overexposure and blown-out details. Compare it to Figure 7.9 where flash balanced the lighting extremes. Exposure: ISO 100, f/11, 1/4 sec.

7.9 For this shot, I used two Speedlites on stands fired wirelessly by the Canon ST-E2 transmitter. One Speedlite was to camera right to lighten the chair seat shadows, and the other was held above the place settings. I set the exposure for the outdoor scene, and the two Speedlites properly exposed the interior. Exposure: ISO 100, f/11, 1/100 sec.

image. The panel throws light into the eyes, creating catchlights that add a sense of vitality to the eyes. For best results be within 5 feet of the subject.

If your Speedlite doesn't have a panel, you can tape an index card to the top of the flash to create catchlights as described previously.

Using a Speedlite as an auxiliary light

Especially with location shooting, it's important to evaluate the ambient light carefully and then use the Speedlite as a complement or supplement to it. I prefer this approach because the ambient light provides the sense of the subject's environment and the ambience of the location. As a result, I use the ambient light as the main light source whenever possible. And then I use one or more Speedlites as supporting lights to fill shadow areas or light the background, for example.

Balancing lighting extremes

With a little creativity in thinking about the flash and exposure modifications that are available on the 50D and Speedlites, you can balance the extremes in lighting differences between two areas. For example, if you're shooting an interior space that has a view to the outdoors and you want good detail and exposure in both areas, then combine Auto Exposure Compensation on the camera with Flash Exposure Compensation to balance the two areas.

Lenses and Accessories

The old axiom "the camera is as good as the lens" certainly holds true for the EOS 50D. With the 50's high resolution, small pixel size, and the small APS-C-size sensor, the camera demands a lot from lenses. While 50D images are excellent with all of the Canon lenses, it delivers the best images with high-quality lenses. With this in mind, the decisions that you make on adding lenses to your gear bag are some of the most important decisions you'll make. And, as most photographers know, over time, the investment in lenses over time far exceeds the investment in the camera body.

This chapter explores the world of Canon lenses, and it details the 50D's new lens calibration and peripheral illumination correction features. In addition, this chapter examines lens accessories that can extend your photographic system, and introduces key lens terms and technologies so that you'll know what to look for as you add lenses to your system.

Evaluating Lens Choices for the 50D

The EOS 50D is compatible with more than 50 Canon EF and EF-S lenses and accessories. That's a wide range of lenses, and your options are even more extensive when you factor in compatible lens from third-party companies. This section gives you a solid grounding in lens types and characteristics as they relate to the EOS 50D.

Building a lens system

One of the first considerations photographers face is how to build a lens system. In practice, the answer is different for everyone, but a few basic tips can help you create a solid strategy. For photographers buying their first and second lenses, a rule of thumb is to buy two lenses that cover the focal range from wide-angle to telephoto. With those two lenses, you can shoot 80 to 95 percent of the scenes and subjects that you'll encounter. These two lenses form the foundation for all your shooting, and, for that reason, they should be high-quality lenses that produce images with snappy contrast and excellent sharpness, and they should be fast enough to allow shooting in lowlight. A "fast lens" is generally considered to be a lens with a maximum aperture of f/2.8 or faster.

For example, when I switched to Canon cameras about six years ago, I followed this advice and bought the Canon EF 24-70mm f/2.8L USM lens and the EF 70-200mm f/2.8L IS USM lens — two high-quality lenses that covered the focal range of 24mm to 200mm. Six years later, these two lenses are still the ones I most often use for everyday shooting. And because I shoot with a variety of Canon EOS cameras, I know that I can mount these lenses on the 50D, the XSi, the 5D Mark II, or the 1Ds Mark III and get sterling images.

If you bought the 50D as a kit with the EF 28-135mm f/3.5-5.6 IS USM, then you may already have learned that while this lens seems to provide a good focal range, in practice, it falls short of giving a true wide-angle view. The 28-135mm lens falls short on the wide-angle side of the focal range

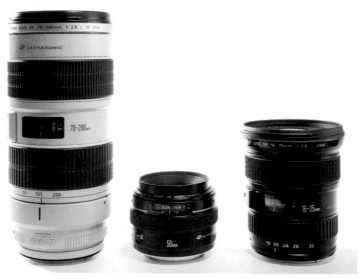

8.1 The EF 70-200mm f/2.8L IS USM, the EF 50mm f/1.4 USM, and the 16-35mm f/2.8L USM lenses cover most everyday shooting situations, and they are a good starting point for building a lens system.

because of the focal length multiplier, which is discussed next. Getting a wide-angle view is, of course, important for landscape, cityscape, interior, and architectural shooting as well as for photographing groups of people. On the other hand, if you bought the 50D as a kit with the EF-S 18-200mm f/3.5-5.6 IS lens, you paid more, but you also got a lens that is truly wide-angle.

Understanding the focal-length multiplier

One of the most important lens considerations for the 50D is its smaller APS-C-size image sensor. APS-C is simply a designation that indicates that the image sensor is 1.6 times smaller than a traditional full 35mm frame. As a result, the lenses you use on the 50D have a smaller angle of view than a full-frame camera. A lens's angle of view is how much of the scene, side-to-side and top-to-bottom, that the lens encompasses in the image.

In short, the angle of view for Canon EF lenses that you use on the 50D is reduced by a factor of 1.6 times at any given focal length. That means that a 100mm lens is equivalent to a 160mm when used on the 50D. Likewise, a 50mm normal lens is the equivalent to using an 80mm lens — a short telephoto lens.

This focal-length multiplication factor works to your advantage with a telephoto lens because it effectively increases the lens's focal length (although technically the focal length doesn't change). And because telephoto lenses tend to be more expensive than other lenses, you can buy a shorter and less expensive telephoto lens and get 1.6 times more magnification at no extra cost.

The focal-length multiplication factor works to your disadvantage with a wide-angle lens because the sensor sees less of the scene because the focal length is magnified by 1.6. However, because wide-angle lenses tend to be less expensive than telephoto lenses, you can buy an ultrawide 14mm lens to get the equivalent of an angle of view of 22mm.

As you think about the focal-length multiplier effect on telephoto lenses, it seems reasonable to assume that the multiplier also produces the same depth of field that a longer lens — the equivalent focal length — gives. That isn't the case, however. Although an 85mm lens on a full 35mm-frame camera is equivalent to a 136mm lens on the 50D, the depth of field on the 50D matches the 85mm lens, not a 136mm lens.

This depth-of-field principle holds true for enlargements. The depth of field in the print is shallower for the longer lens on a full-frame camera than it is for the 50D.

And that brings us to another important lens distinction for the 50D. The 50D is compatible with all EF-mount lenses and with all EF-S-mount lenses. The EF lens mount is compatible across all Canon EOS cameras regardless of image sensor size, and regardless of camera type, whether digital or film. The EF-S lens mount, however, is specially designed to have a smaller image circle, or the area covered by the image on the sensor plane. EF-S lenses can be used only on cameras with a cropped frame such as the 50D, XSi, and 40D among others because of a rear element that protrudes back into the camera body.

The difference in lens mounts should also factor into your plan for building a lens system. As you consider lenses, think about

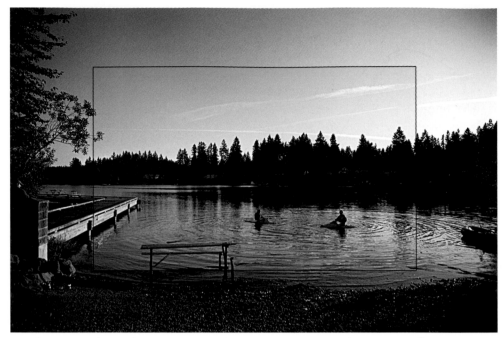

8.2 This image shows the approximate difference in image size between a full-frame 35mm camera and the 50D. The smaller image size represents the 50D's image size.

whether you want lenses that are compatible with both a full-frame camera and a cropped sensor, or not. Remember that as your photography career continues, you'll most likely buy a second camera body or move to another EOS camera body. And if your next EOS camera body has a full-frame sensor, then you'll want the lenses that you've already acquired to be compatible with it.

Types of Lenses

The most common question that photography students ask is, "What lens should I buy?" It is virtually impossible to answer that question for someone else because the answer depends on so many variables, including the photographer's shooting preferences, existing lenses, and budget. The best advice is to have a strategy based on the scenes and subjects that you shoot, your budget, and your plans for expanding your photography. With that said, the best starting point for considering new lenses is to gain a solid understanding of the different types of lenses and their characteristics. Only then can you evaluate which types of lenses best fit your needs. The following sections provide a foundation for evaluating lenses by category and by characteristics.

Lenses are divided by whether they zoom to different focal lengths or have a fixed focal length — known as prime lenses. Then within

those two categories, lenses are grouped by focal length (the amount of the scene included in the frame) in three main categories: wide angle, normal, and telephoto. And within those categories are macro lenses that serve double-duty as either normal or telephoto lenses with macro capability.

At the top level of lens groupings are zoom and prime, or single focal-length lenses. The primary difference between zoom and prime lenses is that zoom lenses offer a range of focal lengths in a single lens while prime lenses offer a fixed, or single, focal length. There are additional distinctions that come into play as you evaluate whether a zoom or prime lens is best for your shooting needs.

About zoom lenses

Zoom lenses, with variable focal lengths, are versatile — just zoom the lens to bring the subject closer or farther away. The obvious advantage of a zoom lens is the ability to quickly change focal length and image composition without changing lenses. In addition, zoom lenses allow you to carry fewer lenses. For example, carrying a Canon EF-S 17-55mm f/2.8 IS USM lens and a Canon EF 55-200mm f/4.5-5.6 II USM lens, or a similar combination of lenses, provides the focal range needed for most everyday shooting.

Zoom lenses, which are available in wide-angle and telephoto ranges, are able to maintain focus during zooming. To keep the lens size compact, and to compensate for aberrations with fewer lens elements, most zoom lenses use a multi-group zoom with three or more movable lens groups. Most

mid-priced and more expensive zoom lenses offer high-quality optics that produce sharp images with excellent contrast. As with all Canon lenses, full-time manual focusing is available by switching the button on the side of the lens to MF (Manual Focusing).

Some zoom lenses are slower than single focal-length lenses, and getting a fast zoom lens means paying a higher price. In addition, some zoom lenses have a variable aperture, which means that the minimum aperture changes at different zoom settings (discussed in the following sections). While zoom lenses allow you to carry around fewer lenses, they tend to be heavier than their single focal-length counterparts.

Other zoom lenses have variable apertures. An f/4.5 to f/5.6 variable-aperture lens means that at the widest focal length, the maximum aperture is f/4.5 and at the longer end of the focal range, the maximum aperture is f/5.6. In practical terms, this limits the versatility of the lens at the longest focal length for shooting in all but bright light or at a high ISO setting. And unless you use a tripod or your subject is stone still, your ability to get a crisp picture in lower light at f/5.6 will be questionable.

> **Cross-Reference** *For a complete discussion of aperture, see Appendix A.*

More expensive zoom lenses offer a fixed and fast maximum aperture, meaning that with maximum apertures of f/2.8, they allow faster shutter speeds that enhance your ability to get sharp images when handholding the camera. But the lens speed comes at a price: the faster the lens, the higher the price.

expressiveness. Wide apertures allow fast shutter speeds that enable you to handhold the camera in lower light and still get a sharp image. Compared to zoom lenses, single focal-length lenses are lighter and smaller. In addition, single focal-length lenses tend to be sharper than some zoom lenses.

8.3 Wide-angle zoom lenses such as the Canon EF 16-35mm f/2.8L USM lens help bridge the focal-length multiplier gap by providing a wide view of the scene.

About prime lenses

While you hear much less about prime or single-focal-length lenses, they are worth careful evaluation. With a prime lens, the focal length is fixed, so you must move closer to or farther from your subject, or change lenses to change image composition. Canon's venerable EF 50mm f/1.4 USM lens and EF 100mm f/2.8 Macro USM are only two of a full lineup of Canon prime lenses.

Unlike zoom lenses, prime lenses tend to be fast with maximum apertures of f/2.8 or wider, and they enable a broad range of creative

8.4 Single focal-length lenses such as the EF 50mm f/1.4 USM lens are smaller and lighter and provide excellent sharpness, contrast, and resolution when used on the 50D.

Most prime lenses are lightweight, but you need more of them to cover the range of focal lengths needed for everyday photography. Prime lenses also limit the options for on-the-fly composition changes that are possible with zoom lenses.

Working with Different Types of Lenses

Within the categories of zoom and prime lenses, lenses are grouped by their focal length. While some lenses cross group lines, the groupings are still useful for talking about lenses in general. Each type of lens has specific characteristics that you can use creatively to render images as you envision them. So as you read about the characteristics, consider how you can use each lens creatively and perhaps out of the traditional context.

Before going into specific lenses, here are several concepts that are helpful to understand. First, the lens's angle of view is expressed as the angle of the range that's being photographed, and it's generally shown as the angle of the diagonal direction. The image sensor is rectangular, but the image captured by the lens is circular, and it's called the image circle. The image that's captured is taken from the center of the image circle.

For a 15mm fisheye lens, the angle of view is 180 degrees on a full-frame 35mm camera. For a 50mm lens, it's 46 degrees; and for a 200mm lens, the angle of view is 12 degrees. Simply stated, the shorter the focal length, the wider the scene coverage, and the longer the focal length, the narrower the coverage.

The lens's aperture range also affects the depth of field. Depth of field is the range in front of and behind the subject that is in acceptably sharp focus. The depth of field is affected by several factors including the lens's focal length, aperture (f-stop), focus position, camera-to-subject distance, and subject-to-background distance.

 Cross-Reference *Depth of field and the basic elements of photography are detailed in Appendix A.*

Finally, the lens you choose affects the perspective of images. Perspective is the visual effect that determines how close or far away the background appears to be from the main subject. The shorter (wider) the lens, the more distant background elements appear to be, and the longer (more telephoto) the lens, the more compressed the elements appear.

Using wide-angle lenses

Wide-angle lenses are aptly named because they offer a wide view of a scene. Generally, lenses shorter than 50mm are commonly considered wide angle on full-frame 35mm image sensors. Not including the 15mm fisheye lens, wide-angle and ultra-wide lenses range from 17mm to 40mm on a full-frame camera. The wide-angle lens category provides angles of view ranging from 114 to 63 degrees.

However, on the EOS 50D, the 1.6x focal-length multiplier works to your disadvantage. For example, with the EF 28-135mm f/3.5-5.6 IS kit lens, the lens translates to only 44mm on the wide end and 216mm on the telephoto end of the lens. The telephoto range is excellent, but you don't get a wide angle of view on the 50D with this lens. Thus, if you often shoot landscapes,

cityscapes, architecture, and interiors, a first priority will be to get a lens that offers a true wide-angle view. Good choices include the EF 16-35mm f/2.8L II USM (approximately 26 to 56mm with the 1.6x multiplier), the EF-S 10-22mm f/3.5-4.5 USM lens (approximately 16 to 35mm with the multiplier), or the EF 17-40mm f/4L USM lens (approximately 27 to 64mm with the multiplier).

Wide-angle lenses are ideal for capturing scenes ranging from sweeping landscapes and underwater subjects to large groups of people, and for taking pictures in places where space is cramped.

When you shoot with a wide-angle lens, keep these lens characteristics in mind:

✦ **Extensive depth of field.** Particularly at small apertures from f/11 to f/32, the entire scene, front to back, will be in acceptably sharp focus. This characteristic gives you slightly more latitude for less-than-perfectly focused pictures.

✦ **Fast apertures.** Wide-angle lenses tend to be faster (meaning they have wider apertures) than telephoto lenses. As a result, these lenses are good choices for everyday shooting when the lighting conditions are not optimal.

8.5 To get the traditional wide-angle view on the 50D, you need an ultra-wide-angle lens such as the EF 16-35mm f/2.8L USM lens that I used here. The focal length was set to 17mm. Exposure: ISO 100, f/16, 1/80 sec.

✦ **Distortion.** Wide-angle lenses can distort lines and objects in a scene, especially if you tilt the camera up or down when shooting. For example, if you tilt the camera up to photograph a group of skyscrapers, the lines of the buildings tend to converge and the buildings appear to fall backward (also called *keystoning*). You can use this wide-angle lens characteristic to creatively enhance a composition, or you can move back from the subject and keep the camera parallel to the main subject to help avoid the distortion.

✦ **Perspective.** Wide-angle lenses make objects close to the camera appear disproportionately large. You can use this characteristic to move the closest object farther forward in the image, or you can move back from the closest object to reduce the effect. Wide-angle lenses are popular for portraits, but if you use a wide-angle lens for close-up portraiture, keep in mind that the lens exaggerates the size of facial features closest to the lens, which is unflattering.

Using telephoto lenses

Telephoto lenses offer a narrow angle of view, enabling close-ups of distant scenes. On full 35mm-frame cameras, lenses with focal lengths longer than 50mm are considered telephoto lenses. For example, 80mm and 200mm lenses are telephoto lenses. On the 50D, however, the focal-length multiplier works to your advantage with telephoto lenses. Factoring in the 1.6x multiplier, a 50mm lens is equivalent to 80mm, or a short telephoto lens. And because telephoto

lenses are more expensive overall than wide-angle lenses, you get more focal length for your money when you buy telephoto lenses for the 50D.

Telephoto lenses offer an inherently shallow depth of field that is heightened by shooting at wide apertures. Lenses such as 85mm and 100mm are ideal for portraits, while longer lenses (200mm to 800mm) allow you to photograph distant birds, wildlife, and athletes. When photographing wildlife, these lenses also allow you to keep a safe distance.

8.6 For this Cascade Mountains sunset, I used the EF 100-400mm f/4.5-5.6L IS USM lens. I used a 100mm focal length, and Image Stabilization enabled me to handhold the camera and lens at a 1/50-second shutter speed. Exposure: ISO 100, f/4.5, 1/50 second.

When you shoot with a telephoto lens, keep these lens characteristics in mind:

✦ **Shallow depth of field.** Telephoto lenses magnify subjects and provide a limited range of sharp focus. At wide apertures, you can reduce the background to a soft blur. Because of the extremely shallow depth of field, it's important to get tack-sharp focus. Canon lenses include full-time manual focusing that you can use to fine-tune the camera's autofocus as well as an extensive lineup of Image Stabilized telephoto lenses.

✦ **Narrow coverage of a scene.** Because the angle of view is narrow with a telephoto lens, much less of the scene is included in the image. You can use this characteristic to exclude distracting scene elements from the image.

✦ **Slow speed.** Midpriced telephoto lenses tend to be slow; the widest aperture is often f/4.5 or f/5.6, which limits the ability to get sharp images without a tripod in all but the brightest light unless they also feature Image Stabilization. And because of the magnification factor, even the slightest movement is exaggerated.

✦ **Perspective.** Telephoto lenses tend to compress perspective, making objects in the scene appear close together.

Using normal lenses

Normal lenses offer an angle of view and perspective very much as your eyes see the scene. On full 35mm-frame cameras, 50mm to 55mm lenses are considered normal lenses. However, on the 50D, a normal lens is 28mm to 35mm when you take into account the focal-length multiplier. And, likewise, the 50mm lens is equivalent to an 80mm lens on the 50D.

Answering the Inevitable Question

I don't make it a habit to recommend specific lenses particularly because the lenses that suit my shooting assignments and budget may not match your needs and budget. But I'll say that my general approach to adding lenses to my system is to buy the highest-quality lens available in the focal length that I need. If I can't afford the highest-quality lens, then I wait and save money until I can buy it. For example, my last lens purchase was an EF 100-400 f/4.5-5.6L IS USM lens, and it took me a year to save enough money to buy it.

But for inquiring minds, the workhorse lenses in my gear bag are the first two Canon lenses I bought: the EF 70-200mm f/2.8L IS USM and the EF 24-70mm f/2.8L USM lens. Both lenses have outstanding optics, superb sharpness, and excellent resolution and contrast on *any* EOS camera body. I also frequently use the EF 100mm f/2.8 Macro USM lens, the EF 50mm f/1.4 USM, and the EF 100-400 f/4.5-5.6L IS USM. I've used these and other lenses on the 50D with great image results. If you're looking for a new lens, always check lens reviews in magazines and on the Web.

When you shoot with a normal lens, keep these lens characteristics in mind:

✦ **Natural angle of view.** On the 50D, a 28 or 35mm lens closely replicates the sense of distance and perspective of the human eye. This means the final image will look much as you remember seeing it when you made the picture.

✦ **Little distortion.** Given the natural angle of view, the 28-35mm lens retains a normal sense of distance, especially when you balance the subject distance, perspective, and aperture.

Using macro lenses

Macro lenses are designed to provide a closer lens-to-subject focusing distance than non-macro lenses. Depending on the lens, the magnification ranges from half life size (0.5x) to 5x magnification. Thus, objects as small as a penny or a postage stamp can fill the frame, while nature macro shots can reveal breathtaking details that are commonly overlooked or are not visible to the human eye. Macro lenses are single focal-length lenses that come in normal and telephoto focal lengths.

8.7 The EF 50mm f/1.4 USM lens is a "normal" lens on a full-frame camera. On the 50D it translates to a short telephoto. Regardless of designation, this lens offers snappy contrast as it did with these yellow roses. Exposure: ISO 100, f/5.6, 1/125 sec.

8.8 Canon offers several macro lenses including the EF 180mm f/3.5L Macro USM (left) that offers 1x (life-size) magnification and a minimum focusing distance of 0.48m/1.6 ft. Also shown here is the Canon EF 100mm f/2.8 Macro USM lens.

Macro lenses open a new world of photographic possibilities by offering an extreme level of magnification. In addition, the reduced focusing distance allows beautiful, moderate close-ups as well as extreme close-ups of flowers and plants, animals, raindrops, and everyday objects. The closest focusing distance can be further reduced by using extension tubes.

Normal and telephoto lenses offer macro capability. Because these lenses can be used both at their normal focal length as well as for macro photography, they do double-duty. Macro lenses offer one-half or life-size magnification or up to 5X magnification with the MP-E 65mm f/2.8 1-5 Macro Photo lens.

If you're buying a macro lens, you can choose lenses by focal length or by magnification. If you want to photograph moving subjects such as insects, choose a telephoto lens with macro capability. Moving subjects require special techniques and much practice.

8.9 One of my favorite lenses on the 50D is the EF 100mm f/2.8 Macro USM lens that I used to capture this detail shot of a lily petal. Exposure: ISO 400, f/2.8, 1/50 sec.

Using tilt-and-shift lenses

Tilt-and-shift lenses, referred to as TS-E lenses, allow you to alter the angle of the plane of focus between the lens and sensor plane to provide a broad depth of field even at wide apertures and to correct or alter perspective at almost any angle. This allows you to correct perspective distortion and control focusing range.

Tilt movements allow you to bring an entire scene into focus even at maximum apertures. By tilting the lens barrel, you can adjust the lens so that the plane of focus is uniform on the focal plane, thus changing the normally perpendicular relationship between the lens's optical axis and the camera's focal plane. Alternately, reversing the tilt has the opposite effect of greatly reducing the range of focusing.

Shift movements avoid the trapezoidal effect that results from using wide-angle lenses pointed up to take a picture of a building, for example. Keeping the camera so that the focal plane is parallel to the surface of a wall and then shifting the TS-E lens to raise the lens results in an image with the perpendicular lines of the structure being rendered perpendicular and with the structure being rendered with a rectangular appearance.

TS-E lenses revolve within a range of plus/minus 90 degrees making horizontal shift possible, which is useful in shooting a series of panoramic images. You can also use shifting to prevent having reflections of the camera or yourself in images that include reflective surfaces, such as windows, car surfaces, and other similar surfaces.

All of Canon's TS-E lenses are manual focus only. These lenses, depending on the focal length, are excellent for architectural, interior, merchandise, nature, and food photography.

Using Image Stabilized lenses

For anyone who's thrown away a stack of images blurred from handholding the camera at slow shutter speeds, the idea of Image Stabilization is a welcome one. Image Stabilization (IS) counteracts some or all of the motion blur from handholding the camera and lens. If you've shopped for lenses lately, then you know that IS comes at a premium price. IS lenses are pricey because they give you from 1 to 4 f-stops of additional stability over non-Image Stabilized lenses — and that means that you may be able to leave the tripod at home.

With an IS lens, miniature sensors and a high-speed microcomputer built into the lens analyze vibrations and apply correction via a stabilizing lens group that shifts the image parallel to the focal plane to cancel camera shake. The lens detects camera motion via two gyro sensors — one for yaw and one for pitch. The sensors detect the angle and speed of shake. Then the lens shifts the IS lens group to suit the degree of shake to steady the light rays reaching the focal plane.

Stabilization is particularly important with long lenses, where the effect of shake increases as the focal length increases. As a result, the correction needed to cancel camera shake increases proportionately.

8.10 To capture this image of a robin at the birdbath, I used the EF 100-400mm f/4.5-5.6L IS USM lens zoomed to 400mm with Image Stabilization turned on for this handheld shot. Exposure: ISO 100, f/5.6, 1/125 sec.

To see how the increased stability pays off, consider that the rule of thumb for hand-holding the camera and a non-IS lens is 1/ [focal length]. For example, the slowest shutter speed at which you can handhold a 200mm lens and avoid motion blur is 1/200 second. If the handholding limit is pushed, then shake from handholding the camera bends light rays coming from the subject into the lens relative to the optical axis, and the result is a blurry image.

Thus, if you're shooting in low light at a music concert or a school play, the chances of getting sharp images at 200mm are low because the light is too low to allow a 1/200 second shutter speed even at the maximum aperture of the lens. You can, of course, increase the ISO sensitivity setting and risk introducing digital noise into the images. But if you're using an IS lens, the extra stops of stability help minimize ISO increases to get better image quality, and you still have a good chance of getting sharp images by handholding the camera and lens.

But what about when you want to pan or move the camera with the motion of a sub-ject? Predictably, IS detects panning as cam-era shake and the stabilization then interferes with framing the subject. To correct this, Canon offers two modes on IS lenses. Mode

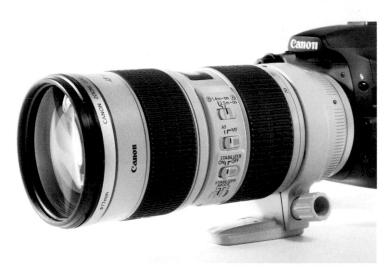

8.11 This 70-200mm f/2.8L IS USM lens offers Image Stabilization in two modes: one for stationary subjects and the second for panning with subjects horizontally.

1 is designed for stationary subjects. Mode 2 shuts off image stabilization in the direction of movement when the lens detects large movements for a preset amount of time. So when panning horizontally, horizontal IS stops but vertical IS continues to correct any vertical shake during the panning movement.

Calibrating and Fine-Tuning Lenses

Two common lens problems are vignetting and back or front focusing. You can correct these problems yourself with two new 50D features. If you've winced more than once over images where the point of sharpest focus is slightly in front of or behind where

you set it, you can now tweak the lens focus in the comfort of your own home or studio. And with the Peripheral Illumination Correction option, you can have the camera automatically correct for vignetting for up to 20 Canon lenses.

Calibrating lenses for focus accuracy

In the past, if a lens focused slightly in front of or behind a subject, you'd send the camera to Canon where technicians would carefully make microadjustments to refine the focus. Now, however, Canon puts that ability in your hands — should you decide to accept the assignment. Generally this assignment is not for the faint of heart or for the impatient.

In practice, you should seldom need to use Canon's AF Microadjustment option. According to Canon documents on this subject, the adjustment should be made only in two instances. The first instance is if you notice a consistent tendency for the sharpest plane of focus in *all* of your images to be in front of or behind the actual plane where you focused. This is commonly referred to as front focusing and back focusing. In this case, microadjustment is applied to all lenses. The second instance is if you notice front or back focusing only with *specific* lenses. In this case, microadjustment is applied only to specific lenses.

When you make microadjustments, the camera's sharpest plane of focus is shifted forward or backward to compensate for front or back focusing. The adjustment is applied within the camera body and its internal AF system. And if you need to, you can store adjustment information for up to 20 lenses.

If you search the Web, you'll find various test targets that you can use for the microadjustment procedure. Typically, the test targets are displayed on a computer monitor. Alternately, Canon suggests that you can use something as simple as a 12-inch ruler for making test shots.

If you notice front- or back-focusing on one or all lenses, then you can adjust the plane of focus using the new microadjustment function on the 50D. Before you begin, be aware that you cannot make the microadjustments using Live View shooting.

To make the adjustments, follow these steps.

1. **With the 50D mounted on a tripod, shoot a target subject at a distance similar to what you'd normally shoot the subject.** The subject should have discernable detail both in front of and behind where you focus. Keep the focus point at the exact same spot for all images in the test.

2. **With the lens at the widest aperture, select the center AF point *manually*.** Do not use Automatic AF-point selection mode. With zoom lenses, zoom the lens to its maximum telephoto focal length. Avoid using wide focal lengths for creating test photos. The adjustment is always based on the lens's maximum aperture, not on the lens's focal length.

> **Note** *The camera cannot distinguish between two of the same lenses. In other words, it cannot distinguish between two 70-200mm f/2.8L lenses. But it can distinguish between an EF 70-200mm f/2.8L USM and an EF 70-200mm f/2.8L IS USM lens. You can also do the test with either the 1.4x or 2x teleextender on the lens.*

3. **With the camera set to P, Tv, Av, M, or A-DEP shooting mode, press the Menu button and turn the Main dial to select the Custom Functions menu.**

4. **Turn the Quick Control dial to select C. Fn III: Autofocus/Drive, and then press the Set button.** The last C.Fn that you accessed is displayed.

5. **Turn the Quick Control dial until the number 7 appears in the control at the top right of the screen with the C. Fn III: Autofocus/Drive AF Microadjustment screen.**

6. **Press the Set button.** The options control is activated. One of three options can be selected: Option 0: Disable; Option 1: Adjust all by same amount; and Option 2: Adjust by lens. If all images are front or back focused, then choose Option 1. If only one or two lenses are front or back focused, then choose Option 2.

7. **Turn the Quick Control dial to select the option you want, and then press the INFO. button.** The AF Microadjustment screen appears with the currently mounted lens listed on the screen and a scale with plus/minus 20 steps of correction.

8. **Turn the Quick Control dial to the left to adjust focusing forward or to the right to adjust focusing toward the back.** Single-step adjustments are very fine, so starting with a large adjustment such as + or -20 and progressively narrowing the adjustment from there is recommended.

9. **Take several images at various adjustment positions and view the images at 100 percent enlargement on a high-quality computer monitor.** Do not use the LCD monitor to judge the correction levels. When you find the adjustment that is closest to putting the plane of focus where it should be, then shoot some real-world images at the setting, evaluate the sharpness, and adjust if necessary.

If you don't like the results, you can reset the adjustment scale to the zero point. Or after completing step 7, press the Erase button on the back of the camera to clear all AF Microadjustment registered data. Then turn the Quick Control dial to select OK, and press the Set button.

Setting lens peripheral correction

Depending on the lens that you use on the 50D, you may notice a bit of light falloff and darkening in the four corners of the frame. Light falloff describes the effect of less light reaching the corners of the frame as compared to the center of the frame. The darkening effect at the frame corners is known as vignetting. Vignetting is most likely to be evident in images when you shoot with wide-angle lenses, when you shoot at a lens's maximum aperture, or when an obstruction such as the lens barrel rim or a filter reduces light reaching the frame corners. Light falloff is also sometimes referred to as vignetting, and I use vignetting as a general term to encompass both.

On the 50D, you can correct vignetting for JPEG shooting. If you shoot RAW or sRAW images, you can correct vignetting in Canon's Digital Photo Professional program during RAW image conversion. When you turn on Peripheral Illumination Correction, the camera detects the lens that you've mounted, and it applies the appropriate correction level. The 50D can detect 20 lenses, but you can add information for other lenses by using the EOS Utility software supplied on the EOS Solutions Disk.

Note *In the strictest sense, vignetting is considered to be unwanted effects in images. However, vignetting is also a creative effect that photographers sometimes intentionally add to an image during editing to bring the viewer's eye inward toward the subject.*

You can test your lenses for vignetting by photographing an evenly lit white subject such as a white paper background or wall at the lens's maximum aperture and at a moderate aperture such as f/8 and examine the images for dark corners. Then you can enable Peripheral Illumination Correction on the camera and repeat the images to see how much difference it makes.

If you use Peripheral Illumination Correction for JPEG images, the amount of correction applied is just shy of the maximum amount. If you shoot RAW images, you can, however, apply the maximum correction in Digital Photo Professional. Also, the amount of correction for JPEG images decreases as the ISO sensitivity setting increases. If the lens has little vignetting, the difference in using Peripheral Illumination Correction may be difficult to detect. If the lens does not communicate distance information to the camera, then less correction is applied. Canon recommends that you turn off correction if you use a non-Canon lens.

Here's how to turn on Peripheral Illumination Correction:

1. **Set the camera to the JPEG image quality setting that you want.**

2. **Press the Menu button, and then turn the Main dial to highlight the Shooting 1 menu.**

3. **Turn the Quick Control dial to highlight Peripheral illumin. Correct., and then press the Set button.** The Peripheral illumin. Correct. screen appears with the attached lens listed, and whether or not correction data is available. If correction data is unavailable, then you can register correction data using the Canon EOS Utility program.

4. **Turn the Quick Control dial to select Enable if it isn't already selected, and then press the Set button.**

Doing More with Lens Accessories

There are a variety of ways to increase the focal range and decrease the focusing distance to provide flexibility for the lenses you already own. These accessories are not only economical, but they extend the range and creative options of existing and new lenses. Accessories can be as simple as a lens hood to avoid flare, a tripod mount to quickly change between vertical and horizontal positions without changing the optical axis or the geometrical center of the lens, or a drop-in or adapter-type gelatin filter holder. Other options include using extension tubes, extenders, and close-up lenses.

Lens extenders

For relatively little cost, you can increase the focal length of any lens by using an extender. An *extender* is a lens set in a small ring mounted between the camera body and a regular lens. Canon offers two extenders, a 1.4x and 2x, that are compatible only with L-series Canon lenses. Extenders can also be combined for even greater magnification.

For example, using the Canon EF 2x II extender with a 600mm lens doubles the lens's focal length to 1200mm before applying 1.6x. Using the Canon EF 1.4x II extender increases a 600mm lens to 840mm.

However, extenders reduce the light reaching the sensor. The EF 1.4x II extender decreases the light by 1 f-stop, and the EF 2x II extender decreases the light by 2 f-stops. In addition to being fairly lightweight, the obvious advantage of extenders is that they can reduce the number of telephoto lenses you carry.

The 1.4x extender can be used with fixed focal-length lenses 135mm and longer (except the 135mm f/2.8 Softfocus lens) and the 70-200mm f/2.8L, 70-200mm f/2.8L IS, 70-200mm f/4.0L, 70-200mm f/4.0L IS USM, and 100-400mm f/4.5-5.6L IS zoom lenses. With the EF 2x II, autofocus is possible if the lens has an f/2.8 or faster maximum aperture and compatible IS lenses continue to provide stabilization for two shutter speeds less than 1/focal length in seconds.

Extension tubes and close-up lenses

Extension tubes are close-up accessories that provide magnification increases from approximately 0.3 to 0.7, and they can be used on many EF lenses, though there are exceptions. Extension tubes are placed between the camera body and lens and connect to the camera via eight electronic contact points. Extension tubes can be combined for greater magnification.

8.12 Extenders, such as this Canon EF 1.4x II mounted between the camera body and the lens, extend the range of L-series lenses. They increase the focal length by a factor of 1.4x, in addition to the 1.6x focal-length conversion factor inherent in the camera.

Canon offers two extension tubes, the E 12 II and the EF 25 II. Magnification differs by lens, but with the EF12 II and standard zoom lenses, it is approximately 0.3 to 0.5. With the EF25 II, magnification is 0.7. When combining tubes, you may need to focus manually.

Extension tube EF 25 II is not compatible with the EF 15mm f/2.8 Fisheye, EF 14mm f/2.8L USM, EF 20mm f/2.8 USM, EF 24mm f/1.4L USM, EF 16-35mm f/2.8L USM, EF 17-40mm f/4L USM, EF 20-35mm f/3.5-4.5 USM, EF 24-70mm f/2.8L USM, MP-E 65mm f/2.8 1-5x Macro Photo, TS-E 45mm f/2.8, and EF-S 18-55mm f/3.5-5.6 (at wide angles). Extension tube EF12 II is not compatible with the EF 15mm f/2.8 Fisheye, EF 14mm, f/2.8L USM, and MP-E 65mm f/2.8 1-5X Macro Photo lens.

Additionally, you can use screw-in close-up lenses. Canon offers three lenses that provide enhanced close-up photography. The 250D/500D series uses a double-element design for enhanced optical performance. The 250D/500D series features double-element achromatic design to maximize optical performance. The 500 series has a single-element construction for economy. The working distance from the end of the lens is 25cm for the 250D and 50cm for the 500D.

Learning Lens Lingo and Technology

As you think about the lenses that you want to add to your system, it helps to also understand the language and technologies that apply to lenses. Canon uses several designations and lens construction technologies that are summarized here.

✦ **EF lens mount.** The designation EF identifies the type of mount that the lens has. The EF lens mount provides not only quick mounting and removal of lenses, but it also provides the communication channel between the lens and the camera body. The EF mount is fully electronic and resists abrasion, play, and shock. The EF system does a self-test using a built-in microcomputer that alerts you to possible malfunctions of the lens via the camera's LCD screen. In addition, if you use lens extenders, the exposure compensation is automatically calculated.

✦ **USM.** When you see USM it indicates the lens features an ultrasonic motor. A USM lens has an ultrasonic and very quiet focusing mechanism (motor) that is built in. The motor is powered by the camera; however, because the lens has its own focusing motor you get exceptionally fast focus. USM lenses use electronic vibrations created by piezoelectric ceramic elements to provide quick and quiet focusing action with near instantaneous starts and stops.

In addition, lenses with a ring-type ultrasonic motor offer full-time manual focusing without the need to first switch the lens to manual focus. This design is offered in the large-aperture and super-telephoto lenses. A second design, the micro ultrasonic motor, provides the advantages of this technology in the less expensive EF lenses.

✦ **L-series lenses.** Canon's L-series lenses feature a distinctive red ring on the outer barrel, or in the case of telephoto and super-telephoto lenses, are distinguished by Canon's well-known white barrel. The distinguishing characteristics of L-series lenses, in addition to their sobering price tags, are a combination of technologies that provide outstanding optical performance. L-series lenses include one or more of the following technologies and features:

- **UD/Fluorite elements.** Ultralow Dispersion (UD) glass elements help minimize color fringing or chromatic aberration. This glass also provides improved contrast and sharpness. UD elements are used, for example, in the EF 70-200mm f/2.8L IS USM and EF 300mm f/1L IS USM lenses. Fluorite elements, which are used in super-telephoto L-series lenses, reduce chromatic aberration. Lenses with UD or fluorite elements are designated as CaF2, UD, and/or S-UD.

- **Aspherical elements.** This technology is designed to help counteract spherical aberration that happens when wide-angle and fast normal lenses cannot resolve light rays coming into the lens from the center with light rays coming into the lens from the edge into a sharp point of focus. The result is a blurred image. An aspherical element uses a varying curved surface to ensure that the entire image plane appears focused.

These types of optics help correct curvilinear distortion in ultrawide-angle lenses as well. Lenses with aspherical elements are designated as AL.

- **Dust, water-resistant construction.** For any photographer who shoots in inclement weather, whether it's a wedding, editorial assignment, or sports event, having a lens with adequate weather sealing is critical. The L-series EF lenses have rubber seals at the switch panels, exterior seams, drop-in filter compartments, and lens mounts to make them both dust and water resistant. Moving parts including the focusing ring and switches are also designed to keep out environmental contaminants.

✦ **Image Stabilization.** Lenses labeled as IS lenses offer image stabilization. IS lenses allow you to handhold the camera at light levels that normally require a tripod. The amount of handholding latitude varies by lens and the photographer's ability to hold the lens steady, but you can generally count on 1 to 4 additional f-stops of stability with an IS lens than with a non-IS lens.

✦ **Macro.** Macro lenses enable close-up focusing with subject magnification of one-half to life size and up to 5X with the MP-E 65mm f/2.8 Macro Photo lens.

✦ **Full-time manual focusing.** An advantage of Canon lenses is the ability to use autofocus, and then tweak focus manually using the

lens's focusing ring without switching out of autofocus mode or changing the switch on the lens from the AF to MF setting. Full-time manual focusing comes in very handy, for example, with macro shots and when using extension tubes.

✦ **Inner and rear focusing.** Lens's focusing groups can be located in front or behind the diaphragm, both of which allow for compact optical systems with fast AF. Lenses with rear optical focusing, such as the EF 85mm f/1.8 USM, focus faster than lenses that move their entire optical system, such as the EF 85mm f/1.2L II USM.

✦ **Floating System.** Canon lenses use a floating system that dynamically varies the gap between key lens elements based on the focusing distance. As a result, optical aberrations are reduced or suppressed through the entire focusing range. In comparison, optical aberrations in non-floating-system lenses are corrected only at commonly used focusing distances. At other focusing distances, particularly at close focusing distances, the aberrations appear and reduce image quality.

✦ **AF Stop.** The AF Stop button allows you to temporarily suspend autofocusing of the lens. For example, you can press the AF Stop button to stop focusing when an obstruction comes between the lens and

the subject to prevent the focusing from being thrown off. When the obstruction passes by the subject, the focus remains on the subject provided that the subject hasn't moved so that you can resume shooting. The AF Stop button is available on several EF IS super-telephoto lenses.

✦ **Focus preset.** This feature lets you program a focusing distance into the camera's memory. For example, if you shoot a bicycle race near the finish line, you can preset focus on the finish line and then shoot normally as riders approach. When the racers near the finish line, you can turn a ring on the lens to instantly return to the preset focusing distance, which is on the finish line.

✦ **Diffractive optics.** Diffractive optics (DO) are made by bonding diffractive coatings to the surfaces of two or more lens elements. The elements are then combined to form a single multilayer DO element designed to cancel chromatic aberrations at various wavelengths when combined with conventional glass optics. Diffractive optics result in smaller and shorter telephoto lenses without compromising image quality. For example, the EF 70-300mm f/4.5-5.6 DO IS USM lens is 28 percent shorter than the EF 70-300mm f/4.5-5.6 IS USM lens.

Evaluating Bokeh Characteristics

The quality of the out-of-focus area in a wide-aperture image is called *bokeh*. Pronounced bo-keh, it is originally from the Japanese word *boke,* which means fuzzy. In photography, bokeh reflects the shape and number of diaphragm blades in the lens, and that determines, in part, the way that out-of-focus points of light are rendered in the image. Bokeh is also a result of spherical aberration that affects how the light is collected.

Although subject to controversy, photographers often judge bokeh as being either good or bad. Good bokeh renders the out-of-focus areas as smooth, uniform, and generally circular shapes with nicely blurred edges. Bad bokeh, on the other hand, renders out-of-focus areas with polygonal shapes, hard edges, and with illumination that creates a brighter area at the outside of the disc shape. Also, if the disc has sharper edges, then either points of light or lines in the background become more distinct when, in fact, they are better rendered blurred.

As you consider lenses, bokeh may be one consideration. In general, lenses with normal aperture diaphragms create polygonal shapes in the background. On the other hand, circular aperture diaphragms optimize the shape of the blades to create circular blur because the point source is circular. Canon lenses that feature circular aperture diaphragms use curved blades to create a rounded opening when the lens is stopped down and maintains the circular appearance even in continuous shooting burst mode.

Ken Rockwell provides an article on bokeh with excellent examples at www.kenrockwell.com/tech/bokeh.htm

Using the EOS 50D in the Field

Until now, I've concentrated on the technical aspects of choosing modes, features, and options on the EOS 50D. But the technical aspects of using the camera are only half the story. The true fun and satisfaction of using the 50D is combining the camera's extensive creative control with your photographic vision.

In this chapter, we complete the picture by combining both the technical and creative aspects of shooting with the 50D. Of course, in the process of making an image, there isn't a point where you adjust all the settings, and then you suddenly switch into creative mode. Rather, making pictures is the unconscious blending of the two into a synergistic and fluid process. Once in a while, a technical or creative glitch pops up to interrupt the flow, but those glitches are simply opportunities to learn.

In this chapter, I talk about using the 50D for everyday shooting, showing what it can do, and what you can expect as you shoot with it. The areas that I cover are some of the most common photographic scenes and subjects. And while your photography may concentrate on an area that isn't covered in this chapter, the techniques presented here have broad applicability to many shooting specialties. As you read, think about how you can apply these techniques creatively to other situations.

Nature and Landscape Photography

The area of nature and landscape shooting is a broad one that encompasses virtually all outdoor shooting scenes. This category easily includes travel, fine-art landscape and flowers, wildlife, birds, and macro photography. But the techniques used for nature and landscape can also be applied to shooting skyscapes, cityscapes, and, in part, to outdoor architectural photography. These areas share commonality in the wide diversity of light, in the goal of capturing the singular beauty, structure, and rhythm of the scenes and subjects, and in the need to creatively interpret what we see and perceive.

Packing the camera bag

The lenses and filters that you choose depend on the scene and subject you're shooting. Because nature offers such an amazing variety of subjects and because the light can change in minutes, my approach is to be prepared for everything from capturing sweeping landscapes to capturing close-ups of flora and fauna, and to be prepared for any light and weather.

At the top of the packing list are lenses. Here are some lenses to consider packing in addition to other gear that will come in handy.

9.1 Macro shooting offers an opportunity to eavesdrop on the behavior of nature's creatures. Exposure: ISO 100, f/5 at 1/500 second using an EF 100mm f/2.8 Macro USM lens.

✦ **Wide-angle lenses.** For truly sweeping landscapes with the 50D, you'll need a wide-angle lens such as the EF 16-35mm f/2.8L II USM, EF-S 10-22mm f/3.5-4.5 USM, or the EF 17-40mm f/4L USM lens. Alternately, you can use a lens with a narrower angle of view such as the EF 24mm or the EF 28mm lens and shoot a panorama of images that you can later stitch together using the PhotoStitch program that Canon provides on the EOS Digital Solution Disk.

✦ **Telephoto lenses.** Your choice of telephoto lenses depends to some extent on what shooting opportunities you'll most likely encounter. For example, if the area has wildlife, then pack the longest telephoto lens that you own along with the Canon Extender EF 2x II or the Extender EF 1.4x II to double the focal length, or to multiply the focal length by 1.4x, respectively, if the lens is compatible with the extenders. If you're shooting strictly landscapes or cityscapes and floodlit buildings, then a lens in the 70-200mm range is a good choice.

✦ **Macro lens.** I seldom go anywhere without a macro lens. If I know that I'll be doing a lot of macro shooting, I take both a long and short macro lens. For macro work where you can't or don't want to get close to the subject, the EF 180mm f/3.5L Macro USM lens is ideal. For flowers and plants, either the EF-S 60mm f/2.8 Macro USM or the EF 100mm f/2.8 Macro USM lens are excellent choices.

 Note *Lens extenders can be used with all prime lenses of 135mm and longer except the 135mm f/2.8 Softfocus lens, and they can be used with the EF 70-200 f/2.8L, 70-200 f/2.8L IS, 70-200 f/4.0L, 70-200 f/4.0L IS USM, and 100-400 f/4.5-5.6L IS zoom lenses. The 1.4x extender reduces the effective aperture by one f-stop, and the 2x extender reduces it by two f-stops.*

✦ **Filters.** Standard filters for outdoor shooting include a high-quality circular polarizer, and graduated neutral density filters. Filters are detailed in the Optional Filters sidebar in this section.

✦ **Weatherproof camera and lens sleeves.** The EOS 50D has more weather sealing than some EOS cameras, but it's not as extensive as the 1DS Mark III or 1D Mark III. And non-L-series lenses also lack extensive weather sealing. As a result, water-repellant bags and sleeves are simply good insurance. You can buy a wide variety of weatherproof camera protectors from Storm Jacket, Pelican, Aquatec, and Op-Tech.

✦ **Additional gear.** Because conditions can change quickly, and depending on the time of day, and depending on the focal length of your telephoto lenses, you may need a sturdy tripod or a monopod. You also need spare CF cards, charged camera batteries, cell phone, plastic bags, florist's wire (to steady plants), silver reflectors, and water and snacks as necessary. If you're on an extended shooting trip, you'll want to carry a laptop or handheld hard drive.

One of the most important things that you can pack is your curiosity and passion for capturing all that unfolds before you during your shooting time. Let nothing go unnoticed and unexplored. While the 50D is a great camera and the lenses are superb, the camera and lens see only what you see. So keep your photographic eye practiced and tack sharp.

If your nature and landscape trip includes air travel, be sure to check the carry-on guidelines for the specific airline you're flying on. Some airlines are more restrictive than others.

Optional Filters

The most useful filters in nature, landscape, and travel — collectively referred to as outdoor photography — include the circular polarizer, neutral density and vari-neutral density filters, and warm-up filters. Here is a brief overview of each type of filter.

✦ **Polarizer.** Polarizers deepen blue skies, reduce glare on surfaces to increase color saturation, and remove spectral reflections from water and other reflective surfaces. A circular polarizer attaches to the lens, and you rotate it to reduce glare and increase saturation. Maximum polarization occurs when the lens is at right angles to the sun. With wide-angle lenses, uneven polarization can occur causing part of the sky to be darker than the sky closest to the sun. You can use a one- to two-stop neutral density (ND) graduation filter to tone down the lighter area of the sky by carefully positioning the grad-ND filter. If you use an ultrawide-angle lens, be sure to get the thin polarizing filter to help avoid vignetting that can happen when thicker filters are used at small apertures. Both B+W and Heliopan offer thin polarizing filters.

✦ **Variable neutral density filters.** Sing-Ray's Vari-ND variable neutral density filter (www.singh-ray.com/varind.html) allows you to continuously control the amount of light passing through your lens up to 8 stops, making it possible to use narrow apertures and slow shutter speeds even in brightly lit scenes. Thus you can show the fluid motion of a waterfall, the motion of clouds, or flying birds. The filter is pricey, but it is a handy addition to the gear bag.

✦ **Graduated neutral density filters.** These filters allow you to hold back a bright sky from 1 to 3 f-stops to balance a darker foreground with a brighter sky. Filters are available in hard- or soft-stop types and in different densities; 0.3 (1 stop); 0.45 (1.5 stops); 0.6 (2 stops), and 0.9 (3 stops). With this filter, you can darken the sky without changing its color; its brightness is similar to that of the landscape and it appears in the image as it appears to your eye.

✦ **Warm-up filters.** Originally designed to correct blue deficiencies in light or certain brands of film, warm-up filters correct the cool bias of the light. You can use them to enhance the naturally warm light of early morning and late afternoon. Warm-up filters come in different strengths, such as 81 (weakest); 81A, B, C, and D; and EF, with 81EF being the strongest. For the greatest effect, combine a warm-up filter with a polarizer.

Setting up the 50D for outdoor shooting

Before you strike out with the camera, spend some time setting it up first. A first step is to set the shooting mode. Many photographers use Av mode because it allows quick control of the depth of field by changing the aperture. Other photographers contend that Tv mode is best because you have to ensure that the shutter speed is fast enough to get a tack-sharp image. After all, some argue, the ability to control depth of field is useful only so long as the final image has sharp focus. You can take your pick, but whichever you choose, be sure to monitor the shutter speed as you shoot and verify sharp focus before you walk away from a once-in-a-life-time scene or subject.

One approach to setting up the 50D for landscape and nature shooting is to register your preferred settings for the shooting, metering, drive, and autofocus mode, the Custom Functions that you prefer, and the Picture Style you most often use in one of the C shooting modes. Here is one example of how I set up a C mode for outdoor shooting. You can use these examples as a springboard for setting your favorite settings.

✦ **Tv or Av shooting mode.** You can choose either, but I use Tv mode to control shutter speed if I'm hand-holding the camera and lens. If the camera is on a tripod or a monopod, then I switch to Av mode. If you routinely shoot in Av mode, make it a habit to monitor the shutter speed and stabilize the camera at slow

9.2 For this shot of a coyote, I monitored the shutter speed because I was handholding the camera with the lens zoomed to 400mm. I used Tv mode and set the shutter speed to 1/400 second, and I used IS on the lens to ensure tack-sharp focus. Exposure: ISO 100, f/5.6 at 1/400 second with -1/3 exposure compensation using the EF 100-400mm f/4.5-5.6L IS USM lens.

shutter speeds. If you use A-DEP mode, be aware that to get the optimal depth of field, which is what this mode promises, the aperture is most often very narrow. That means that the shutter speed will be very slow even in decent light. Monitor the shutter speed in the viewfinder, and increase the ISO, use a tripod, or IS lens, or a combination of these to get sharp images in this mode.

Tip *As a rule of thumb, the minimum shutter speed at which you can handhold a non-IS lens is the reciprocal of the focal length. Thus, for a 200mm lens or zoom setting, the minimum shutter speed at which you can handhold the camera and get a sharp image is 1/200 second. For a 300mm lens, the fastest shutter speed is 1/300 second, and so on.*

✦ **Single-shot AF mode with manual AF-point selection.** I use single-shot with manual AF-point selection because I always want to control where the point of sharpest focus is in the image. This goes back to the earlier discussion about getting sharp focus. For me, part of sharp focus is manually setting the point of sharpest focus precisely where I want it in the image. If you're shooting birds or other wildlife, then you can use AF Focus AF that automatically switches to focus tracking (AI Servo AF) if the animal or bird begins to move.

✦ **Single or Low-speed Continuous Drive mode.** I use Single shooting or Low-speed continuous shooting (3 fps) depending on the scene or subject. If I'm shooting in areas where birds and wildlife are

common, then I use Low-speed continuous shooting. But if I'm shooting only landscapes, then I use Single drive mode.

✦ **Evaluative or Spot Metering mode.** As you learn in subsequent exposure topics in this section, I often use Spot metering for many scenes. But if you're new to the 50D, then you can count on Evaluative metering to give good results in a majority of scenes. I use AE Lock to meter on middle-tone areas and lock that exposure. To review how to use AE Lock, go to Chapter 3.

✦ **Picture Style.** Because I always edit my images on the computer before displaying them on the Web or printing them, I use my modified Neutral Picture Style. This style offers ample room for interpreting the color and contrast during image editing, and the colors are very true to the scene. Alternately, you can use Landscape Picture Style with its characteristic vivid greens and blues. If you don't edit images on the computer before printing them, then the Standard Picture Style produces good prints from the camera.

Cross-Reference *For more information on modifying Picture Styles, see Chapter 5.*

✦ **Custom Functions.** My choices depend on the scene and subject, but in general, here are some C. Fn's that you may want to set. If you want to make larger or smaller changes in aperture and shutter speed, then you can set exposure level increments, C.Fn I-1, to 1/2 stop instead of the default 1/3-stop

increment. Safety shift (C.Fn I-6) offers some insurance to automatically change the exposure setting if the light suddenly changes. Long exposure and High ISO noise reduction (C.Fn II: 1 and 2) are recommended if you're shooting low-light at a high ISO setting and/or long exposures. If you're using a super-telephoto lens, the C.Fn III-1 and 2 will make using autofocus and the AF Stop button more comfortable. Finally, you can set C.Fn III-6 to lock up the reflex mirror to prevent blur when you're making long exposures, macro shots, or using a long lens.

9.3 In average scenes such as this, the 50D produces very good exposures. However, to keep good detail in the brightest leaves, I used a -1 Exposure Compensation setting. Exposure: ISO 100, f/5.6, 1/400 second, -1 Exposure Compensation using an EF 16-35mm f/2.8L USM lens.

Exposing average scenes

Before discussing exposure techniques, it's important to specify what a good exposure is. A good exposure is an image that retains detail in the highlights and shadows, and that has a full range of tones between the brightest highlight and the deepest shadow. In addition, the late, great photographer Monte Zucker added this caveat: "A properly exposed digital file is one in which the [tonal range] fits within the range that can be printed on photographic paper and still show the same detail."

And, for the record, "good exposure" should happen in the camera rather than in the image-editing phase. I often hear photographers say, "I'll fix it in Photoshop." Doubtless many image problems can be made better with skillful editing both in a RAW conversion program and in Photoshop. But if you are serious about growing your skills as a photographer, then your aim should be to get the best in-camera exposure that the 50D is capable of delivering.

The exposure sections that follow assume that you want the best exposures from the 50D that you can get. At first blush, these exposure approaches may seem too complex or too much trouble. In that case, my recommendation is to point and shoot because the 50D will give you consistently good exposures. But if you want the best exposure rather than a good exposure, then try the techniques provided.

You can expect the 50D's onboard reflective camera meter along with Canon's Evaluative metering to provide reliably good exposure for average scenes. However, in some scenes, I find that the 50D has a tendency toward slight overexposure, particularly

when using Highlight tone priority, C.Fn II-3 and with Auto Lighting Optimizer, C.Fn II-4, disabled. One of the first things you should do is to shoot with the 50D in a variety of scenes and evaluate the images so that you can identify any characteristics that are specific to your camera.

For example, by identifying a slight but consistent overexposure in brightly lit scenes, I usually set a -1/3-stop compensation for in these scenes. But it's important to note that different cameras can vary. Your 50D may be spot-on for exposure outdoors and indoors, so no compensation is needed. Also, Canon's ongoing firmware releases often correct common problems, so I strongly recommend that you keep up with the latest Canon updates.

As you think about exposure, remember that the 50D's built-in reflective light meter is calibrated to render all scenes for an average 18 percent gray reflectance — or the percentage of light that the subject reflects back to the camera. The camera assumes that all scenes contain a variety of tonal values from the highlights to the shadows. And if all of those values are averaged, they produce middle-gray tonal value. The important thing to know is that if the middle-gray tones are properly exposed, then all the tonal values will also be acceptably exposed and represented accurately in the final image. By knowing this, you can correctly expose most nature and landscape scenes.

9.4 This is another average scene where the onboard light meter will produce an excellent exposure. Exposure: ISO 100, f/11, 1/80 second using an EF 24-70mm f/2.8L USM lens.

Basic exposure technique

For nature and landscape images, the primary consideration is controlling the depth of field — whether you visualize a final image with extensive depth of field for a stunning sweep of flower-covered hills or with the shallowest depth of field for a selective-focus macro shot. In any case, the shortest route to controlling the depth of field via aperture changes is Av shooting mode. And for metering, the Evaluative metering mode is dependable and accurate, even for backlit subjects.

> **Tip** *If you're shooting in Av mode, be vigilant about monitoring the shutter speed to ensure that it is fast enough to handhold the camera and/or to alert you when you need to mount the camera on a tripod, monopod, or stabilize it on a solid surface.*

The usual sequence for basic exposure is to make the first exposure by using the camera's recommended settings. Then you evaluate the image and histogram to see if exposure modifications are needed. In many scenes, exposures will need modifications because landscape and nature scenes and subjects can range from high-dynamic range scenes to flatly lit overcast scenes — and everything between.

> **Tip** *As explained earlier in this book, a spike on the right side of the histogram indicates blown highlights, and a spike on the left side indicates blocked shadows — shadows that transition too quickly to black.*

Most often, photographers have to deal with high-dynamic range scenes that require exposure modification. In practical terms, a high-dynamic range scene is one where the range from highlights to shadows as measured in f-stops is great — specifically, greater than the camera's imaging sensor can handle.

In most high-dynamic range scenes, the camera sacrifices the highlights, resulting in blown highlights, although the shadows may also be blocked. If you're not sure whether the scene has a high dynamic range, you can quickly assess the scene by switching to Spot metering mode and a meter reading on highlights and another on a shadow area. Then calculate the difference between the two readings. And for the 50D, if the difference is greater than approximately 7.5 to 8 stops, then you assume that the camera's sensor will not be able to maintain image detail in both highlights and shadows.

If the range is greater than the camera can handle, photographers have several choices: to use high-dynamic range imaging, to process a single RAW file multiple times and composite the files, or to shoot a single image with exposure modification that is aimed on getting great exposure on the subject while letting other areas go overexposed or underexposed.

Many photographers use high-dynamic range imaging that involves shooting five to eight images bracketed by shutter speed, and then combining them in a high-dynamic range imaging program. To aid in this type of imaging, the 50D enables you to set the bracketing range up to +/- 4 stops. It's beyond the scope of this book to detail the high-dynamic range processing steps, but many new books are available that describe both the steps and the specialty programs for this imaging approach.

Alternately, you can shoot a single RAW image, and then convert the image multiple times in a RAW conversion program saving different versions. For example, one version of the image is processed with an eye toward recovering or retaining highlight detail, another is converted to maximize midtone rendering, and another is to provide good shadow detail. Then three different versions of the image are composited in Photoshop and manipulated to reveal the best of each processed version. I've used the 50D for both of these types of shooting, and the results are excellent.

However, if you don't want to do high-dynamic range shooting or double-process a RAW image, then exposure modification provides the best solution. In high-dynamic range scenes, the goal is to retain highlight detail in the primary subject area if it can't be maintained in all highlight areas. This is especially important if you're shooting JPEG capture because if you don't capture the highlight detail, it can't be added later. If you're shooting RAW capture, you can recover some highlight detail when you convert the image in a RAW conversion program. The amount of highlight detail that you can recover depends on many different variables as well as the conversion program that you use.

So if you're shooting a high-dynamic range scene and the highlights are blown out by using the camera's suggested exposure, the easiest modification you can use is negative Exposure Compensation to give the image less exposure. The amount of compensation that you set depends on the scene. If the original image has large areas of blown highlights, start with a -1 stop compensation. For small areas of blown highlights, start with approximately -1/3 stop. Also know that when you set Exposure Compensation in Av shooting mode, the camera changes the shutter speed to achieve the compensation. So be sure to monitor the shutter speed, and use a tripod if the shutter speed is too slow for hand-holding the camera and lens. Also, you may need to experiment with the Exposure Compensation settings until you get an exposure that retains highlight detail in the critical highlight areas. In some scenes, you may have to live with some blown highlights in non-subject critical areas to avoid severely underexposing the rest of the image.

The third exposure modification option is Auto Exposure Bracketing (AEB). Normally, you use AEB to shoot three exposures: one at the camera's recommended exposure, one with more exposure, and one with less exposure. But if the challenge you're trying to solve is overexposed highlights, then shooting the frame with more exposure is pointless. Fortunately, the 50D enables you to shift AEB so that all frames are in the negative exposure range. This is a seriously handy feature on the 50D, although it's not readily apparent.

Here is how to shift AEB so that all three frames are at negative exposure. If you are in another scene where you want increased exposure, these steps work for that situation as well, with slight modification to move toward the increased exposure side of the scale.

1. **Press the Menu button, and then turn the Main dial to select the Shooting 2 menu.**

2. **Turn the Quick Control dial to highlight Expo. comp./AEB, and then press the Set button.** The Exposure comp./AEB screen appears.

3. **Turn the Main dial to the right to display the AEB scale.**

4. **Turn the Quick Control dial to shift the bracketing tick marks below or above the zero mark.**

5. **Turn the Main dial to the right to set the amount of bracketing difference, and then press the Set button.** As you turn the Main dial, the tick marks separate showing the exposure difference in 1/3-stop increments for the exposures.

6. **To make all three bracketed shots, press the Shutter button three times if you're in One-shot drive mode.**

Alternately, you can use AE Lock. With AE Lock, you point the lens so that the currently selected AF point is over a middle tone area in the scene. (Middle tones are detailed later in this section.) Then you press and hold the AE Lock button on the back-right top of the camera to lock in the exposure settings. Move the camera to recompose the image, focus, and shoot. However, if you use AE Lock and manual AF-point selection, then you should also use Evaluative metering to meter at your selected AF point. In Partial, Spot, and Center-weighted Average metering modes, AE lock is set only at the center AF point, and this is also true if you turn the switch on the lens to MF (Manual Focus).

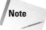 **Note** *With any exposure approach, you may not see any difference in images where you make exposure changes if you have Auto Lighting Optimizer, C.Fn II-4, set to any setting except Disable. Auto Lighting Optimizer automatically brightens pictures that it thinks are too dark and corrects low contrast. If your goal is to get a great in-camera exposure, then turn off Auto Lighting Optimizer so you can see the effect of exposure modifications you make.*

Advanced exposure approach

The classic exposure approach for landscape and nature scenes is to meter on a gray card or on a middle-tone area in the scene. This approach is based on the calibration of the camera's built-in reflective light meter to 18 percent reflectance. Knowing that the meter is calibrated for the middle tonal value, when the middle tone values in the image are correctly exposed, then all of the other tonal values will also be properly exposed.

To use this exposure technique, switch to Manual (M) shooting mode, and then identify an area in the scene that has the same brightness value as middle gray, or 18 percent reflectance. The color may not be gray, but the tonal value should be the same as middle gray. First set the aperture for the depth of field you want. Then set the 50D set to Spot metering mode and select the center AF point. Point the lens so that the center AF point is on top of the middle gray area. Press the Shutter button halfway and note what the camera suggests for the shutter speed. Then set the shutter speed noted from the meter reading, select the AF point you want, compose, focus, and make the picture.

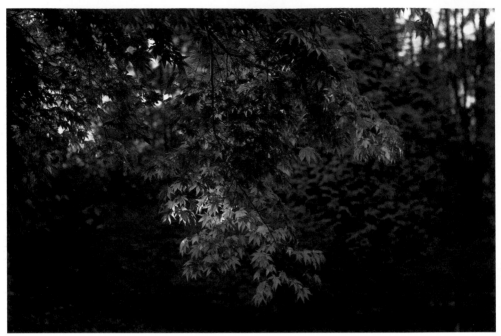

9.5 I used AE Lock for this shot of backlit leaves. I locked the exposure on one of the middle-toned leaves, but a few of the brightest highlights on the leaves still blew out. If I had this shot to take again, I'd set a -1 compensation. Exposure: ISO 100, f/3.2, 1/60 second using an EF 24-70mm f/2.8L USM lens.

If you're unaccustomed to finding middle gray, it can take some visual training to spot middle gray in the scene. Figure 9.1 can be used to help you identify the tonal value to look for and its comparative brightness. Then the task is for you to be able to translate the middle gray tonal value in a scene that you're viewing in color. With practice, you'll be able to spot middle-toned areas in scenes quickly.

Alternately you can meter off of a gray card that is placed in the same light as the scene or subject. Or if you have a middle-gray color camera bag, you can meter off it as long as it's in the same light as the subject. If you use a gray card, ensure that there are no shadows, glare, or hotspots on the card, and then hold the camera about 6 inches from

Midtone Photographic gray card

9.6 In this abbreviated tonal scale, middle gray is the fourth from the left gray square. At the far right is a section of a photographic gray card.

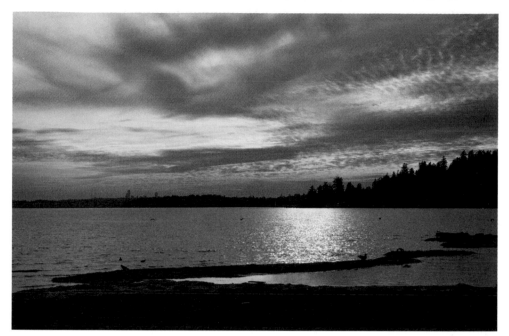

9.7 For this Lake Washington sunset image, I metered on the middle tonal value of the clouds. Exposure: ISO 100, f/16, 1/250 second using an EF 16-35mm f/2.8L USM lens.

the card. Press the Shutter button halfway to get the meter reading, and then use AE Lock or M mode to set the aperture and shutter speed from the meter reading.

Tip

An advantage of using a gray card is that you can use it not only to take a meter reading but also to correct color during RAW- image conversion, as explained in Chapter 4.

Exposing nonaverage scenes

Because the camera is calibrated to properly expose scenes with an average distribution of tonal values, it follows that scenes with a predominance of light or dark tones will throw off the camera's suggested exposures. Thus it's important to be able to recognize nonaverage scenes and adjust the exposure appropriately. Nonaverage scenes include

sunrise and sunset, backlit scenes, white-on-white and black-on-black subjects, snow, white sand, large expanses of dark water, and similar scenes.

When you're presented with a breathtaking snowy landscape or an expanse of white sandy beach, you know by now that if you don't make an exposure modification, the camera will average all of the tones in the scene to middle gray. As a result, you'll get gray snow and gray water.

The most common approach to these kinds of scenes is to set positive exposure compensation for bright-toned scenes and negative exposure compensation for dark-toned scenes.

If you use exposure compensation, you can set a +1 or +2 exposure compensation for scenes with a predominance of light tones,

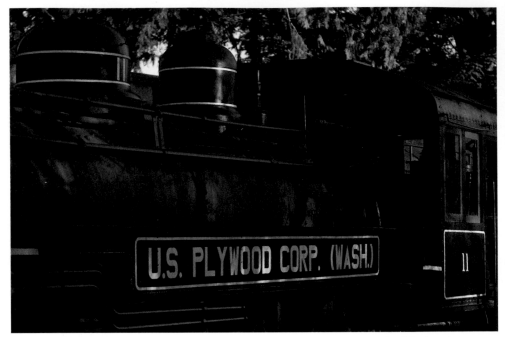

9.8 Before I remembered to set a -2 Exposure Compensation setting, this black train was rendered as a dark gray. After I made the compensation, the true blacks of the train were properly exposed. Exposure: ISO 200, f/2.8, 1/1250 second, -2 EV using an EF 70-200mm f/2.8L IS USM lens.

or -1 to -2 compensation for scenes with a predominance of dark tones. Then check the histogram to ensure that highlights are not blown or the shadows are not blocked. This method is less precise because you have to experiment to find the amount of compensation needed. Alternately, you can meter on a middle-tone value in the scene, a tree trunk in a snow scene, a middle-gray cloud, and so on, and then use those exposure settings to make the picture. If the middle tones are properly exposed, the rest of the tones will be rendered accurately as well.

As you can see, the approach of metering on a middle tonal value works in virtually all nature and landscape scenes, as does knowing when to set Exposure Compensation, Exposure Bracketing, or AE Lock. And the same holds true for many lowlight and night scenes. If the scene includes buildings or structures, you can meter bricks, stones, or concrete in the scene. And if you're photographing buildings or structures lit by artificial light, then meter on an area that is lit by the light, but not the light source itself. In scenes lit by both artificial and ambient (natural) light, you can take a meter reading from the sky just after sunset.

9.9 For this image of Snoqualmie Falls, I metered on a midtone value in the cliff wall. Exposure: ISO 100, f/22, 1/20 second using an EF 24-70mm f/2.8L USM lens.

Tip *With a variety of different light sources and light colors in night scenes that include natural and artificial light, I've gotten the best color using Automatic White Balance. I've found that this applies when shooting fair rides, flood-lit buildings, and street scenes.*

If you're shooting into the bright sun, the camera meter tries to bring the foreground elements to middle-gray tonal value, and, in the process, it often overexposes the brighter sky. In these scenes, take a meter reading on a part of the sky that you want to be rendered as middle gray, for example, a

neutral-toned (middle-gray toned) cloud in the sky, to keep the sky from being too bright. Or if you want a partial silhouette that retains some detail in the foreground objects, then meter on a cloud that is slightly brighter than middle gray.

Tip *A venerable exposure rule that comes in handy for a variety of scenes and subjects is the Sunny f/16 rule. The rule says that on a bright, sunny day with the sun at your back, the correct shutter speed is the reciprocal of the ISO. So if you were shooting at ISO 100, then the exposure would be f/16 at 1/100 second.*

9.10 For this shot of a lighted fountain, I used a narrow aperture, which gives the starburst effect to the landscape lights. Exposure: ISO 100, f/8, 1/15 second with -1.33 exposure compensation using the EF 24-70mm f/2.8L USM lens.

9.11 A sturdy tripod with a ball head is essential for capturing celestial images like this one of the fall moon. Exposure: ISO 200, f/8, 1/6 second using an EF 100-400mm f/4.5-5.6L IS USM lens.

Shooting landscape and nature images

As with each area of photography in this chapter, countless other books have been written specifically on these topics. In my experience, however, all the tips in the world cannot make great images if the photographer doesn't constantly practice seeing and appreciating everything in nature. I've irritated more people on the highway than I can count because I routinely slow down to appreciate a stunning mountain lit by that rare and incomparable God-light that happens only occasionally.

✦ **Keep your eye in practice.**

✦ **Look for the light.** Maybe it's side light illuminating an expanse of trees on a mountainside with gold and purple that defies description, or maybe it's a small shaft of light piercing through the forest trees to illuminate a tiny frog or a mushroom. Light, especially beautiful light, is transitory and fleeting. With a practiced eye, look for the light, and then be ready to shoot regardless of what lens is on the camera and whether it's the right or wrong lens. Don't let the opportunities pass you by.

✦ **Image composition is very important.** Study and ponder the compositions in nature because nature itself is the ultimate field guide to good composition.

9.12 Some of the best images are found in your own front yard, as was the case with this sunset scene with the Cascade mountain range in the distance. Exposure: ISO 100, f/8, 1/60 second using an EF 100-400mm f/4.5-5.6L IS USM lens.

9.13 If the subject and background have approximately the same amount of light falling on them, then as long as the subject is properly exposed and it is far from the background, the background will go dark as it does in this picture of a sunflower. Exposure: ISO 100, f/13, 1/100 second using an EF 100mm f/2.8 Macro USM lens.

Maximizing Depth of Field

Maximizing depth of field is especially important in landscape photography. Certainly a narrow aperture is part of maximizing depth of field, but you can also use hyperfocal focusing to maximize the acceptably sharp focus from near to far in the frame. With hyperfocal focusing, the depth of field extends from half the hyperfocal distance to infinity at any given aperture.

The easy way to set hyperfocal distance focusing is if you have a lens that has both a distance scale and a depth-of-field scale. If you have this type of lens, first focus the lens on infinity, and then check the depth-of-field scale to see what the nearest point of sharp focus is at the aperture you've set. Then focus the lens on the hyperfocal distance. For example, with the aperture set to f/11 and using the EF 28mm lens, the hyperfocal distance is just over 2 meters. That means you would refocus the lens at a point in the scene just over 2 meters to get acceptable sharpness from half the hyperfocal distance, or approximately 5 feet, to infinity.

If your lens does not have a depth-of-field scale, and most newer lenses do not, then you can buy a hyperfocal focusing calculator. Alternately, you can calculate the distance using a formula. The formula takes into account the circle of confusion, or the maximum size of points on an image that are well defined — that is — to 3 feet. For the 50D with a cropped sensor, that circle size is approximately 0.018mm.

To calculate the hyperfocal distance, use this equation:

$H = (F \times F)/(f \times c)$

Where H is hyperfocal distance, F is the lens focal length, f is the aperture, and c is the circle of confusion.

So a 28mm lens set to f/16 produces:

$H = (28 \times 28)/(16 \times 0.018)$, or H = 2722mm or 2.72 meters. To ensure maximum depth of field, you focus the lens on a point in the scene that is 2.7 meters from the camera.

Portrait Photography

If you have more than passing experience with portrait photography, then you know that the one thing that has to work flawlessly is the camera. Unlike nature and landscape shooting where you can set the pace and face snafus with equanimity, a portrait session puts more demands on your time and attention. In a portrait session, you have to juggle establishing rapport with the subject, providing direction, changing lens and exposure settings, and coordinating clothing, lighting, and background changes. Given the demands, the last thing that you have time to worry about is the camera's performance, and with the 50D, you can depend on the camera.

Selecting gear

The type and amount of gear that you use for a portrait session depends on whether you shoot at your studio or home where your gear is conveniently close by, or if you shoot at a different location. Another aspect that influences the gear selection is whether your subject is a single person or a group, and, if a group, how large the group is.

Consider the following suggestions and make adjustments according to your specific portrait session.

✦ **Two 50Ds or a 50D and a backup EOS camera body.** The 50D is very reliable, and you can easily get by with a single 50D. But if you're shooting professionally, you know that if anything can go wrong, it will go wrong at the wrong time. That's why it pays to have a backup camera body so that you can keep shooting without a hiccup. And if you're just starting with professional assignments, then consider renting a backup 50D which is an economical approach.

✦ **One or more fast wide-angle and short telephoto lenses.** For portraits, I most often use the EF 24-70mm f/2.8L USM or the EF 24-105 f/4L IS USM lens. Both lenses translate to roughly 38mm at the wide focal length with the focal length multiplier, and that's adequate for groups of up to 5 or 6 people. On the long end, the 24-105mm or the EF 28-135mm f/3.5-5.6 IS USM lens is nice for individual portraits. The EF 70-200mm f/2.8L IS USM, or the lighter-weight but slower EF 70-200m f/4L IS USM is also a good choice. A short telephoto between 70 to 100mm minimizes the characteristic telephoto lens compression while still providing a shallow depth of field characteristic of telephoto lenses.

✦ **Reflectors.** I can't imagine shooting a portrait session without using one, two, or more silver, white, or gold reflectors. Reflectors are small, light-weight, collapsible, and indispensable for everything from redirecting the main light or filling shadow areas to adding catchlights to the subject's eyes. Reflectors are easier to manipulate than flash (and much less expensive), and they redirect light while retaining the natural color of the ambient light.

✦ **EX-series flashes, light stands, umbrellas or softboxes, and an ST-E2 Speedlite Transmitter.** You can create a nice portrait with a single flash unit mounted off camera on a flash bracket. But you'll have a lot more creative control if you use two to three Speedlites mounted on stands with either umbrellas or softboxes, and fired wirelessly from the ST-E2 Speedlite Transmitter. The light ratios can be easily controlled from the wireless transmitter while the Speedlites can be placed around the set to replicate almost any classic lighting pattern. Best of all, this system is portable and lightweight.

✦ **Tripod, monopod, CF cards, spare batteries.** These are obvious items, but they bear mentioning.

✦ **Brushes, combs, cosmetic blotters, lip gloss, concealer, safety pins, and anything else you can think of.** The subject will likely forget to bring one of these items, a garment will tear, or a button will pop off. Have a small emergency kit at the ready. The kit will often contain just what you need to keep the session going with minimal stress and interruption.

Setting up the 50D for portrait shooting

If you primarily shoot portraits, then devoting one of the C modes to your portrait settings saves you time setting up for the session. And if you shoot both outdoor and studio portraits, then you can set up a C mode for each location. The choice is yours, but having the camera set up and ready to shoot saves making adjustments for different locations.

Here are suggestions for setting up the 50D for portrait shooting.

✦ **Av shooting mode.** Av shooting mode is a natural for portrait shooting where you base the aperture on how much or how little of the background you want in reasonably sharp focus. Keep an eye on the shutter speed to ensure it's fast enough to handhold the camera. If you shoot with studio strobes, then Manual shooting mode is the best option.

✦ **Single-shot AF mode with manual AF-point selection.** Unless the portrait subject is a young child, I opt for Single-shot mode. If you are shooting a child, then you might want to use AI Focus AF. If you've focused on the child and the child begins to move, the 50D switches automatically to focus tracking. I also always use manual AF-point selection. A portrait isn't successful if the point of sharpest focus is anywhere except on the subject's eyes, and the only way to ensure that is to manually set the AF point.

✦ **Low-speed Continuous drive mode.** This mode allows a succession of shots at a reasonably fast 3 fps shooting speed. If I'm photographing children in ambient light, I switch to High-speed Continuous mode simply to keep up with fast-moving youngsters.

✦ **Evaluative metering mode.** Evaluative metering is both fast and accurate for portraits. Occasionally, you may want to switch to Spot metering mode to take an area-specific meter reading. If you're shooting in the studio, you can use a handheld flash meter if you have one, or simply make test shots, examine the images and histograms, and set the exposure for the best test shot exposure.

✦ **Picture Style.** The Portrait Picture Style produces lovely skin tones and renders colors faithfully and with subdued saturation, which is appropriate for portraits. I also use a modified Neutral Picture Style. If the lighting is flat, then Standard produces a more vibrant rendering. Be sure to test these Picture Styles well before the session and evaluate the prints so that you know which style works best for the lighting and the printer that you'll use.

9.14 This spur-of-the-moment shot was taken with window light located in front of the couple. A neutral-colored wall makes a good backdrop. Exposure: ISO 160, f/2.8. 1/160 second using the EF 70-200mm f/2.8L IS USM lens.

✦ **Custom Functions.** For portraits, consider using Exposure Safety Shift, C.Fn I-6 that automatically adjusts the exposure if the light changes enough to make the current exposure settings inaccurate. If you're using Speedlites, determine whether you want to use a fixed 1/250-second sync speed to make flash the primary illumination, or to sync at shutter speeds slower than 1/250 second to allow more of the ambient light to figure into the exposure. If you're shooting scenes with bright tones such as a bride in a white dress, you can enable C.Fn II-3, Highlight tone priority to expand the top half of the tonal dynamic range.

Making natural-light portraits

The goal of any portrait is to capture the spirit of the subject. When you capture the spirit of the person, the subject's eyes are vibrant, compelling, and they draw the viewer into the image. No amount of skillful lighting, posing, or post-capture editing can substitute for this.

That's not to say that lighting isn't important. It definitely is, and it should provide flattering illumination that defines or models the facial features. Exposure and color are also important, and with the fine levels of exposure control, Picture Style options, and White Balance control the 50D provides excellent results whether you're shooting outdoors or indoors with window light.

Outdoor portraits

There are many times during the day and there are many types of outdoor light that make lovely portraits. With that said, I can think of no one who is flattered in bright, overhead, unmodified midday sunlight. Nor can I think of any subject who is comfortable looking into the sun. So if you have a portrait session outside on a sunny afternoon and you can't reschedule, then move the subject to an area that is shaded from the top such as by a roof, an awning, or a tree. Or use a scrim — fabric or other material stretched over a frame — and hold it over the subject to diffuse the strong sunlight. If the subject is in the shade, use a reflector to direct light onto the frontal plane of the face. Then you can move the subject and use reflectors to create and control shadow areas.

The best outdoor portrait light is during and just after sunrise, just before and during sunset, and, if you use reflectors or fill flash skillfully, the light of an overcast day.

In any type of outdoor light, watch how the shadows fall on the face. If unflattering shadows form under the eyes, nose, and chin, then you can bounce fill light into those areas using a silver or gold reflector. I prefer a silver reflector for the neutral light that it reflects. If I want to diminish the light that's reflecting onto the subject, I use a white reflector because it scatters light and decreases the intensity.

> **Tip**
>
> If you're shooting a head-and-shoulders portrait, you can ask the subject to hold a reflector at waist level, and then watch as the subject tilts the reflector to find the best position to fill in facial and chin shadow areas.

9.15 This was a midafternoon portrait session with only bright sunlight all around. I moved Greg under the awning of a tool shed, which provided a good neutral background. To minimize the wood grain in the shed, I used a wide aperture of f/2.8. Exposure: ISO 160, f/2.8, 1/8000 second using an EF 70-200mm f/2.8L IS USM lens.

Also ensure that catchlights appear in the subject's eyes. In overcast light, in particular, you may need to use a reflector to create the catchlights. The ideal positions for catchlights are at the 10 and 2 o'clock positions. The size and shape of the catchlight reflects the light source. If you use the built-in flash for fill light and to create catchlights, the catchlights will be unattractive pinpoints of white. I prefer the larger size and shape of catchlights created by the skillful use of a reflector.

To get the best color in overcast or cloudy light, use a custom white balance. At sunrise or sunset, you can use either the Daylight or Cloudy White Balance setting. Or if you're shooting RAW, you can shoot a gray card in one frame and use that image to color-correct images as a batch during RAW image conversion, as described in Chapter 4. If you don't want a completely neutral color — and generally you don't want perfectly neutral color — then adjust the temperature and tint controls during RAW image conversion to warm up or cool down the color.

Window light portraits

Without question, window light is the most beautiful of all natural light options for portraits. It offers exceptional versatility. If the light is too bright, you can simply move the subject farther from the window or put a fabric over the window. Window light provides ample light to bounce into the shadow side of the subject using a reflector. The best window light for portraits is when the sun is at a mid to low angle above the horizon. However, strong midday sunlight can also be quite usable if you add a lightweight fabric, such as a sheer curtain, or a heavier material to the window.

A good starting point for window light portraits is to place the subject so that one side of the face is lit and the other side is in shadow. Then position a silver or white reflector so that it bounces light into the shadow side of the face and creates a catchlight in the eye on the shadow side.

To meter window light, it's important to meter for the skin midtones. Evaluative metering or Spot metering both produce excellent metering results. Just move in close or zoom in on the subject's face and meter a skin-tone area, or you can meter a gray card that is in the same light as the subject's face. Then you can switch to Manual shooting mode to shoot with the resulting exposure settings. In Manual shooting mode, you can maintain the same metered skin-tone exposure even if you change the image composition. In other modes such as Av, Tv, or P, the shutter speed will change slightly as you vary the image composition slightly. Of course, the metered skin-tone exposure is good to shoot with as long as the light in the scene doesn't change.

Exposure approaches

For portrait shooting, you can get excellent exposures out of the camera with no exposure modifications. If there are hot spots on the subject's skin or blocked shadows, you can use any of the exposure techniques described in the Landscape and Nature section, including taking a reading on a photographic gray card that the subject holds next to his or her face to determine the exposure.

Just as with nature and landscapes, some portraits can fall into the nonaverage categories. For example, if you're photographing a man in dark clothing against a dark background, then the camera will overexpose the image to get to middle gray. The same exposure error can happen with a subject such as a bride in a white dress against a light background except the camera will underexpose the image. You have two approaches to correct the exposure error: You can set Exposure Compensation as described in previous sections or you can meter from a gray card and use AE Lock to retain the exposure, or set the metered exposure in Manual shooting mode.

On the topic of exposure, my preference for portraits is to ensure very fine detail and the lowest level of digital noise possible in the images. For me, that means shooting between ISO 100 and 400 99 percent of the time.

If you're shooting in lowlight scenes, increasing the ISO to 800 provides good prints; however, examine the shadow areas carefully for noise. If the noise is obvious, apply noise reduction during either RAW image conversion or JPEG image editing, particularly on facial shadow areas. There is nothing that spoils an otherwise beautiful portrait quicker than seeing a colorful scattering of digital noise in facial shadows and in skin areas.

To control depth of field, many photographers rely solely on f-stop changes. Certainly, aperture changes render the background differently, and wide apertures from f/5.6 to f/1.4 are common in portraiture. However, don't overlook the other factors that affect depth of field:

✦ **Lens.** A telephoto lens has an inherently shallow depth of field, and a wide-angle lens has an inherently extensive depth of field.

✦ **Camera-to-subject distance.** The closer you are to the subject, the shallower the depth of field and vice versa.

✦ **Subject-to-background distance.** The farther the subject is from the background, the softer the background details appear and vice versa.

The plane of focus is also a factor, but in portraits, the subject's eye that is closest to the camera should always be the plane of sharp focus.

Making studio portraits

Whether you have one or multiple studio lights such as strobes, continuous lights, or even Speedlites, you have the opportunity to make portraits using classic lighting patterns. And if you combine the lighting with modifiers such as umbrellas, softboxes, barn doors, beauty dishes, reflectors, and other accessories, you can control the light to get just about any type of lighting that you envision.

9.16 For this butterfly lighting — denoted by the butterfly-shaped shadow under the nose — the main (key) light was over and to the left of the camera. A large silver reflector was to camera right and another strobe was to the left of the subject. Two strobes lit the background. Exposure: ISO 100, f/16, 1/125 second using an EF 85mm f/1.2L II USM lens.

Portraits with a One-Light Setup

If you're just starting to build a studio lighting system, it pays to know that you can do a lot with a single light and an umbrella or softbox, combined with silver reflectors. For example, set up the single light on a stand shooting into an umbrella or fitted with a softbox. Then place the light at a 45-degree angle to the right of the camera with the light pointed slightly down onto the subject. This creates a shadow under the subject's nose and lip. Now place a silver reflector to the left of the camera and adjust its position to soften the shadow created by the light.

For classic loop lighting, the nose shadow should follow the lower curve of the cheek on the opposite side of the light. The shadow from the light should cover the unlit side of the nose without the shadow extending onto the subject's cheek. Also ensure that the eyebrows and the top of the eyelids are well lit. You can also adjust the height of the key light to change the curve under the cheekbone.

It's beyond the scope of this book to provide a guide to portrait lighting in the studio or provide setup instructions for a studio lighting system. But whether you have one, two, three, or more lights, you can count on excellent studio portraits from the 50D.

Cross-Reference *For more details on replicating studio lighting, see Chapter 7.*

With multiple-light studio systems, you can use the PC sync terminal and set the sync speed on the camera at 1/60 second, which is Canon's recommendation. However, I use the 50D with my four Photogenic strobes, and I sync at 1/125 second with no problem and with excellent exposures.

It takes only one or two studio sessions to determine the correct light temperature, if you don't already know it. For my system, I use the K White Balance setting, and dial in 5300. This setting gives me a clean, neutral white with no further adjustments during shooting or in image conversion or editing. In addition, if I'm shooting JPEG, which is seldom, I use the Portrait Picture Style. This style produces the subdued color and pleasing skin tones of classic portraiture. If you

think that the color rendition and contrast are too subdued, you can modify the style parameters by bumping both settings to a higher level.

Keep it simple

A library of books has been written on portrait photography. If you want to specialize in portraiture, read the books, practice the classic techniques, and keep practicing until they become second nature.

But when the time comes to start shooting, relax and keep it simple. At a minimum, here are the basic guidelines that I keep in mind for every portrait session.

✦ **Connect with the person, couple, or group.** Engage them in conversation about themselves. When you find a topic that lights up the eyes, start shooting and keep talking with them.

✦ **Focus on the eye that is closest to the camera.** If the eyes are not in tack-sharp focus, reshoot.

✦ **Keep the subject's eyes in the top third of the frame.**

✦ The best pose is the pose in which the subject feels comfortable and relaxed.

✦ Be prepared. Be unflappable. Back up everything. And check the histograms as you shoot.

Event and Action Photography

With a generous burst rate and reasonable performance at higher ISO settings, the EOS 50D is especially well suited for shooting events and action whether it's sports events and races, or concerts, carnivals, festivals, receptions, and parties. And whether you're a seasoned professional, or you're just starting with event photography, the opportunities for income and making great images make these areas of photography attractive.

Regardless of the subject, the objective is to show the energy and emotion of the event as well as capturing the decisive moments, and at 6.3 fps with up to 90 Large/JPEG shots per burst with an Ultra DMA card, the 50D won't slow you down.

Packing the gear bag

As always, the gear that you pack in the camera bag is directly related to the scene and subjects that you're going to shoot as well as other factors including your distance from the action, the lighting, weather, length of the event, how much you're willing to carry, and other factors.

As you look at these suggestions, consider them a starting point for your planning.

✦ **The 50D and a backup camera body.** Like weddings, many events occur once in a lifetime, so if anything goes wrong with the 50D, you need a backup 50D or other EOS camera body so that you can continue shooting without a hiccup. If

you are fortunate enough to have two 50D bodies, then you can have one body with a wide-angle lens and the other with a telephoto lens.

✦ **One or more wide-angle and telephoto zoom lenses.** I've found the 24-70mm f/2.8L USM lens and the 70-200mm f/2.8L IS USM lens to be a versatile combination depending, of course, on the shooting proximity to the players or participants. In good light, you can make good use of the Extender EF 1.4x II or Extender EF 2x II to get more reach with compatible telephoto lenses. (See Chapter 8 for details on which lenses work with extenders.) Other good telephoto lens choices are the EF 28-135mm f/3.5-5.6 IS USM, the EF 100-400mm f/4.5-5.6L IS USM, or the EF 70-300mm f/4.5-5.6 IS USM lens. For outdoor events such as motocross or events where dirt and wind collide, be sure to have lens-cleaning cloths handy as well.

✦ **Monopod or tripod.** If the event continues through sunset and evening hours, then you'll be glad to have the solid support of a tripod. Even when I'm reasonably sure that I won't need a tripod or monopod, I keep one in the truck just in case.

✦ **Laptop computer or portable storage device, spare CF cards, and charged batteries.** Any event that features action means that you'll take far more images than when you're shooting still subjects. If you have multiple CF cards, be sure that you have a system for keeping used cards separate from

empty cards. And depending on how many cards you have, you may want to begin offloading images to a laptop or handheld storage unit during lulls in the action. Certainly you want a minimum of one spare charged battery and maybe two, depending on the duration of the event.

✦ **Weatherproof sleeves and camera cover.** If it rains, or if you're shooting in fog or mist, having a weatherproof camera jacket and lens sleeve is good insurance against camera damage and malfunctions.

Setting up the 50D for event and action shooting

By now, you know that I'm a big fan of the 50D's C shooting mode customization. So if you routinely shoot events in a specific venue such as an arena, then you can set up and register settings for one of the C modes specifically for that venue. Then you have little if any camera setup to do before you begin shooting.

Here are some suggestions for camera and Custom Function settings for action and event photography. Modify them as appropriate for your needs.

✦ **RAW + JPEG, or sRAW + JPEG image quality.** Many photographers shoot events and sell the images to players and family. They post the event images to a Web site where players can order prints. If you do this or are considering doing it, then the RAW + JPEG or sRAW + JPEG image quality options come in handy. The JPEG images enable you to immediately post

images to the Web site while the RAW or sRAW images give you the option to process exceptional shots for maximum potential or tweak shots that need more attention.

✦ **Tv shooting mode.** This mode gives you control over the shutter speed so that you can freeze action of the players or participants and get tack-sharp focus given the lens that you're using. Just remember that for non-IS lenses, the handholding limit is 1/[focal length]. So for a 300mm lens, you need at least a 1/300 second shutter speed to be able to handhold the camera and lens and get a sharp image.

9.17 A local jazz concert gave me the opportunity to photograph this sax player. I darkened the background during image editing to keep stage posts from becoming a distraction. Exposure: ISO 100, f/2.8, 1/400 second using an EF 70-200m f/2.8L IS USM lens.

✦ **AI Servo AF mode and manual or automatic AF-point selection.** AI Servo AF is designed for action shooting. In this mode, the camera focuses on the subject as long as you hold the Shutter button halfway down. Alternately, you can use the AF-ON button to focus. You can manually choose the AF point or let the camera choose it. If you let the camera choose the AF point, then it sets focus at the center AF point and tracks focus as long as the subject is within the rest of the AF point array. The downside of AI Servo AF is that it can lose track of the subject if something comes between the subject and the lens. Your other options are AI Focus AF that starts out in One-shot AF and automatically switches to AI Servo AF if the subject starts moving, or One-shot AF where you choose the focus with no focus tracking from the camera.

✦ **High-speed Continuous drive mode.** High-speed continuous shooting (6.3 fps) allows a succession of shots up to 90 Large Fine JPEGs if you're using an Ultra DMA card or 60 with a non-UDMA card per burst. When the internal camera buffer is full, a "buSY" message is displayed in the viewfinder. But as images are off-loaded to the CF card, you'll be able to continue shooting. Also, if you see "FuLL CF" in the viewfinder, be sure to wait until the red access lamp goes out to replace the card.

Tip

If the 50D isn't shooting the burst rate that you expect, check to see if you have enabled C.Fn II-2, High ISO speed noise reduction, which can reduce the burst rate depending on the option chosen.

✦ **Evaluative metering mode.**

✦ **Picture Style.** The Standard Picture Style is a good choice, particularly if you've previously tested it and examined the prints.

✦ **Custom Functions.** For action and events, you can consider using C.Fn I-2, ISO speed setting increments, and choosing Option 1: 1 stop making ISO changes from Auto to 100, 200, 400, 800, 1600, and 3200 instead of the finer increments of 100, 125, 160, and so on. You can consider enabling ISO expansion, C.Fn I-3, but you should test the H1 and H2 settings for digital noise levels before using them. Exposure Safety Shift, C.Fn I-6, automatically adjusts the exposure if the light suddenly changes enough to make the current exposure settings inaccurate. This can be helpful for outdoor events as well as indoor events where the lighting varies across the venue. If you're shooting with a super-telephoto lens that has an AF Stop button, then study the options for C.Fn III-2 to determine if you want to change the default behavior. You can also consider changing the C.Fn III-3, AF-point selection method if you choose to manually select an AF point.

Shooting events and action

The 50D offers versatility in shooting a broad range of events and games with a seriously fast shutter action and excellent burst depth. Couple that with shutter speeds ranging from 1/8000 to 30 seconds, and you have

ample opportunity to freeze or show motion, and to create interesting panned images. Action photography and the techniques used for it are by no means limited to sports. Any event — from a football game to a carnival or concert — is an opportunity to use action-shooting techniques.

Exposure approaches

In most action photography, but not all, the goal is to show the motion of the athlete or participant in mid-whatever — midjump, midrun, middrop — with tack-sharp focus and no motion blur. Stopping action requires fast shutter speeds and fast shutter speeds require ample light, or an increased ISO sensitivity setting. The shutter speed that you need to stop motion depends on the subject's direction in relation to the camera. Table 9.1 provides some common action situations and the shutter speeds needed to stop motion and to pan with the motion of the subject.

9.18 For action shooting, you have many options including showing stopped motion with a bit of blur, as illustrated by this image. Exposure: ISO 100, f/5.6, 1/200 second using an EF 70-200mm f/2.8L IS USM lens.

Table 9.1
Recommended Shutter Speeds for Action Shooting

Subject direction in relation to the camera	Shutter Speed in seconds
The subject is moving toward the camera	1/250
The subject is moving side-to-side or up and down	1/500 to 1/2000
Panning with the motion of the subject	1/30 to 1/8

Depending on the light and the speed of the lens that you're using, getting a fast shutter speed often means increasing the ISO sensitivity setting. In previous chapters, I recommended shooting at the higher ISO settings and then evaluating the images for digital noise at 100 percent enlargement on the computer. And you also need to print the images and view them at a standard 1-foot viewing distance to evaluate whether noise is objectionable, and at what ISO setting it becomes objectionable. I personally shoot

9.19 Twilight is an excellent time to capture a sapphire blue in the sky and show the motion of carnival rides. Exposure: ISO 250, f/11, 1/25 second using an EF 24-70mm f/2.8L USM lens.

at the lowest ISO possible to get the shutter speed that I need to stop subject motion. I do not shoot higher than ISO 1600, and I use ISO 1600 only if the light simply won't allow shooting at ISO 800 or 400.

Getting accurate and visually pleasing color is important as well. For outdoor events and games, the preset White Balance settings such as Daylight, Cloudy, and so on are excellent, and you will always get better color by using one of these settings versus setting Auto White Balance. Indoors, I try to arrive early enough to set a custom white balance. From my perspective, this is the easiest approach and it speeds up the workflow while I process images because the color is already correct. Setting a custom white balance takes no more than about 3 minutes, and it pays off every time.

Shooting action images

Beyond the point of selecting the correct shutter speed to capture the action, the biggest challenges of action shooting are timing shots and composing images. The first challenge is to anticipate the moments of high emotion and the decisive moment. And when the mirror flips up, you hold your

breath during the blackout hoping that you captured the moment. Because the subject is in constant motion, there's limited time to compose the image as you react to the subject's motion. I find myself zooming in and out and moving to follow the subject provided that there is room to move. In many scenarios, action shooting often means getting a handful of keepers from 50 to 100 exposures.

9.20 Shutter speed was fast enough here to stop the action of the wood chips coming off the chainsaw mid-flight. Exposure: ISO 100, f/2.8, 1/250 second using an EF 70-200mm f/2.8L IS USM lens.

You can use a few approaches to increase your ability to get good action images.

✦ **In a venue with spotty lighting, find an area with good light.** Prefocus on the area, and then wait for the action to come to that spot. If your lens allows prefocusing, then you can prefocus on an important area such as the goal line. Then continue shooting other areas until the action moves to the goal line, and press the preset button to have the lens automatically return focus to that area.

✦ **Keep exposure changes to a minimum for as long as the light allows so that you can concentrate on capturing the important moments and composing images.**

✦ **Anticipate the action.** Whether the event is a football game or a wedding recessional, knowing what is likely to happen next means that you can set up for the next action sequence before the subject gets to the area.

You can switch between using a telephoto lens to photograph action, and a wide-angle lens to capture "establishing" shots of the overall venue, the audience, and crowd reactions. These are the shots that help create the full story and spirit of the event.

As you shoot, remember the beauty and fun of using slow shutter speeds as well. You can do everything from placing sharp focus on the finish line sign, and then setting a slow shutter speed to blur the motion of runners or bikers crossing the line. And lighted carnival and fair rides offer colorful slow-motion action opportunities.

Appendixes

The Fundamentals of Exposure

APPENDIX

✦　✦　✦　✦

In This Appendix

The four elements of exposure

Equivalent exposures

Putting it all together

✦　✦　✦　✦

In my years of working as a photographer and in teaching photography courses, I've found many photographers have a good understanding of most aspects of photographic exposure while other aspects are vague or less well understood. And in other cases, I've worked with photographers who are returning to photography after a long absence and want a refresher on the fundamentals of exposure. If you fall into either camp, then this appendix is for you.

The Four Elements of Exposure

Photographic exposure is a precise combination of four elements: light, the medium's sensitivity to light, the intensity of light, and the length of time that light falls on the medium. The medium, of course, is the 50D's image sensor. And because all of the elements are interrelated, if one element changes, then the others must change proportionally.

✦ **Light.** The starting point of exposure is the amount of light that's available in the scene to make a picture. Every exposure depends on the amount of light the camera has to work with. Scene light is read using the onboard light meter. Then the camera bases exposure calculations on the meter reading.

✦ **Sensitivity.** Sensitivity refers to the amount of light that the camera's image sensor needs to make an exposure, or, in short, the sensor's sensitivity to light. Sensitivity is determined by the ISO setting.

✦ **Intensity.** Intensity is the strength or amount of light that reaches the image sensor. Intensity is controlled by the aperture, or f-stop. The aperture controls the lens diaphragm, an adjustable opening that expands or contracts to allow more or less light through the lens and into the image sensor.

✦ **Time.** Time is the length of time that light is allowed to reach the sensor. Time is controlled by the shutter speed, which determines how long the shutter stays open.

The following sections look at each element in more detail.

Light

The starting point of all exposures is light. And to calculate the amount of light that's available to make the exposure, the light is measured, or metered, by the 50D's onboard reflective light meter. When you half-press the Shutter button, it activates the camera's light meter, which measures the light that is reflected from the subject back to the camera. On the 50D, the light meter reading is weighted toward the active autofocus (AF) point in Evaluative metering mode, and at the center AF point in Partial, Spot, and Center-weighted Average metering modes. Then the camera uses the light meter reading to calculate its suggested, or ideal, exposure. And that's where the other three exposure factors come into play.

Cross-Reference *The 50D uses the active AF point to weight both the exposure in Evaluative metering mode and set the focus. These functions are performed simultaneously when you half-press the Shutter button. The only way to decouple these functions is by using AutoExposure Lock (AE Lock), which is detailed in Chapter 3.*

Now that the amount of light is known, it's a matter of getting the exact proportions of sensitivity (ISO), intensity (aperture), and time (shutter speed) to make a good exposure.

The camera gives you its suggested exposure. And depending on the shooting mode you choose on the 50D, you can modify all, part, or none of the exposure settings. In automatic shooting modes such as Portrait, Landscape, and Sports, the camera automatically sets the exposure settings and you can't change them. In semiautomatic modes such as Av and Tv, you can set the ISO (sensitivity), and then set the aperture (Av mode) or shutter speed (Tv mode), and the camera figures out and sets the shutter speed or aperture, respectively. In Manual mode (M), you set all the ISO, aperture, and shutter speed by using the exposure level meter displayed in the viewfinder or by knowing in advance what exposure settings you want for the subject or scene.

Tip *As a refresher, Evaluative metering mode meters light throughout the viewfinder based on the selected AF point; Spot and Partial modes meter a much smaller area at the center of the viewfinder; and Center-weighted Average mode gives more weight to light metered at the center of the frame. As you continue reading, consider which metering mode you'd use in different scenes.*

Depending on the camera shooting mode, you now have creative control over the exposure to change the depth of field, stop subject motion in progress, show subject motion as a blur, and virtually anything else you want. And sometimes, the exposure controls are simply a matter of being able to get the shot at all given the constraints of the light. For example, in a lowlight scene, you may not be able to get a fast enough shutter speed in Tv mode to handhold the

camera even shooting wide open. In that case, you know that the only alternative is to increase the sensitivity setting to a higher ISO. In this and other scenes, it's important to know how the exposure elements interact so you can make the necessary exposure changes to get the shot.

Sensitivity: The role of ISO

The ISO setting determines how sensitive the image sensor is to light. The higher the ISO number, the less light that's needed to make a picture. The lower the ISO number, the more light that's needed to make a picture. As a practical matter, photographers use high ISO numbers or settings such as ISO 800 to 1600 to get shutter speeds that are fast enough to handhold the camera and get a sharp image particularly in lowlight scenes. But in bright to moderately bright light, low ISO settings from 100 to 400 work well because there is enough light in the scene to ensure a fast enough shutter speed to get a sharp image.

Note *How fast is fast enough to handhold the camera and lens? The most common formulas for determining the answer to this question are provided in the Time section later in this appendix.*

Each ISO setting is twice as sensitive to light as the previous setting. For example, an ISO of 800 is twice as sensitive to light as ISO 400. As a result, the sensor needs half as much light to make an exposure at ISO 800 as it does at ISO 400.

On the 50D, the ISO sequence encompasses Auto (ISO 100-1600), and ISO 100 to 3200. In automatic shooting modes such as Portrait, Landscape and so on, the camera automatically sets Auto ISO. In P, Tv, Av, M,

and A-DEP shooting modes, you can set the ISO for Auto, or for 100 to 3200. And if you enable ISO expansion using C.Fn I-3, the ISO settings of H1 (6400) and H2 (12800) are available. When you change the ISO on the 50D, the changes are made in 1/3-stop increments unless you set C.Fn I-2 to Option 1: 1-stop increments.

Note *The International Organization for Standardization (ISO) measures, tests, and sets standards for many photographic products, including the rating or speed for film, which has, in turn, been applied to equivalents for the sensitivity of digital image sensors.*

In addition to setting the relative light sensitivity of the sensor, ISO also factors into the overall image quality in several areas, including sharpness, color saturation, contrast, and digital noise or lack thereof. Digital noise appears in images as a grainy appearance and as flecks of color in shadow areas.

Increasing the ISO setting amplifies both the signal and the noise in the image, much like hiss or static in an audio system that becomes more audible as the volume increases. Noise in digital images is roughly analogous to grain in high-ISO film. However, in digital photography, noise is comprised of luminance and chroma noise. Luminance noise is similar to film grain. Chroma noise appears as mottled color variations and as colorful pixels in the shadow areas of the image.

Regardless of the type, digital noise degrades overall image quality by overpowering fine detail in foliage and fabrics, reducing sharpness and color saturation, and giving the image a mottled look. Digital noise increases with high ISO settings, long exposures, and underexposure as well as high ambient temperatures, such as from leaving the camera in a hot car or in the hot sun.

A.1 In bright light, you can set a low ISO, such as 100, to get fast shutter speeds. Exposure: ISO 100, f/4, 1/640 second.

The tolerance for digital noise is subjective and varies by photographer. It's important to shoot images at each of the ISO settings and examine the images for noise. This type of testing helps you know what to expect in terms of digital noise at each ISO setting. Then you can determine how high an ISO you want to use on an average shooting day.

To reduce digital noise in long exposures, you can also enable a Custom Function (C. Fn II-1: Long exposure noise reduction) to reduce digital noise in exposures of 1 second or longer. This option doubles the exposure time duration, but the noise is virtually imperceptible.

Checking for Digital Noise

If you choose a high ISO setting, be sure to check for digital noise by zooming the image to 100 percent in an image-editing program. Look for flecks of color in the shadow and midtone areas that don't match the other pixels and for areas that resemble the appearance of film grain.

If you detect objectionable levels of digital noise, you can use noise reduction programs such as Noise Ninja (www.picturecode.com), Neat Image (www.neatimage. com), or NIK Dfine (www.niksoftware.com) to reduce it. Typically, noise reduction softens fine detail in the image, but these programs minimize the softening. If you shoot RAW images, programs including Canon's Digital Photo Professional and Adobe Camera Raw offer noise reduction that you can apply during RAW conversion.

Tip *I always shoot at the lowest ISO sensitivity setting possible based on the factors of ambient light, the lens I'm using, and whether I'm shooting on a tripod or using an Image-Stabilized lens. Shooting at low ISO settings ensures the highest image quality, and that is my goal for all of the images that I make.*

Intensity: The role of the aperture

The lens aperture (the size of the lens diaphragm opening) determines the intensity of light that strikes the image sensor. Aperture is indicated as f-stop numbers, such as f/2.8, f/4.0, f/5.6, f/8, and so on. When you increase or decrease the aperture by one full f-stop, it doubles or halves the exposure, respectively. For example, f/8 halves the light that f/5.6 provides, while f/5.6 provides twice as much light as f/4.0. Aperture plays a starring role in determining the depth of field in an image. Depth of field is discussed later in this appendix.

Note *The apertures that you can choose depend on the lens that you're using. For example, the Canon EF-S 18-55mm f/4.5-5.6 lens has a maximum aperture of f/4.5 at 18mm and f/5.6 at 55mm and a minimum aperture of f/22, while the EF 100-300mm f/4.5-5.6 USM lens has a maximum aperture of f/4.5 at 100mm and f/5.6 at 300mm and a minimum aperture of f/32-38 at the same respective zoom settings.*

wide aperture (a large diaphragm opening) such as f/5.6 delivers sufficient light to the sensor so that the amount of time that the shutter has to stay open to make the exposure decreases, thus allowing a relatively faster shutter speed.

Note *Aperture also plays a starring role in the depth of field of images. Depth of field is detailed later in this chapter.*

A.2 To keep the deck flooring from becoming distracting, I used a wide f/5.6 aperture for this image of a lily. Exposure: ISO 100, f/5.6, 1/125 second

Wide aperture

Smaller f-stop numbers, such as f/2.8, set the lens diaphragm to a large opening that lets more light reach the sensor. A large lens opening is referred to as a *wide aperture*. Based on the ISO and in moderate light, a

Narrow aperture

Larger f-stop numbers, such as f/16, set the lens diaphragm to a small opening that lets less light reach the sensor. A small lens opening is referred to as a *narrow aperture*.

Based on the ISO and in moderate to low light, a small diaphragm opening such as f/11 delivers less light to the sensor. Thus, the shutter has to stay open longer resulting in a comparatively slow shutter speed.

Choosing an aperture

In everyday shooting, photographers most often select an aperture based on how they want background detail to be rendered in the image — either with distinct detail or with softly blurred background detail. This is called controlling the depth of field, discussed later in the appendix. In addition, choosing a specific aperture may involve other factors. For example, if you want to avoid blur from camera shake in lower light, choose a wide aperture to get the faster shutter speeds. And if you want selective focus, where only a small part of the image is in sharp focus, choose a wide aperture.

You can control the aperture by switching to Av or M mode. In Av mode, you set the aperture, and the camera automatically sets the correct shutter speed based on the selected ISO. In M mode, you set both the aperture and the shutter speed based on the reading from the camera's light meter. The exposure level indicator is displayed in the viewfinder as a scale and it indicates over-, under-, and correct exposure based on the aperture, shutter speed, and ISO.

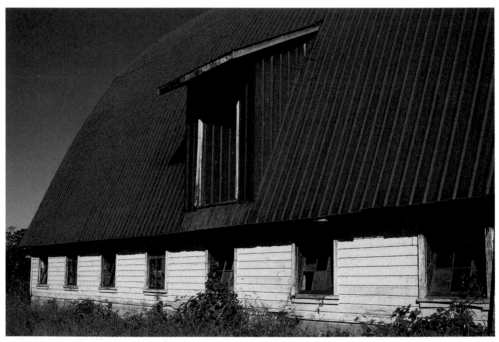

A.3 To maintain good sharpness from front to back on this old barn, or an extensive depth of field, I used a narrow aperture of f/11. Exposure: ISO 100, f/11, 1/125 second.

Tip *You can use P mode to make one-time changes to the aperture that the camera initially sets. Unlike Av mode where the aperture you choose remains in effect until you change it, in P mode, changing the aperture is temporary. After you take the picture, the camera reverts to its suggested aperture and shutter speed.*

Cross-Reference *You can learn about exposure modes in Chapter 3.*

What is depth of field?

Depth of field is the zone of acceptably sharp focus in front of and behind the subject. In simple terms, depth of field determines if the foreground and background are rendered as a soft blur or with distinct detail. Depth of field generally extends one-third in front of the point of sharp focus and two-thirds behind it. Aperture is the main factor that controls depth of field, although camera-to-subject distance and focal length affect it as well. Depth of field is both a practical matter — based on the light that's available in the scene to make the picture — and a creative choice to render background and foreground elements in the image to suit your photographic vision of the scene or subject.

Shallow depth of field

Images where the subject is in sharp focus and the background is softly blurred have a shallow depth of field. As a creative tool, shallow depth of field is typically preferred for portraits, some still-life images, and food photography.

As a practical tool, choosing a wide aperture that creates a shallow depth of field is necessary when shooting in lowlight. In general terms, to get a shallow depth of field, choose a wide aperture such as f/2.8, f/4, or f/5.6. The subject will be sharp, and the background will be blurred and nondistracting.

Lenses also factor into depth of field, with a telephoto lens offering a shallower depth of field than a normal or wide-angle lens. Camera-to-subject distance also factors in with a close distance creating a shallow depth of field and vice versa.

A.4 The shallow depth of field helps to bring the statue visually forward in this image yet it keeps the garden context of the setting. Exposure: ISO 100, f/2.8, 1/125 second.

Extensive depth of field

Pictures with acceptably sharp focus throughout the frame are described as having extensive depth of field. Extensive depth of field is preferred for images of large groups of people, landscapes, architecture, and interiors. To get extensive depth of field, choose a narrow aperture, such as f/8 or f/11, or smaller.

Given the same ISO, choosing a narrow aperture such as f/16 requires a longer shutter speed to ensure that enough light reaches the sensor for a correct exposure than a wide aperture that requires a comparatively shorter shutter speed.

While aperture is the most important factor that affects the range of acceptably sharp focus in a picture, other factors also affect depth of field:

✦ **Camera-to-subject distance.** At any aperture, the farther you are from a subject, the greater the depth of field is and vice versa.

✦ **Focal length.** Focal length, or angle of view, is how much of a scene the lens "sees." From the same shooting position, a wide-angle lens produces more extensive depth of field.

Throughout this section, I've referred to wide and narrow apertures in general terms. More specifically, wide apertures are f/5.6 and wider, such as f/4.0, f/3.2, f/2.8, f/2.0, f/1.4, and f/1.2. Narrow apertures begin at f/8 and continue through f/11, f/16, f/22, and f/32.

Lenses with a wide maximum aperture such as f/2.8 are referred to as *fast* lenses, and vice versa. In addition, some lenses have variable apertures, where the maximum aperture changes based on the zoom setting on the lens. For example, the Canon EF 28-300mm f/3.5-f/5.6L IS USM lens allows a maximum aperture of f/3.5 at the 28mm zoom setting and f/5.6 at the 300mm zoom setting.

 For more information on lenses, see Chapter 8.

A.5 Despite setting a wide aperture and using a telephoto lens, the great amount of distance from the camera to the subject provided relatively extensive depth of field in this image. Exposure: ISO 100, f/4.5, 1/30 second.

Time: The role of shutter speed

Shutter speed controls how long the shutter stays open to let light from the lens strike the image sensor. The longer the shutter, or curtain, stays open, the more light reaches the sensor (at the aperture and ISO that you set). When you increase or decrease the shutter speed by one full setting, it doubles or halves the exposure. For example, twice as much light reaches the image sensor at 1/30 second as at 1/60 second.

In daily shooting, shutter speed is also related to:

✦ **The ability to handhold the camera and get sharp images, particularly in lowlight.** The general rule for handholding a non-Image Stabilized lens is the reciprocal of the focal length. For example, if you're shooting at 200mm, then the slowest shutter speed at which you can handhold the lens and get a sharp image is 1/200 second.

A.6 A relatively fast shutter speed stops the motion at the center of this ride but shows motion blur in areas that are off the plane of sharp focus. Exposure: ISO 400, f/2.8, 1/125 second.

✦ **The ability to freeze motion or show it as blurred in a picture.** For example, you can set a fast shutter speed to show a basketball player's jump in midair with no blur.

You can control the shutter speed in Shutter-priority AE (Tv) or Manual (M) mode. In Shutter-priority AE (Tv) mode, you set the shutter speed, and the camera automatically sets the correct aperture. In Manual (M) mode, you set both the shutter speed and the aperture based on the reading from the camera's light meter and the ISO. The light meter is displayed in the viewfinder as a scale — the exposure level indicator — and it shows over-, under-, and correct exposure based on the shutter speed, aperture, and ISO.

Equivalent Exposures

As you have seen, after the camera meters the light and factors in the selected ISO, the two remaining factors determine the exposure — the aperture and the shutter speed.

A.7 Working with different aperture, shutter speed, and ISO combinations is the best way to learn how they work together to create the effect that you want and to get the picture regardless of the challenges that the subject or scene present. Exposure: ISO 200, f/2.8, 1/50 second.

Many combinations of aperture (f-stop) and shutter speed produce exactly the same exposure at the same ISO setting. For example, f/22 at 1/4 second is equivalent to f/16 at 1/8 second, as is f/11 at 1/15, f/8 at 1/30, and so on. And this is based on the doubling and halving effect discussed earlier. For example, if you are shooting at f/8 and 1/30 second, and you change the aperture (f-stop) to f/5.6, then you have doubled the amount of light reaching the image sensor, so the time that the shutter stays open must be halved to 1/60 second.

While these exposures are equivalent, the rendering of the image, and your shooting options, change proportionally. An exposure of f/22 at 1/4 second produces extensive depth of field in the image, but the shutter speed is slow, so your ability to handhold the camera and get a sharp image is dubious. But if you switch to an equivalent exposure of f/5.6 at 1/60 second, you are more likely to be able to handhold the camera, but the depth of field will be shallow. As with all aspects of photography, evaluate the tradeoffs as you make changes to the exposure. Your creative options for exposure are most often determined by the amount of light in the scene.

Putting It All Together

ISO, aperture, shutter speed, and the amount of light in a scene are the essential elements of photographic exposure. On a bright, sunny day, you can select from many different f-stops and still get fast shutter speeds to prevent image blur. You have little need to switch to a high ISO for fast shutter speeds at small apertures.

As it begins to get dark, your choice of f-stops becomes limited at ISO 100 or 200. You need to use wide apertures, such as f/2.8 or wider, to get a fast shutter speed. Otherwise, your images will show some blur from camera shake or subject movement. Switch to ISO 400, 800, or higher, however, and your options increase and you can select narrow apertures, such as f/8 or f/11, for greater depth of field. The higher ISO allows you to shoot at faster shutter speeds to reduce the risk of blurred images, but it also increases the chances of digital noise.

Exploring
RAW Capture

I f you want to get the highest quality images from the EOS 50D, then RAW capture is the way to get them. In addition, you have the opportunity to determine how the image data from the camera is interpreted as you convert, or process, the RAW image. While RAW capture offers significant advantages, it isn't for everyone. If you prefer images that are ready to print straight out of the camera, then JPEG capture is the best option. However, if you enjoy working with images on the computer and having creative control over the quality and appearance of the image, then RAW is the option to explore.

This appendix provides an overview of RAW capture, as well as a brief walk-through on converting RAW image data into a final image.

Learning about RAW Capture

One way to understand RAW capture is by comparing it to JPEG capture, which most photographers are familiar with already. When you shoot JPEG images, the camera edits or processes the images before storing them on the CF card. This processing includes converting images from 14-bit files to 8-bit files, setting the color rendering and contrast, and generally giving you a file that is finished. Very often, the images are ready to print. But in other cases, you may encounter images where you want more control over how the image is rendered — perhaps to recover blown highlights that have no detail, to tone down very

high-contrast images, or to correct the color of an image. Of course, you can edit JPEG images in an editing program and make some of these corrections, but the amount of latitude for editing is limited.

By contrast, RAW capture allows you to work with the data that comes off the image sensor with virtually no internal camera processing. The only camera settings that the camera applies to a RAW image are ISO, shutter speed, and aperture. And because many of the key camera settings have been noted but not applied in the camera, you have the opportunity to make changes to settings, including image brightness, white balance, contrast, and saturation, when you convert the RAW image data into a final image using a conversion program such as Canon's Digital Photo Professional, Adobe Camera Raw, Adobe Lightroom, or Apple Aperture.

Note *In addition to the RAW image data, the RAW file also includes information, called metadata, about how the image was shot, the camera and lens used, and other description fields.*

An important characteristic of RAW capture is that it offers more latitude and stability in editing converted RAW files than JPEG files offer. With JPEG images, large amounts of image data are discarded when the images are converted to 8-bit mode in the camera, and then the image data is further reduced when JPEG algorithms compress image files to reduce the size. As a result, the image leaves little, if any, wiggle room to correct tonal range, white balance, contrast, and saturation during image editing. Ultimately, this means that if the highlights in an image

are overexposed, or blown, then they're blown for good. If the shadows are blocked up (meaning they lack detail), then they will likely stay blocked up. It is possible to make improvements in Photoshop, but the edits make the final image susceptible to posterization or banding that occurs when the tonal range is stretched and gaps appear between tonal levels. This stretching makes the tonal range on the histogram look like a comb.

On the other hand, RAW images have rich data depth and provide significantly more image data to work with during conversion and subsequent image editing. In addition, RAW files are more forgiving if you need to recover overexposed highlight detail during conversion of the RAW file.

Note *With digital cameras, dynamic range depends on the sensor. The brightest f-stop is a function of the brightest highlight in the scene that the sensor can capture, or the point at which the sensor element is saturated with photons. The darkest tone is determined by the point at which the noise in the system is greater than the comparatively weak signal generated by the photons hitting the sensor element.*

These differences in data richness translate directly to editing leeway. And maximum editing leeway is important because after the image is converted, all the edits you make in an editing program are destructive.

Proper exposure is important with any image, and it is no less so with RAW images. With RAW images, proper exposure provides a file that captures rich tonal data that withstands conversion and editing well. For

example, during conversion, image brightness levels must be mapped so that the levels look more like what we see with our eyes — a process called gamma encoding. In addition, you will also likely adjust the contrast and midtones and move the endpoints on the histogram. For an image to withstand these conversions and changes, a correctly exposed and data-rich file is critical.

Proper exposure is also critical, considering that digital capture devotes the lion's share of tonal levels to highlights while devoting far fewer levels to shadows. In fact, half of all the tonal levels in the image are assigned to the first f-stop of brightness. Half of the rest of the tonal levels account for the second f-stop, and half into the next f-stop, and so on.

Clearly, capturing the first f-stop of image data is critical because fully half of the image data is devoted to that f-stop. If an image is underexposed, not only is important image data sacrificed, but the file is also more likely to have digital noise in the shadow areas.

Underexposure also means that during image conversion, the fewer captured levels must be stretched across the entire tonal range. Stretching tonal levels creates gaps between levels that reduce the continuous gradation between levels.

The general guideline when shooting RAW capture is to expose to the right so that the highlight pixels just touch the right side of the histogram. Thus, when tonal mapping is applied during conversion, the file has significantly more bits that can be redistributed to the midtones and darker tones where the human eye is most sensitive to changes.

If you've always shot JPEG capture, the exposing-to-the-right approach may just seem wrong. When shooting JPEG images, the guideline is to expose so that the highlights are not blown out because if detail is not captured in the highlights, it's gone for good. This guideline is good for JPEG images where the tonal levels are encoded and the image is essentially pre-edited inside the camera. However, with RAW capture, gamma encoding and other contrast adjustments are made during conversion with a good bit of latitude. And if highlights are overexposed, conversion programs such as Adobe Camera Raw or Digital Photo Professional can recover varying amounts of highlight detail.

In summary, RAW capture produces files with the most image data that the camera can deliver, and you get a great deal of creative control over how the RAW data is converted into a final image. Most important, you get strong, data- and color-rich files that withstand image editing and can be used to create lovely prints.

However, if you decide to shoot RAW images, you also sign on for another step in the process from capturing images to getting finished images, and that step is RAW conversion. With RAW capture, the overall workflow is to capture the images, convert the RAW data in a RAW-conversion program, edit images in an image-editing program, and then print them. You may decide that you want to shoot in RAW+JPEG so that you have JPEGs that require no conversion, but you have the option to convert exceptional or problem images from the RAW files with more creative control and latitude.

Canon's RAW Conversion Program

Unlike JPEG images, RAW images are stored in proprietary format, and they cannot be viewed on some computers or opened in some image-editing programs without first converting the files to a more universal file format such as TIFF, PSD, or JPEG. Canon includes a free program, Digital Photo Professional, on the EOS Digital Solution Disk. You can use this program to convert 50D RAW files, and then save them as TIFF or JPEG files.

Note Images captured in RAW mode have a .cr2 filename extension.

Digital Photo Professional (DPP) is noticeably different from traditional image-editing programs. It focuses on image conversion tasks, including correcting, tweaking, or adjusting white balance, brightness, shadow areas, contrast, saturation, sharpness, noise reduction, and so on. It doesn't include some familiar image-editing tools, such as healing or history brushes, nor does it offer the ability to work with layers.

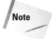

Note Canon also includes a Picture Style Editor on the disc that comes with the camera. This program is a great way to set up a Picture Style that works well for RAW capture.

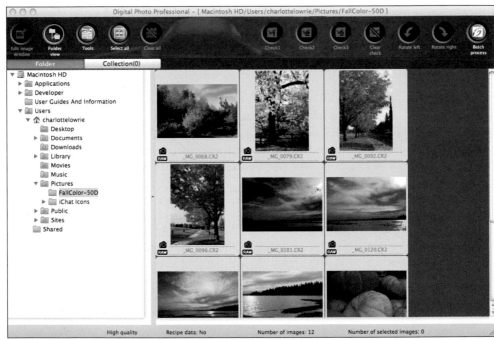

B.1 This figure shows Canon's Digital Photo Professional's main window with the toolbar for quick access to commonly accessed tasks.

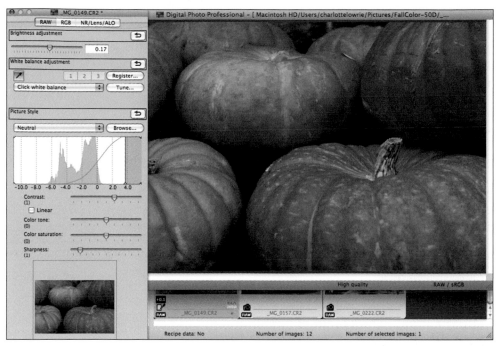

B.2 This figure shows the RAW image adjustment controls in Canon's Digital Photo Professional. Here I've increased the image brightness.

Which Conversion Program Is Best?

Choosing a RAW conversion program is a matter of personal preference in many cases. Canon's Digital Photo Professional is included with the 50D, and program updates are offered free. Third-party programs, however, often have a lag time between when the camera is available for sale and when the program supports the new camera.

Arguments can be made for using either the manufacturer's or a third-party program. The most-often cited argument for using Canon's program is that because Canon knows the image data best, it is most likely to provide the highest quality RAW conversion. On the other hand, many photographers have tested the conversion results from Canon's program and Adobe's Camera Raw plug-in, and they report little or no difference in conversion quality.

Assuming there is parity in image-conversion quality, the choice of conversion programs boils down to which program offers the ease of use and features that you want and need. Certainly Adobe has years of experience building feature-rich programs for photographers within an interface that is familiar and relatively easy to use. Canon, on the other hand, has less experience in designing software features and user interfaces, but Canon's program has made significant strides in recent releases.

continued

continued

Because both programs are free (provided you have Photoshop in the case of Adobe Camera Raw), you should try both programs and other RAW conversion programs that offer free trials. Then decide which one best suits your needs. I often switch between using Canon's DPP program and Adobe Camera Raw.

Whatever conversion program you choose, be sure to explore the full capabilities of the program. One of the advantages of RAW conversion is that as conversion programs improve, you can go back to older RAW image files and convert them again using the improved features and capabilities of the conversion program.

Sample RAW Image Conversion

Although RAW image conversion adds a step to image processing, this important step is well worth the time. To illustrate the overall process, here is a high-level workflow for converting an EOS 50D RAW image using Canon's DPP.

Be sure to install the Digital Photo Professional application provided on the EOS Digital Solution Disk before following this task sequence.

1. **Start Digital Photo Professional (DPP).** The program opens. If no images are displayed, you can select a directory and folder from the Folder panel.

2. **Double-click the image you want to process.** The RAW image tool palette opens next to an image preview with the RAW tab selected. In this mode, you can:

 • **Drag the Brightness adjustment slider to the left to darken the image or to the right to lighten it.** To quickly return to the original brightness setting, click the curved arrow above and to the right of the slider.

 • **Use the White Balance adjustment control to adjust color.** You can click the Eyedropper tool, and then click an area that is white or gray in the image to quickly set white balance, choose one of the preset White Balance settings from the Shot Setting drop-down menu, or click Tune to adjust the white balance using a color wheel. After you correct the color you can click Register to save the setting and then use it to correct other images.

 • **Change the Picture Style by clicking the down arrow next to the currently listed Picture Style and selecting a different Picture Style from the list.** The Picture Styles offered in DPP are the same as those offered on the menu on the 50D. When you change the Picture Style in DPP, the image preview updates to show the change. You can adjust the curve, color tone, saturation, and sharpness. If you don't like the results, you can click the curved arrow to the right of Picture Style to switch back to the original Picture Style.

- **Adjust the black and white points on the image histogram by dragging the bars at the far left and right of the histogram toward the center.** By dragging the slider under the histogram, you can adjust the tonal curve.

- **Adjust the Color tone, Color saturation, and Sharpness by dragging the sliders.** Dragging the Color tone slider to the right increases the green tone, and dragging it to the left increases the magenta tone. Dragging the Color saturation slider to the right increases the saturation, and vice versa. Dragging the Sharpness slider to the right increases the sharpness, and vice versa.

3. **Click the RGB image adjustment tab.** Here you can apply an RGB curve and also apply separate curves in each of the three color channels: Red, Green, and Blue. You can also adjust the following:

 - **Click one of the tonal curve options to the right of Tone curve assist to set a classic S-curve that lightens the mid-tones in the image without changing the black and white points.** If you want to increase the curve, click the Tone curve assist button marked with a plus (+) sign one or more times to increase the curve. Alternately, you can click the linear line on the histogram, and then drag the line to set a custom tonal adjustment curve. If you want to undo the curve changes, click the curved arrow to the right of Tone curve adjustment, or the curved arrow to the right of Tone curve assist.

- **Click the R, G, or B buttons next to RGB to make changes to a single color channel.** Working with an individual color channel is helpful when you need to reduce an overall colorcast in an image.

- **Drag the Brightness slider to the left to darken the image or to the right to brighten the image.** The changes you make are shown on the RGB histogram as you make them.

- **Drag the Contrast slider to the left to decrease contrast or to the right to increase contrast.**

4. **In the image preview window, choose File ⇨ Convert and save.** The Convert and save dialog box appears. In the dialog box, you can specify the file type and bit depth at which you want to save the image. Just click the down arrow next to Kind of file and choose one of the options, such as TIFF 16-bit. Then you can set the Image Quality setting if you are saving in JPEG or TIFF plus JPEG format, set the Output resolution, choose to embed the color profile, or resize the image.

Tip *The Edit menu also enables you to save the current image's conversion settings as a recipe. Then you can apply the recipe to other images in the folder.*

5. **Click Save.** DPP displays the Digital Photo Professional dialog box until the file is converted. DPP saves the image in the location and format that you choose.

B.3 This figure shows an S-curve set in Canon's DPP RAW conversion window.

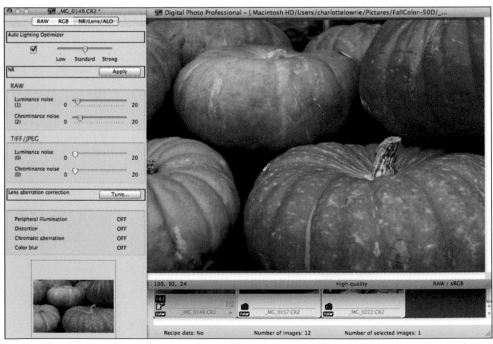

B.4 On the NR/Lens/ALO tab, you can set Auto Lighting Optimizer, lens correction, and apply noise reduction.

Maintaining the 50D

In addition to setting up, ongoing use of the 50D requires a few maintenance tasks that keep the camera performing well and save you time as you work with images. While the camera provides automatic sensor cleaning, there are additional sensor cleaning options that you can use to ensure spot-free images.

You'll also want to stay up to date with the firmware that Canon releases periodically. Plus Canon posts updates to the programs on the EOS Digital Solution Disk. In both cases, it's worth taking the time to download the updates as they become available. Firmware updates most often fix minor bugs that you may or may not encounter on the camera. The program updates include new features to programs such as the Picture Style Editor, Digital Photo Professional, and the EOS Utility.

Cleaning the Image Sensor

While recent Canon EOS cameras have offered excellent automatic image sensor cleaning, the 50D goes a step farther with a new fluorine coating that's been added to the camera's low-pass filter — the filter that sits in front of the sensor. This coating is designed to make cleaning more effective in removing particles that adhere to the filter. The automatic cleaning system uses an ultrasonic vibration to loosen and shake off dust each time the camera is turned on and off. The dust is then captured by material around the filter to prevent it from returning to the sensor.

The 50D offers four sensor-cleaning techniques that range from automatic to manual and using Canon's Digital Photo Professional program.

✦ **Auto cleaning.** This option is initiated when the camera is turned on and off and lasts approximately 1 second. You can interrupt the cleaning by pressing the Shutter button. In addition, you can turn off the Auto cleaning option. This option is turned on by default. If you want to turn it off, go to the Set-up 2 menu, select Sensor cleaning, and then press the Set button. Select Auto cleaning, and then select Disable.

✦ **Clean now.** This cleaning option lasts approximately 3.5 seconds and is more thorough than the Auto cleaning option. You can initiate this option at any time from the Set-up 2 camera menu. Select Clean now, and then press the Set button. The cleaning screen appears for a few seconds.

✦ **Clean manually.** This is the choice to use when sticky or wet dust or other particles can't be removed by the ultrasonic vibration. Choosing this option locks up the camera's reflex mirror so that you can use a cleaning swab or brush to clean the filter in front of the sensor. This option is available only in P, Tv, Av, M, A-DEP, C1, and C2 modes.

✦ **Dust Delete Data.** This option deals with stubborn dust particles by identifying their location on the sensor, and then using Canon's Digital Photo Professional program to erase the spots after images are captured. The data should be updated periodically.

Mapping and removing dust

One approach to removing dust in images is to map where particles on the sensor are located, and then use that information in Canon's Digital Photo Professional program to remove it after the image is captured. Capturing Dust Delete Data involves taking a picture of a piece of white paper from which the camera identifies the size and location of dust particles. Then a tiny data file is created and appended to subsequent images. After downloading images to the computer, you can use Digital Photo Professional to erase the spots that appear in images.

Deleting dust using the data mapping and application is perhaps the easiest approach when automatic cleaning doesn't remove all the particles. However, it requires that you use Digital Photo Professional after downloading images. Another alternative is manual sensor cleaning, detailed later in this appendix.

The first step in capturing Dust Delete Data is to take a picture that the camera uses to map particles on the sensor. Here is how to prepare for taking the picture.

✦ Have a clean piece of solid white paper large enough to fill the viewfinder when it's positioned 1 foot from the lens. Light the paper evenly with any light source.

✦ Set the lens focal length to 50mm or longer.

✦ Set the lens to manual focus by sliding the switch on the side of the lens to the MF setting.

✦ With the camera facing forward, set the focus to infinity by turning the lens focusing ring all the way to the left. On the lens distance scale, the infinity symbol looks like an "8" lying on its side.

✦ Ensure that you've installed Digital Photo Professional from the EOS Digital Solution Disk that comes with the 50D.

Now, you can create the Dust Delete Data file. Follow these steps:

1. **Set the camera to P, Tv, Av, M, A-DEP, C1, or C2 shooting mode, press the Menu button, and then highlight the Shooting 2 tab.**

2. **Highlight Dust Delete Data, and then press the Set button.** The Dust Delete Data screen appears and includes the last date, if any, that the data was captured.

3. **Highlight OK, and then press the Set button.** The camera displays a screen reminding you to press the Shutter button completely to obtain the data.

4. **Position the camera 1 foot from the white paper so that the paper fills the viewfinder, and then press the Shutter button completely.** The camera sets the exposure automatically and displays a confirmation message if the data was obtained successfully. If not, a message appears telling you that the data wasn't obtained.

5. **Press the Set button to select OK.** The Shooting 2 menu appears. The camera records the Dust Delete Data although no image is recorded on the CF card.

Take images as you normally take them with the camera. Then download the images to the computer. When you're ready to apply the Dust Delete Data, follow these steps.

1. **Start Digital Photo Professional, and then open the folder on your computer that contains images with Dust Delete Data appended.** Images taken after obtaining the Dust Delete Data file have the data appended.

2. **Select an image, and then click the Edit image window button in the toolbar.** The image opens in the editing window.

3. **Choose Tools ⇨ Start Stamp tool.** A separate window appears with the image displayed.

4. **Click the Apply Dust Delete Data button in the panel to erase dust.**

Cleaning the sensor manually

Sometimes the only way to remove stubborn dust is by cleaning the sensor manually. The tools you use to clean the sensor can range from an inexpensive rubber blower without a brush to swabs or special soft brushes.

It pays to research the different cleaning products on the market in advance of cleaning. A quick Google search will yield a plethora of products. I use products from VisibleDust (www.visibledust.com). It has a wide variety of brushes, swabs, and solutions, and offers instructions on using the products. Whatever you do, do not use canned air or blower brushes sold to clean lenses. Both can cause permanent damage to the filter in front of the sensor and other camera mechanisms.

Here is a precleaning checklist.

✦ **Charge the camera battery.**
Alternately, you can use the accessory AC Adapter Kit ACK-E2.

✦ **Find a brightly lit indoor location away from drifting dust, lint, pets, and so on in which to do the cleaning.** The light must be bright enough for you to examine the filter in front of the sensor thoroughly.

✦ **Read through the cleaning steps to get a sense of the task flow before you begin.**

✦ **Assemble the products you need for cleaning and prepare them for use.**

✦ **Remove the lens and attach the camera body cap until you're ready to begin.**

With the supplies and camera ready, follow these steps to clean the sensor.

1. **Set the camera to P, Tv, Av, M, A-DEP, C1, or C2 shooting mode.**

2. **Press the Menu button, and then highlight the Setup 2 menu.**

3. **Select Sensor cleaning, and then press the Set button.** The Sensor cleaning screen appears.

4. **Highlight Clean manually, and then press the Set button.** The Clean manually screen appears alerting you that the reflex mirror will lock up and to turn off the camera when cleaning is complete.

5. **Highlight OK, and then press the Set button.** The camera locks up the mirror and the shutter opens. "CLEA n" blinks in the LCD panel. During this time, do nothing that would disrupt power to the camera.

6. **Remove the body cap and clean the sensor according to the instructions for the product you're using.**

7. **When you finish, turn the Power switch to the Off position.** The camera turns off, the shutter closes, and the reflex mirror flips back down. You can attach the lens, turn on the camera, and begin shooting.

To determine how well you cleaned the sensor, make some pictures of a blue sky at a narrow aperture such as f/22 and evaluate them. You may need to repeat this process if there is dust remaining on the filter.

Tip *While there are no foolproof ways to prevent dust accumulating on the filter, it helps to keep the rear optical lens element clean, change lenses with the lens mount pointed down, change lenses in a large plastic bag when you're in dusty areas, and always have a lens mounted or attach the body cap to the body.*

Updating Firmware and Software

Periodically, Canon posts updates for the firmware, or the internal set of instructions for the 50D, as well as updates for all or some of the programs that are included on

the EOS Digital Solution Disk that comes with the camera. Firmware updates can add improved functionality to existing features, and, in some cases, resolve reported problems with the camera. For example, photographers contacted Canon asking for direct control of the AF-point selection on another Canon EOS camera, and a recent firmware update modified a Custom Function to allow that functionality.

Before you download firmware, you need to know the firmware version number that's installed on your 50D to ensure that the version posted by Canon is newer than what's currently installed. You can find the number in the Setup 3 menu. Firmware versions are numbered so the highest numbered version is the most current. For example, the initial firmware version is numbered as 1.0.1. When a firmware update becomes available, it will have a higher number such as 1.0.2 or 1.0.3.

In addition to the firmware code, Canon includes a summary that details the changes included in the update and detailed instructions on downloading the firmware and installing it on the camera. You'll also be asked to sign the End User License Agreement before downloading the firmware.

When you check for new firmware, you can also browse thorough the Software section on the Canon Web site to see if there are updates to the EOS Digital Solution Disk programs or camera accessories such as the wireless transmitter that you want to download. The process for downloading programs follows the general steps as for the firmware, which is detailed in the following list. And the Canon Web site includes specific instructions for downloading and installing updated programs.

Tip *To receive e-mail alerts on new firmware, go to www.usa.canon.com/ consumer, and click the banner that says "Sign up to receive" at the bottom of the Web page. Select the updates you want to receive, complete the form, and click Submit.*

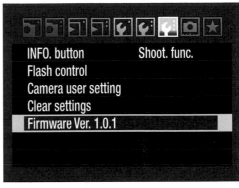

AC.1 The firmware version number display in the Setup 3 menu

Before you download the firmware, be sure to:

✦ **Know what installed version of firmware your camera is using.** If you aren't sure, press the Menu button, go to the Setup 3 menu, and write down the number shown beside the Firmware Ver. option.

✦ **Charge the camera battery and have a freshly formatted CF card in your CF card reader or in the camera.** If you're going to connect the camera to the computer using the USB cable, this is essential.

To download and install updated firmware updates, follow these steps.

1. **Insert the CF card in your card reader, or into the camera. If the card is in the camera, use the USB cable to connect the camera to the computer.**

2. On your computer, go to the Canon Web site at www.usa. canon.com/consumer/controller? act=ModelInfoAct&tabact= DownloadDetailTabAct&fcategory id=314&modelid=17499.

3. Click the arrow next to Select OS, and select your computer's operating system.

4. **Under Firmware, verify that the version number is newer than the version installed on your 50D, and, if it is, then click the firmware version text link.** The screen updates to display the Drivers & Downloads information.

5. **Scroll down and click I Agree - Begin Download.** A new window opens with the firmware details and another End User License Agreement. Be sure to review the installation instructions on the Web page.

6. **Scroll to the bottom of the page, click Agree, and then click the firmware link for your computer's operating system in the window that appears.**

7. **Copy the firmware file to the CF card if necessary, insert it into the camera if the camera is not connected to the computer, and then press the Menu button. If the camera is connected to the computer, turn off the camera, and disconnect it from the computer. Then turn the camera back on.**

8. **On the Setup 3 menu, highlight Firmware Ver. [number], and then press the Set button.** The Firmware update screen appears.

9. **Highlight OK, and then press the Set button.** The Firmware update program screen appears showing the new firmware version number.

10. **Press the Set button.** A Firmware update program confirmation screen appears

11. **Highlight OK, and then press the Set button.** The screen displays a progress bar as the firmware is installed. Do not press any buttons, turn off the camera, or open the CF Card slot door during installation. When the update is complete, a Firmware update program screen appears confirming completion.

12. **Press the Set button to complete the firmware update.** I typically format the CF card after I verify that the camera is operating correctly.

Glossary

AE Automatic exposure.

AE lock (Automatic Exposure Lock) A camera control that enables the photographer to decouple exposure from autofocusing by locking the exposure at a point in the scene other than where the focus is set. AE lock enables the photographer to set the exposure for a critical area in the scene.

ambient light The natural or artificial light within a scene. Also called available light.

angle of view The amount or area seen by a lens or viewfinder, measured in degrees. Shorter or wide-angle lenses and zoom settings have a greater angle of view. Longer or telephoto lenses and zoom settings have a narrower angle of view.

aperture The lens opening through which light passes. Aperture size is adjusted by opening or closing the lens diaphragm. Aperture is expressed in f-numbers such as f/8, f/5.6, and so on.

artifact An unintentional or unwanted element in an image caused by an imaging device or as a byproduct of software processing such as compression, flaws from compression, color flecks, and digital noise.

artificial light The light from an electric light or flash unit. The opposite of natural light.

automatic exposure (AE) A function where the camera sets all or part of the exposure elements automatically. In automatic modes, the camera sets all exposure settings. In semi-automatic modes, the photographer sets the ISO and either the aperture (Av mode) or the shutter speed (Tv mode), and the camera automatically sets the shutter speed or aperture, respectively.

autofocus A function where the camera automatically focuses on the subject using the selected autofocus point or points. Pressing the Shutter button halfway down activates autofocus. The opposite of manual focus.

axial chromatic aberration A lens phenomenon that bends different color light rays at different angles, thereby focusing them on different planes, which results in color blur or flare.

barrel distortion A lens aberration resulting in a bowing of straight lines outward from the center.

bit depth The number of bits used to represent each pixel in an image.

blocked up Describes shadow areas of an image that lack detail.

blooming Bright edges or halos in digital images around light sources, and bright reflections caused by an oversaturation of image sensor photosites.

bokeh The shape and illumination characteristics of the out-of-focus area in an image.

bounce light Light that is directed toward an object such as a wall or ceiling so that it reflects (or bounces) light back onto the subject.

brightness The perception of the light reflected or emitted by a source. The lightness of an object or image. See also *luminance*.

buffer Temporary storage for data in a camera or computer.

bulb A shutter speed setting that keeps the shutter open as long as the Shutter button is fully depressed.

cable release An accessory that connects to the camera and allows you to trip the shutter using the cable instead of by pressing the Shutter button.

chroma noise Extraneous, unwanted color artifacts in an image.

chromatic aberration A lens phenomena that bends different color light rays at different angles, thereby focusing them on different planes. Two types of chromatic aberration exist: axial and chromatic difference of magnification. The effect of chromatic aberration increases at longer focal lengths. See also *axial chromatic aberration* and *chromatic difference of magnification*.

chromatic difference of magnification A lens phenomena that bends different color light rays at different angles, thereby focusing them on different planes, which appears as color fringing where high-contrast edges show a line of color along their borders.

CMOS (complementary metal-oxide semiconductor) The type of imaging sensor used in the 50D to record images. CMOS sensors are chips that use power more efficiently than other types of recording mediums.

color balance The color reproduction fidelity of a digital camera's image sensor and of the lens. In a digital camera, color balance is achieved by setting the white balance to match the scene's primary light source. You can adjust color balance in image-editing programs using the color Temperature and Tint controls.

color/light temperature A numerical description of the color of light measured in Kelvin. Warm, late-day light has a lower color temperature. Cool, early-day light has a higher temperature. Midday light is often considered to be white light (5000K). Flash units are often calibrated to 5000K.

color space In the spectrum of colors, a subset of colors that is encompassed by a particular space. Different color spaces include more or fewer colors. See also RGB and sRGB.

compression A means of reducing file size. Lossy compression permanently discards information from the original file. Lossless compression does not discard information from the original file and allows you to re-create an exact copy of the original file without any data loss. See also *lossless* and *lossy*.

contrast The range of tones from light to dark in an image or scene.

contrasty A term used to describe a scene or image with great differences in brightness between light and dark areas.

crop To trim or discard one or more edges of an image. You can crop when taking a picture by changing position (moving closer or farther away) to exclude parts of a scene, by zooming in with a zoom lens, or via an image-editing program.

daylight balance General term used to describe the color of light at approximately 5500K, such as midday sunlight or an electronic flash.

depth of field The zone of acceptable sharpness in a photo extending in front of and behind the plane of sharp focus.

diaphragm Adjustable blades inside the lens that open and close to determine the lens aperture.

diffuser Material such as fabric or paper that is placed over the light source to soften the light.

dpi (dots per inch) A measure of printing resolution.

dynamic range The difference between the lightest and darkest values in an image as measured by f-stops. A camera that can hold detail in both highlight and shadow areas over a broad range of values is said to have a high dynamic range.

exposure The amount of light reaching the image sensor. It is the result of the intensity of light multiplied by the length of time the light strikes the sensor.

exposure meter A built-in light meter that measures the light reflected from the subject back to the camera. EOS cameras use reflective meters. The exposure is shown in the viewfinder and on the LCD panel as a scale with a tick mark under the scale that indicates ideal exposure, overexposure, and underexposure.

extender An attachment that fits between the camera body and the lens to increase the focal length of the lens.

extension tube A hollow ring attached between the camera lens mount and the lens that increases distance between the optical center of the lens and the sensor, and decreases minimum focusing distance.

fast Refers to film, digital camera settings, and photographic paper that have high sensitivity to light. Also refers to lenses that offer a very wide aperture, such as f/1.4, and to a short shutter speed.

filter A piece of glass or plastic that is usually attached to the front of the lens to alter the color, intensity, or quality of the light. Filters also are used to alter the rendition of tones, reduce haze and glare, and create special effects such as soft focus and star effects.

fisheye lens A lens with a 180-degree angle of view.

flare Unwanted light reflecting and scattering inside the lens causing a loss of contrast and sharpness and/or artifacts in the image.

flat Describes a scene, light, photograph, or negative that displays little difference between dark and light tones. The opposite of contrasty.

fluorite A lens material with an extremely low index of refraction and dispersion when compared to optical glass. Fluorite features special partial dispersion characteristics that allow almost ideal correction of chromatic aberrations when combined with optical glass.

f-number A number representing the maximum light-gathering ability of a lens or the aperture setting at which a photo is taken. It is calculated by dividing the focal length of the lens by its diameter. Wide apertures are designated with small numbers, such as f/2.8. Narrow apertures are designated with large numbers, such as f/22. See also *aperture*.

focal length The distance from the optical center of the lens to the focal plane when the lens is focused on infinity. The longer the focal length is, the greater the magnification.

focal point The point in an image where rays of light intersect after reflecting from a single point on a subject.

focus The point at which light rays from the lens converge to form a sharp image. Also the sharpest point in an image achieved by adjusting the distance between the lens and image.

frame Used to indicate a single exposure or image. Also refers to the edges around the image.

f-stop See also *f-number* and *aperture*.

ghosting A type of flare that causes a clearly defined reflection to appear in the image symmetrically opposite to the light source creating a ghost-like appearance. Ghosting is caused when the sun or a strong light source is included in the scene and a complex series of reflections among the lens surfaces occur.

gigabyte The usual measure of the capacity of digital mass storage devices; slightly more than 1 billion bytes.

grain See *noise*.

gray-balanced The property of a color model or color profile where equal values of red, green, and blue correspond to a neutral gray value.

gray card A card that reflects a known percentage of the light that falls on it. Typical gray cards reflect 18 percent of the light. Gray cards are standard for taking accurate exposure-meter readings and for providing a consistent target for color balancing during the color-correction process using an image-editing program.

grayscale A scale that shows the progression of tones from black to white using tones of gray. Also refers to rendering a digital image in black, white, and tones of gray. Also known as monochrome.

highlight A term describing a light or bright area in a scene, or the lightest area in a scene.

histogram A graph that shows the distribution of tones or colors in an image.

hue The color of a pixel defined by the measure of degrees on the color wheel, starting at 0 for red depending on the color system and controls.

infinity The farthest position on the distance scale of a lens (approximately 50 feet and beyond).

ISO (International Organization for Standardization) A rating that describes the sensitivity to light of film or an image sensor. ISO in digital cameras refers to the amplification of the signal at the photosites. Also commonly referred to as film speed. ISO is expressed in numbers such as ISO 100. The ISO rating doubles as the sensitivity to light doubles. ISO 200 is twice as sensitive to light as ISO 100.

JPEG (Joint Photographic Experts Group) A lossy file format that compresses data by discarding information from the original file to create small image file sizes.

Kelvin A scale for measuring temperature based around absolute zero. The scale is used in photography to quantify the color temperature of light.

LCD (liquid crystal display) The image screen on digital cameras that displays menus and images during playback and Live View shooting.

LCD panel The LCD panel is located on the top of the camera and displays exposure information and changes made to exposure, white balance, drive mode, and other camera functions made by using the buttons located above the LCD panel.

lightness A measure of the amount of light reflected or emitted. See also *brightness* and *luminance*.

linear A relationship where doubling the intensity of light produces double the response, as in digital images. The human eye does not respond to light in a linear fashion. See also *nonlinear*.

lossless A term that refers to file compression that discards no image data. TIFF is a lossless file format.

lossy A term that refers to compression algorithms that discard image data, often in the process of compressing image data to a smaller size. The higher the compression rate, the more data that's discarded and the lower the image quality. JPEG is a lossy file format.

luminance The light reflected or produced by an area of the subject in a specific direction and measurable by a reflected light meter. See also *brightness*.

megabyte Slightly more than 1 million bytes.

megapixel One million pixels. Used as a measure of the capacity of a digital image sensor.

memory card In digital photography, removable media that stores digital images, such as the CompactFlash media used to store 50D images.

metadata Data about data, or more specifically, information about a file. This information, which is embedded in image files by the camera, includes aperture, shutter speed, ISO, focal length, date of capture, and other technical information. Photographers can add additional metadata in image-editing programs, including name, address, copyright, and so on.

middle gray A shade of gray that has 18 percent reflectance.

midtone An area of medium brightness; a medium gray tone in a photographic print. A midtone is neither a dark shadow nor a bright highlight.

neutral density filter A filter attached to the lens or light source to reduce the required exposure.

noise Extraneous visible artifacts that degrade digital image quality. In digital images, noise appears as multicolored flecks and as grain that is similar to grain seen in film. Both types of noise are most visible in high-speed digital images captured at high ISO settings.

nonlinear A relationship where a change in stimulus does not always produce a corresponding change in response. For example, if the light in a room is doubled, the room is not perceived as being twice as bright. See also *linear*.

normal lens or zoom setting A lens or zoom setting whose focal length is approximately the same as the diagonal measurement of the film or image sensor used. In full-frame 35mm format, a 50 to 60mm lens is considered to be a normal lens. On the 50D, normal is about 28mm. A normal lens more closely represents the perspective of normal human vision.

open up Switching to a lower f-stop, which increases the size of the diaphragm opening.

overexposure Giving an image sensor more light than is required to make an acceptable exposure. The resulting picture is too light.

panning A technique of moving the camera horizontally to follow a moving subject, which keeps the subject sharp but blurs background details.

photosite The place on the image sensor that captures and stores the brightness value for one pixel in the image.

pincushion distortion A lens aberration causing straight lines to bow inward toward the center of the image.

pixel The smallest unit of information in a digital image. Pixels contain tone and color that can be modified. The human eye merges very small pixels so they appear as continuous tones.

plane of critical focus The most sharply focused part of a scene. Also referred to as the point of sharpest focus.

polarizing filter A filter that reduces glare from reflective surfaces such as glass or water at certain angles.

ppi (pixels per inch) The number of pixels per linear inch on a monitor or image file that are used to describe overall display quality or resolution. See also *resolution*.

RAM (Random Access Memory) The memory in a computer that temporarily stores information for rapid access.

RAW A proprietary image file in which the image has little or no in-camera processing. Because image data has not been processed, you can change key camera settings, including brightness and white balance, in a conversion program (such as Canon DPP or Adobe Camera Raw) after the picture is taken.

reflective light meter A device — usually a built-in camera meter — that measures light emitted by a photographic subject back to the camera.

reflector A surface, such as white cardboard, used to redirect light into shadow areas of a scene or subject.

resolution The number of pixels in a linear inch. Resolution is the amount of data in an image to represent detail in a digital image. Also, the resolution of a lens that indicates the capacity of reproduction. Lens resolution is expressed as a numerical value such as 50 or 100 lines, which indicates the number of lines per millimeter of the smallest black and white line pattern that can be clearly recorded.

RGB (Red, Green, Blue) A color model based on additive primary colors of red, green, and blue. This model is used to represent colors based on how much light of each color is required to produce a given color.

saturation As it pertains to color, a strong, pure hue undiluted by the presence of white, black, or other colors. The higher the color purity is, the more vibrant the color.

sharp The point in an image at which fine detail is clear and well defined.

shutter A mechanism that regulates the amount of time during which light is let into the camera to make an exposure. Shutter time or shutter speed is expressed in seconds and fractions of seconds such as 1/30 second.

slave A flash unit that is synchronized to and controlled by another flash unit.

slow Refers to film, digital camera settings, and photographic paper that have low sensitivity to light, requiring relatively more light to achieve accurate exposure. Also refers to lenses that have a relatively wide aperture, such as f/3.5 or f/5.6, and to a long shutter speed.

speed Refers to the relative sensitivity to light of photographic materials such as film, digital camera sensors, and photo paper. Also refers to the ISO setting, and the ability of a lens to let in more light by opening the lens to a wider aperture.

spot meter A device that measures reflected light or brightness from a small portion of a subject.

sRGB A color space that encompasses a typical computer monitor.

stop See *aperture*.

stop down To switch to a higher f-stop, thereby reducing the size of the diaphragm opening.

telephoto A lens or zoom setting with a focal length longer than 50 to 60mm in full-frame 35mm format.

TIFF (Tagged Image File Format) A universal file format that most operating systems and image-editing applications can read. Commonly used for images, TIFF supports 16.8 million colors and offers lossless compression to preserve all the original file information.

tonal range The range from the lightest to the darkest tones in an image.

TTL (Through the Lens) A system that reads the light passing through a lens that strikes an image sensor.

tungsten lighting Common household lighting that uses tungsten filaments. Without filtering or adjusting to the correct white balance settings, pictures taken under tungsten light display a yellow-orange colorcast.

underexposure The effect of exposing an image sensor to less light than required to make an accurate exposure. The picture is too dark.

viewfinder A viewing system that allows the photographer to see all or part of the scene that will be included in the final picture. Some viewfinders show the scene as the lens sees it. Others show approximately the area that will be captured in the image.

vignetting Darkening of edges on an image that can be caused by lens distortion, using a filter, or using the wrong lens hood. Also used creatively in image editing to draw the viewer's eye toward the center of the image.

white balance The relative intensity of red, green, and blue in a light source. On a digital camera, white balance compensates for light that is different from daylight to create correct color balance.

wide angle Describes a lens with a focal length shorter than 50 to 60mm in full-frame 35mm format.

Index

Guides to go.

Colorful, portable *Digital Field Guides* are packed with essential tips and techniques about your camera equipment, iPod, or notebook. They go where you go; more than books—they're *gear*. Each $19.99.